SCHWITTERS

IN

Edited By Emma Chambers and Karin Orchard
With contributions from Adam Chodzko, Alistair Hudson,
Megan Luke, Jennifer Powell, Laure Prouvost, Isabel Schulz,
Katharine Stout and Michael White

Tate Publishing

BRITAIN

First published 2013 by order of the
Tate Trustees by Tate Publishing,
a division of Tate Enterprises Ltd,
Millbank, London SW1P 4RG
www.tate.org.uk/publishing

on the occasion of the exhibition
Schwitters in Britain

Tate Britain
30 January – 12 May 2013

Sprengel Museum Hannover
2 June – 25 August 2013

Organised by Tate Britain and Sprengel
Museum Hannover, with the cooperation of
Kurt und Ernst Schwitters Stiftung, Hanover

The exhibition at Tate Britain is generously
supported by Tate Patrons

A catalogue record for this book is available
from the British Library

ISBN 978 1 84976 026 3

Distributed in the United States and Canada by
ABRAMS, New York

Library of Congress Control Number applied for

Designed by The Studio of Williamson Curran
Colour reproduction by DL Imaging Ltd, London
Printed by Grafos SA, Barcelona

Front cover: Detail from Kurt Schwitters,
EN MORN 1947 (p.125)

Measurements of artworks are given in
centimetres, height before width

FOREWORD

The idea of an exhibition devoted to Schwitters's years in Britain has long been a possibility. While in 1985 the Tate Gallery presented John Elderfield's longer survey, covering Schwitters's life from his emergence in Germany around 1920 through to his emigration to both Norway and Britain, it seems right that the reconfigured Tate Britain should take the opportunity to look in more detail at the British years. Although Schwitters arrived in Scotland through force of necessity – taking the last icebreaker out of Norway in the face of its occupation by Nazi forces – and was immediately interned as an enemy alien, this late period was in fact an amazingly prolific one, and one which the Tate Collections document well, notably through his sculpture and through archive material.

Any Schwitters exhibition depends on the collaboration of the Sprengel Museum in Hanover, and when I arrived as Director of Tate Britain, Hanover was one of my first destinations. From the outset we have been supported by Ulrich Krempel, its director, by Isabel Schulz, Executive Director, Kurt und Ernst Schwitters Stiftung (KESS), and in particular by Curator of Prints and Drawings Karin Orchard, who had already begun work on this period. With the arrival here at Tate, some months later, of Emma Chambers as Curator of Modern British Art, we were able to form the partnership which has created this project, which will travel on to Hanover from London. At Tate, the support of the Tate Patrons has been invaluable, while at Hanover the exhibition has been made possible by long-standing supporters Niedersächsiche Sparkassenstiftung, in addition to Sparkasse Hannover and NORD/LB Hannover who have been instrumental in securing a group of thirty-nine works for permanent laon to the Sprengel. This exhibition has been made possible by the provision of insurance through the Government Indemnity Scheme. Tate Britain would like to thank HM Government for providing Government Indemnity and the Department for Culture, Media and Sport and Arts Council England for arranging the indemnity.

The geographical trajectory of Schwitters's life in Britain has become somewhat mythical, with its tragi-comic combination of an internment camp on the Isle of Man, the leafy suburbs of London and the apparent remoteness of Ambleside and Elterwater in the Lake District. This exhibition seeks to examine each of these periods and places with greater rigour, so that we can understand more fully the nature of the different milieux in which Schwitters found himself, along with the nature of his contribution.

Equally mythic is the legacy that Schwitters left for artists in this country: a legacy which begins with Richard Hamilton and continues through to Damien Hirst, and which we have taken the opportunity to demonstrate further, with the contributions of Adam Chodzko and Laure Prouvost. In this respect Kurt Schwitters is very much a part of British art history.

This exhibition benefits from the inspiration that Schwitters provides locally, as well as further afield. The artists' commissions have been realised by Katharine Stout in close collaboration with Grizedale Arts, and the hut itself has been secured through the Littoral Trust, which has revivified Schwitters's presence in the local community in recent years. While the major lenders to the show are our partners in Hanover, many others have helped us flesh out the story, not least locally, through a number of significant loans made by those families and institutions who encountered Mr Schwitters.

The hut where Schwitters made his last work still stands on the Cylinders Estate in Elterwater. Last year a facsimile was recreated in the courtyard of the Royal Academy, within the environs of an alternative exhibiting structure and another art world. The hut has become a powerful symbol which many artists have been drawn to explore. The art work which Schwitters made inside it has long since been removed to the Hatton Gallery in Newcastle,

and yet the hut, more than the actual composition, speaks to artists, and to the public more generally, of the possibility of creative survival.

Each of the Merz structures that Schwitters created around him, in Germany, in Norway, and in England, has been largely destroyed, whether by opposing air forces, or by time and good intentions. If the Merz structures, like Adam's hut in paradise, live perhaps more powerfully in our imaginations, this exhibition has nonetheless sought to be strictly empirical, using material evidence as it is available and when it is genuinely of its time. In this way Emma Chambers and Karin Orchard, with research input from Jennifer Powell, seek, if not to debunk the romantic aura surrounding Schwitters, at least to set it to one side, and to present us instead with the historical evidence of the time, whether from the camp in Douglas, the galleries of war-time London, or the mixed local economy of Ambleside. This show may be one of the first to attempt to understand Schwitters's production in Britain in holistic terms, putting the naturalistic paintings together with the abstract collages to give us a picture of an artist who needed both, rather than either one.

Penelope Curtis
Director, Tate Britain

Kurt Schwitters, born in Hanover, is an European artist of international stature. He himself was always certain that his art and his contribution to international modernism would be recognised after his death. His reputation has grown continuously ever since and his standing as an early pioneer who transgressed boundaries is now undisputed. Kurt Schwitters's global artistic intentions, as realised early on in his comprehensive Merz art, his radical Merzbau (his 'accessible sculpture'), extended far beyond the domesticated practices of the art academy. His life was affected by adverse circumstances and tragic experiences. National Socialism's brutal

interventions into art forced him to emigrate to Norway and later, after its occupation, to Britain. The destruction of many of his works in the bombing of Germany was one of the most bitter pieces of information to reach him in his English exile. The compilation of the catalogue raisonné at Sprengel Museum Hannover has laid the foundation for an overview of his oeuvre including Kurt Schwitters's time in Britain, which has until now only been superficially dealt with in exhibitions.

I am accordingly all the more pleased that this epoch of his life and work has now been examined so meticulously through the cooperation between Tate Britain and Sprengel Museum Hannover and in the collaboration between Emma Chambers and Karin Orchard in particular. New insights into the breadth of his work, especially sculpture, can be found here in an intense biographical examination of the artist's British years. Some works have been lost or destroyed or can only be documented in secondary sources, for example the Norwegian *Merzbau*, the *Merz Barn* and the original Merz building whose single room is on display at the Sprengel in the reconstruction by Schwitters's son Ernst, Peter Bissegger and Harold Szeemann. *Schwitters in Britain*, however, does much to fill this gap thanks to a wealth of information about the life and work of Kurt Schwitters. The present account dealing with the final creative periods of this tragic European figure moreover makes the common roots of contemporary art evident, irrespective of borders.

Marlis Drevermann
City Councillor, State Capital of Hanover

EMMA CHAMBERS

Schwitters and Britain

When Kurt Schwitters arrived in Britain in June 1940, having fled Nazi Germany via Norway, he was already an artist of international repute, known as the founder of Merz, a practice that he had defined in 1919:

> The word Merz denotes essentially the combination of all conceivable materials for artistic purposes, and technically the principle of equal evaluation of the individual materials ... A perambulator wheel, wire-netting, string and cotton wool are factors having equal rights with paint. The artist creates through the choice, distribution and metamorphosis of the materials.[1]

In line with this early artistic statement, Schwitters's reputation had been built on his work in collage, assemblage and poetry, and he had been closely associated with avant-garde developments such as dadaism and constructivism in Europe, maintaining productive dialogues with artists such as Raoul Hausmann, Hans Arp and Theo van Doesburg, while pursuing his own distinctive brand of art. The culmination of his production in Germany was the *Merzbau*, an architectural construction that encompassed several rooms of his house in Hannover.

Schwitters spent the last eight years of his life in Britain, a period that is often depicted as one of isolation and neglect. Indeed, the narrative of the 'rediscovery' of his work in the Lake District remains a key element of how Schwitters is still perceived in Britain.[2] John Elderfield's comprehensive 1985 account of his career conflated his Norwegian and British work into a single 'exile' period, arguing that his work changed in this last decade because he spent so much of it in rural settings, professional isolation leading to his stepping outside the mainstream of contemporary art. Elderfield also identified new developments in Schwitters's abstract work as a result of this shift in the physical sources of his art, such as the use of found natural objects and a painterliness that referred to the natural world.[3]

More recently, Sarah Wilson has contested the characterisation of Schwitters's final years, 'that England was simply "exile", a cultural desert, that he was lonely, unappreciated'. She has argued instead that this period should be understood in terms of a 'dialectics of exile' in which the artist's past lives on through 'memory, repetition, recreation', and she has emphasised the 'inspirational possibilities of a new "genius loci", a spirit of place: England'.[4] Anna Müller-Härlin moved discussion beyond the rural aspects of Schwitters's work by stressing the importance of Schwitters's time in London. She traced how he made intense efforts to engage with the city's avant-garde art circles.[5] But she concluded that he was unable to establish the creative dialogues with other artists to which he had been accustomed in Europe, and that his work was out of step with a British art world where abstract art had largely been eclipsed by neo-romanticism.

Being out of step had always been part of Schwitters's experience, as Nicholas Wadley has explored,[6] so it is perhaps timely to re-examine how this condition shaped his work in Britain. His practice was intimately connected to location and in London his use of British source material led him in new directions. But even when physically distant from the mainstream of British art and intensely involved in local culture in the Lake District through his depiction of the landscape and his search for portrait commissions, Schwitters was at the same time connected to London, Europe and America by his copious correspondence. His situation was therefore simultaneously one of presence and absence, opposed states that also played out creatively in the juxtaposition of materials from different sources in his collages, and the dialogue between representation and abstraction in his work. This essay will examine Schwitters's connections with the British art world, but also how the dislocation and reframing of British subject matter and source material was essential to his work and to his condition as an émigré artist.

GERMAN ART IN 1930s LONDON

Schwitters's interaction with the British art world has to be understood in the context of the reception of German art in Britain in the 1930s. When the critic Herbert Read wrote two articles on modern German painting in the *Listener* magazine in 1930, he was still able to remark on how unfamiliar the British public was with German art:

> In England we have for many years been content to take all our ideas about contemporary art from Paris … That we … should wilfully deny ourselves the art with which we are likely to have the most sympathy is a curious phase in our cultural history.[7]

Although Read was right that modern German art was not widely known in Britain, Schwitters's work had already been seen in the British avant-garde periodical *Ray*, where four poems and reproductions of several of his most important works, including *Das Undbild* (fig.1), were published in 1926 and 1927.[8] One of his photograms was also published in the *Studio* in 1931.[9] His work was also known in Britain through his strong connections with Paris in the early 1930s. It appeared in the French periodical *Cahiers d'art*, which was read by British artists eager to find out about developments in Europe,[10]

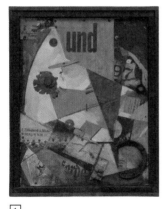

1

Das Undbild
The And Picture
1919
Gouache, paper, cardboard, wood, metal, leather, cork and wire grating on cardboard
35.8 x 28
Staatsgalerie Stuttgart
CR:447

and he exhibited and published with avant-garde groups such as Cercle et Carré and Abstraction-Création, whose journals featured the work of British artists Barbara Hepworth, Ben Nicholson and Edward Wadsworth.[11]

Schwitters's work also began to appear in British surveys of contemporary art in the 1930s. Herbert Read's *Art Now* was first published in 1933 and gained a wide British readership, being reissued in several new editions throughout the decade. The book was unusual in its desire to give equal attention to French, German and British traditions of modern art. Schwitters's assemblage *Grey-rose picture* (*Bild grau-rosa*; fig.2) was illustrated in the section on abstraction, which was international in its scope.[12] However, an opposing strand in British criticism at this time, exemplified by the then director of the National Gallery, Kenneth Clark, condemned the German influence on modern British art, visible in abstraction, and argued for the development of an inward-focused national identity.[13]

Between 1933 and 1937 commercial galleries in London such as the Mayor Gallery and the London Gallery had begun to show the work of German artists, among them Herbert Bayer, Paul Klee, Max Ernst and Oskar Schlemmer.[14] Public interest in German art also increased as émigrés began to arrive in Britain to escape the religious, political and cultural persecutions of the Nazi government, and the *Studio* magazine published a sober examination of the state of the arts in Germany in 1936.[15] This interest was heightened by reports of the *Entartete Kunst* exhibition, which had opened in Munich in July 1937, featuring 650 works by the most prominent avant-garde artists held in German state collections. These works had been labelled 'degenerate' and confiscated by the regime, only to be exhibited and derided in this touring show before being sold off or destroyed.[16] Schwitters had four pieces included in the exhibition, including *L Merzbild L3 (Das Merzbild)* (fig.3), the work that had served as a foundation for his theories of art.[17] Their inclusion was among the reasons for his move to Norway in 1937, as he realised the impossibility of pursuing his art under the Nazi regime.

The first comprehensive survey of modern German art in London was the *Exhibition of Twentieth Century German Art* held at the New Burlington Galleries in July and August 1938. Organised by Read, it was originally conceived as a response to *Entartete Kunst*. However, it was compromised in this aim by the determination of the organisers to maintain an apolitical stance that focused on artistic freedom rather than political comment, thus aligning it with the appeasement policies of the British government at that time.[18] Many of its 269 exhibits were by artists who had been included in the Munich show. The exhibition included two by Schwitters, the biographical text describing him as: 'One of the leaders of German Dadaism … His collages of different materials are called "Merzprodukte."' It also referred to his poem 'To Anna Blume' ('An Anna Blume'), suggesting that he was as well known in Britain for his literary as for his artistic works.[19]

Although the exhibition received extensive coverage in the press, this was partly as a result of the political topicality of banned and degenerate art,

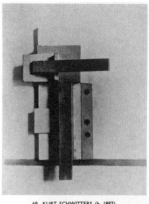

69. KURT SCHWITTERS (b. 1887)
Grey-rose picture. 1932
Museum für Kunst und Landesgeschichte, Hannover
Reproduced by permission of Abstraction-Création

2

Bild grau-rosa
Grey-rose picture
1923–6
Oil and wood on wood
Location unknown
As reproduced in Herbert Read,
Art Now, 1936 (second edn.)
Tate Archive
CR:1102

3

L Merzbild L3 (Das Merzbild)
L Merzpicture L3 (The Merzpicture)
1919
Oil, paper, wire-grating, barbed wire?,
metal and thread on wood?
Location unknown
Photograph from postcard, Tate
Archive
CR:436

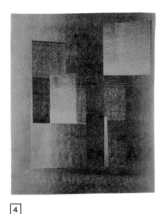

4

blau in blau
Blue in Blue
1926–9
Paper and lithographic crayon on
paper 36.7 x 29.9
The Solomon R. Guggenheim
Foundation, Peggy Guggenheim
Collection, Venice
CR:1627

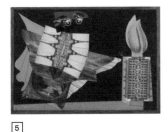

5

Roland Penrose
Magnetic Moths
1938
Mixed media, drawing and
watercolour on board
55.8 x 81.3
Tate. Purchased 1976

and reviews stressed the need to separate art and politics in assessing the work itself, which was widely considered to be of 'extraordinary ugliness'.[20] However, journals such as the *Listener* and the *Studio* were more positive and saw the exhibition as an opportunity to educate their readers about modern German art.[21] A survey of the subject was also published by Penguin Books to coincide with the exhibition. These texts focused on expressionism, which was seen to epitomise the spiritual and emotional nature of German art, but there was little consideration of abstraction.[22]

Shortly after the British public had seen Schwitters's work in the context of modern German art, two exhibitions at the Guggenheim Jeune gallery placed it in a British setting. The *Exhibition of Collages, Papier-Collés and Photomontages* in November 1938 showed five works by Schwitters, including *Blue in Blue* (*blau in blau*; fig.4) alongside other key proponents of collage such as Pablo Picasso and Hans Arp, and the British artists Nigel Henderson, Conroy Maddox, Julian Trevelyan and Roland Penrose (fig.5).[23] Two of these works were also included in Guggenheim Jeune's subsequent exhibition *Abstract and Concrete Art* in May 1939 alongside pieces by Nicholson, Hepworth, Arp, Naum Gabo and Piet Mondrian. These two exhibitions indicate the dual association of Schwitters's work with both constructivism and collage in Britain in the 1930s, and suggest the points of contact with British artists that he might have expected to establish when he arrived.[24]

SCHWITTERS IN LONDON 1941–5

Schwitters's arrival in June 1940 coincided with the introduction of a British government policy to intern all German and Austrian nationals, and as a result he spent over a year in the Hutchinson internment camp on the Isle of Man (see Powell, pp.32–5). Here he made contact with fellow émigré artists including Fred Uhlman, co-founder of the Free German League of Culture, an association of artists, musicians and intellectuals whose aim was to preserve a free German culture undistorted by Nazi ideology.[25] Upon his release in November 1941, Schwitters moved to London, taking advantage of the social opportunities provided by the FGLC to stay in contact with fellow internees including Uhlman, Siegfried Charoux, Erich Kahn, Georg Ehrlich and Paul Hamann. He also made contact with fellow émigré László (Peter) Peri in 1941 and became close to Jankel Adler after Adler's move to London in 1943.[26] In this year he also met the Polish émigré filmmaker Stefan Themerson, who would later play an important role in publishing his poetry.[27]

However, Schwitters had little in common politically or artistically with many of the émigré artists associated with the FGLC and never joined the organisation.[28] Had he chosen to come directly to London when he left Germany in 1937, he could have made contact with existing European friends such as Walter Gropius, László Moholy-Nagy and Gabo, who were all in London at that time. But these London networks had dispersed by the time he arrived late in 1941: Gropius and Moholy-Nagy had emigrated to America, and Gabo had moved to Cornwall with Nicholson and Hepworth. Schwitters finally re-established contact with Gabo and Moholy-Nagy in March 1942. The former wrote expressing his surprise and delight that Schwitters was alive and

in Britain, but also noting the difficulty of their arranging a meeting.[29] The latter, writing from America, gave practical suggestions of whom Schwitters should contact in London, including Read, Penrose, Jim Richards, editor of the *Architectural Review*, and the gallery owner Anton Zwemmer.[30]

That year, 1942, was an active one in which Schwitters sent work to numerous group exhibitions, testing out connections with different sections of the British art world. He began to exhibit soon after his move to London, showing five abstract compositions in January 1942 at fellow German émigré Jack Bilbo's Modern Art Gallery. Bilbo had opened the space in 1941, operating it as a combined gallery, publishing house and cultural forum, showing work by both émigré and British artists.[31] Another organisation that was a valuable source of contacts and exhibiting opportunities for émigrés was the Artists' International Association, founded in 1933 as an anti-fascist exhibiting society. Schwitters joined in 1942, but exhibited only once, in the members' exhibition of February 1942, in a room devoted to British abstract and surrealist artists.[32]

The most significant opportunity for Schwitters in 1942 was the selection of his work for the important touring exhibition *New Movements in Art*, which began in London in March and travelled to Leicester, Birkenhead, Bolton, Manchester, Hull, Doncaster and Liverpool. A survey of the prevailing trends in modern British art, this exhibition was seen at the time as an important demonstration of continuity and solidarity by the major modernist groupings of the 1930s and it included work by the leading figures in British abstraction and surrealism, including Nicholson, Hepworth, Gabo, Paul Nash, Eileen Agar and Ithell Colquhoun.[33] The influential critic E.H. Ramsden selected the show and wrote the catalogue introduction.[34] Margot Eates, the show's co-curator, visited Schwitters's studio at the beginning of April and chose three works, including *Relief* (*Stilllife with penny*; fig.6).[35] Selection for the exhibition cemented his claims to be a member of the avant-garde in Britain and also introduced his work to a large audience; more than 10,000 visitors saw the show in Leicester alone.[36]

Schwitters was also trying to build friendships with members of the British avant-garde and saw Nicholson as a key figure in that respect. He wrote to Gabo in March 1942 asking for an introduction,[37] and they had certainly met by 4 May, when Hepworth wrote to Nicholson, 'Tell me all about Schwitters.'[38] Schwitters and Nicholson became friendly enough for Nicholson to send him a collage (fig.7) in February 1943.[39] But the two seem to have fallen out soon afterwards, and Nicholson wrote to Ramsden in May 1943 saying, 'Schwitters is an ass and a bore, though evidently he was once something else.'[40]

Schwitters also contributed to political exhibitions such as *Aid to Russia*, held at the modernist émigré architect Erno Goldfinger's home at Willow Road, Hampstead, in June 1942. It showed the work of young British artists alongside more established British and European names such as Picasso, Léger and Moore.[41] Schwitters exhibited four abstract works, including *Mother with Egg* (*Untitled [Mother and Egg]*; p.22), and a review by Jan Gordon in the *Observer* praised the high quality of the exhibits and singled out his 'ironic whimsical

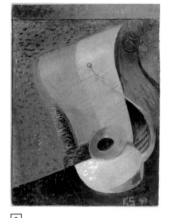

6

Stillife with penny
1941
Oil and coin on cardboard
[Medium according to CR, but according to owner the coin is no longer attached]
32.8 x 24.6
Private collection
CR:2771

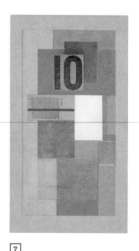

7

Ben Nicholson
1942 (bus ticket)
1942
Paper, cardboard and gauze on cardboard
28 x 15.3
Private collection

collages and sculptures' for attention.[42] This small-scale exhibition organised by Hampstead avant-garde circles would have been an important chance for Schwitters to build relationships with influential artists, critics and collectors in London. The surrealist artist and collector Roland Penrose and Peter Watson, proprietor of the literary and arts journal *Horizon*, were involved with the show, and although Schwitters already knew Penrose, who had been an early collector of his work, he met Watson only around this time.[43] Another important link with the London avant-garde was the Belgian surrealist artist E.L.T. Mesens, whom Schwitters had first met in Paris in 1927. Mesens had come to London in 1936 and ran the London Gallery from April 1938. Schwitters visited him several times in Hampstead during the war, and both Mesens and Penrose bought collages from him.[44] His work also entered the British Museum collection in 1942 as part of a portfolio of Bauhaus prints donated by the German émigré Erich Goeritz, although it is unlikely that Schwitters was aware of this.[45]

Schwitters went on to exhibit works in two further political exhibitions, the much larger *Artists Aid Russia* and *Artists Aid China* exhibitions at the Wallace Collection in July 1942 and March 1943. The latter exhibition continued his association with Ramsden and her circle: he showed his work in a room of abstract and surrealist art selected by the critic, who had been recommended as curator of the section by Ben Nicholson.[46]

But despite these promising beginnings and exposure of his work in both political and avant-garde contexts, these exhibiting opportunities did not translate into sales, and Schwitters also found it difficult to establish the lively dialogues with fellow artists that had characterised his time in Europe. Schwitters's London address book was full of the artists, critics, curators, gallery owners and patrons whom he knew or thought worth meeting (p.21).[47] But despite this assiduous research into useful contacts, his attempts to capitalise on the information could often be disappointing. Kenneth Clark had been an active supporter of many individual émigré artists, and also played a key role in ending the internment of German and Austrian artists through the Artists' Refugee Committee.[48] But Schwitters seems to have been unaware of Clark's opposition to abstraction and when he contacted him after his release to seek his support, he was rebuffed. He incorporated this incident into a story, *On the Bench*, which gives a poignant account of the experiences of a penniless exile artist in London:

> I took a seat on the bench and looked all around me. I was not hungry, because I had been given three pieces of bread in the shop of an art dealer I know … It was raining, a thunderstorm. So I interrupted my business of visiting one shop after another and trying to get commissions for portrait painting. There must be people who would like to have a good portrait of their nice head done by me, but I cannot find them … I felt sad about the hopelessness of my situation … Why did the director of the National Gallery not even want to see me? He does not know that I belong to the *avantgarde* in art. That is my tragedy. Why did Mr. A. tell me that not even the really famous painter, Lieutenant F., could get portrait commissions, and so I should be quite satisfied?

Why did people tell me I should wait until after the war? I have already been waiting seven months for work, and cannot wait without eating.[49]

While many accounts of Schwitters's time in Britain have implied that his hardship was due to the neglect of an undiscerning British public that lacked the critical skills to appreciate abstract art, this is only part of the story. During the war years there was a temporary shift from private to state funding of art and many artists relied on income from official schemes, such as the War Artists Scheme, that were not open to Schwitters as a German émigré.[50] Nonetheless, the commercial sector remained active, and although many established galleries such as the Mayor Gallery and the London Gallery closed for the duration of the war, those that stayed open, which included the Leger Gallery, Leicester Galleries, Redfern Gallery and Zwemmer Gallery, mounted a lively programme of exhibitions.[51] However, with communication with Europe disrupted, these focused necessarily on contemporary British art.[52]

The war years also saw a move in British art away from the international language of abstraction towards the creation of a national culture focusing on figurative contemporary art, designed to appeal to a wide public. One of the key figures in promoting this shift was Clark who, as Brian Foss has argued, was able to shape public taste through his leadership of the War Artists Advisory Committee. Touring exhibitions of war art and shows in commercial galleries focused attention on figurative art, including neo-romantic artists and their reworking of British romantic landscape traditions, rather than abstract art, which Clark saw as having no connection with human emotion or life and appealing only to a minority elite.[53] However, despite this general trend, some galleries such the Redfern Gallery and the Modern Art Gallery continued to support abstraction.

An inability to make a living from his abstract work was nothing new for Schwitters. In Germany, his Merz pictures had not been commercially successful, and most of his income had come from his recitals and typographical work.[54] In London, he also looked for design work, and approached the Central Institute of Art and Design, a crucial institution during the war years for its role in helping artists to find paid employment. Thomas Fennemore of the Register of Industrial Designers wrote several letters of recommendation for Schwitters, but there is no evidence that he obtained any work as a result.[55] Alongside these pragmatic investigations into art that might bring income, Schwitters continued to make abstract work, although he did not show it again until the beginning of 1944, when he exhibited four pieces in the Modern Art Gallery exhibition *The World of the Imagination*, which drew together an eclectic group of artists linked by their common interest in evoking a world beyond the everyday. The show received extensive press coverage: a photograph in the *Daily Sketch* showed a group of sculptures that included Schwitters's *Stork* (fig.8), while both *Stork* (CR:3051) and *Parrot* (a mobile sculpture suspended from the ceiling – CR:3128) featured in a lighthearted Pathé news article on the exhibition.[56]

Schwitters's most significant exhibition in London was his solo show held at the Modern Art Gallery in December 1944, where he showed

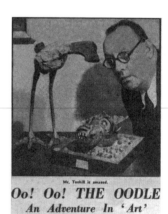

'Oo! Oo! The Oodle', *The Daily Sketch*, 20 January 1944
British Library, London

eleven collages, eighteen oil paintings and ten sculptures (p.20). All were works that had been made since his arrival in Britain. Read's short essay in the catalogue was the most significant critical assessment of Schwitters's work at this period. It began by describing the artist as 'one of the original masters of the modern movement', stressing the important contribution that the concept of Merz had made to modern art:

> Schwitters has shown that it is possible to make art out of anything – so long as one is an artist. Used tram tickets, pieces of cardboard, or corrugated paper, corks, matches, rags – all is grist to the creative imagination, and Schwitters has pursued this line of development far beyond the point reached by Juan Gris and Picasso. Schwitters is the supreme master of the *collage*.[57]

Read aligned Schwitters's work with prevailing British perceptions of the spiritual and emotional character of modern German art. He described how his working practice involved 'taking up the stones which the builders rejected and making something of them' and continued:

> I doubt if Schwitters would like to be called a mystic, but there is nevertheless in his whole attitude to art a deep protest against the chromium-plated conception of modernism. The bourgeois loves slickness and polish: Schwitters hates them. He leaves his edges rough, his surfaces uneven.[58]

Read perceptively identified Schwitters's emotional connection with found objects that had been discarded by society, and Schwitters enthusiastically endorsed this interpretation of his practice in a letter to the critic in November 1944:

> You certainly observed everything and explained it excellently. I especially appreciate your remarks about the mystic in my work, and what you wrote about the 'rejected stone' absolutely expresses my way of feeling and working.[59]

The range of works exhibited at the Modern Art Gallery in 1944 reveals the breadth of Schwitters's practice in Britain and the formal developments that would increasingly shape his art. Schwitters himself later wrote about the selection in the exhibition as being a balanced representation of his work: 'This London exhibition was composed, the right amount of collages, paintings and sculptures fitting together.'[60]

A series of collages such as *Collage with red line* (*Red Line [2]*; fig.9) relied on primarily formal juxtapositions of coloured and textured paper as Schwitters had always done, but *PEN* (fig.10) combined fragments of photographic imagery and English text in a way that would become more prevalent in his later practice. Pieces such as *Sköyen* (*Bild abstrakt Skøyen I*; fig.11) revealed the interest in exploring organic abstract forms through pointillist painting techniques that had increasingly shaped Schwitters's work after his move to Norway as a response to colour and light in the landscape.[61] *Anything*

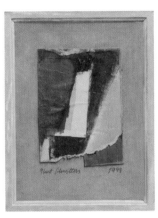

9

Red Line [2]
1944
Oil, gouache, paper, canvas
and cardboard on wood
12.7 x 9.6
Kurt und Ernst Schwitters Stiftung
on loan to Sprengel Museum
Hannover
CR:3079

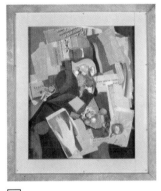

10

PEN
1941
Paper, tinfoil, snail shell, seashell, wool,
porcelain, glass, stone and wood on
plywood
60.5 x 50.7
Kurt und Ernst Schwitters Stiftung
on loan to Sprengel Museum
Hannover
CR:2761

with a flying stone (*Anything with a stone*; p.105) combined large areas of delicately gradated pointillist brushstrokes with geometric shapes and natural material, such as the stone of the title, demonstrating the juxtaposition of real objects and geometric forms with soft painterly areas, which Karin Orchard has identified as a new tendency in Schwitters's Norwegian period, 'as if abstract occurrences were taking place in a real space'.[62] The delicately tinted plaster relief *Beautiful still-life* (*Beautiful Stillife*; fig.12) shared the formal concerns of the sculpture Schwitters showed in the exhibition.

Although sculpture had always been a part of Schwitters's practice it took on increasing significance in Britain. He wrote to Moholy-Nagy in August 1944: 'I believe that at the moment my best things are my small sculptures.'[63] *Dance* (*Dancer*; p.23) demonstrates Schwitters's new method of combining plaster with natural objects to make small abstract sculptures, its twisting organic form, built up from a branch or animal bone using plaster (see Luke, pp.48–9). He also gave a recital of four of his poems at the opening of the exhibition, including an extract from the *Ursonate* (see White, pp.72–5).[64]

Although the exhibition does not seem to have been a commercial success,[65] it was reviewed positively by Cora Gordon in the *Studio* in March 1945:

> In this exhibition Schwitters gives evidence of two sides to his nature. The calmer side shows in the examples of pure *collage*, which are massively designed but quiet in colour, thus aiding the mass and homogeneity of the design. The examples of oil painting plus *collage* are carried to the limit of daring and invention. The sculpture, abstract shapes in wood and wire, seem to express, perhaps, the strongest side of his intellect. These challenging, defiant shapes have an odd pride of balance and fine proportion.[66]

The working method that Read had described so perceptively in the Modern Art Gallery exhibition catalogue was crucial to Schwitters's interaction with Britain. His working practice was especially responsive to a change of environment, since his materials were always rooted in the place where the work was made, and his output of this period was no exception: it was shaped by his engagement with the material culture of wartime London. The collage *For Herbert Read* (p.24) both enacts his intellectual contact with London avant-garde circles and his physical engagement with the city itself, which can be traced through the bus tickets that reveal his journeys from Barnes at the periphery of the capital to the art world at its centre. British packaging featured prominently in collages such as *Untitled (Quality Street)* (p.25), where the shimmering transparency of the overlaid rectangular sweet wrappers create a formal juxtaposition of texture and colour, but also assemble the materials of everyday life in wartime London to encapsulate a moment in the social history of Britain by assembling the offcasts of its commodities (see Orchard, pp.60–4). His engagement with British culture also surfaced in poems such as the 'London Symphony', where he collaged fragments of text from notices and advertising to create a narrative of the city (p.21).[67]

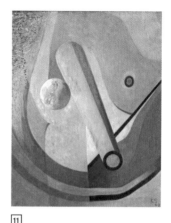

11

Bild abstrakt Skøyen I
Abstract Picture Skøyen I
1940
Oil on wood
65 x 53
Private collection, Switzerland
CR:2629

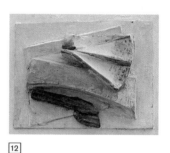

12

Beautiful Stillife
1944
Oil, wood and plaster on wood
18.1 x 23.2
Private collection
CR:3061

SCHWITTERS IN THE LAKES 1945–8

The war ended in Europe in May 1945, and the following month Schwitters moved to the Lake District with his companion Edith Thomas. He hoped to make a living here from painting portraits and landscapes in surroundings that reminded him of Norway. His first impression of the opportunities the Lakes might offer him as an artist was very positive. He wrote to his son Ernst in July 1945 soon after arriving:

> It is now the fourth week that we are in Ambleside. I did first small pictures for tourists and sold 2 of the bridgehouse. Then I had one portrait drawing. And now I have a commission from the Low Wood Hotel, it is the view from this Hotel over Lake Windermere.... In these 3 weeks I earned about what I need for 5 weeks. You see it is quite allright, I hope that I can live anyhow in the summer.[68] (p.29)

Schwitters relied on new friends in the local community to secure work, and at the beginning of August he wrote again to say that he had got two new commissions through George Arnold Varty, the owner of the local bookshop.[69] Nonetheless, he continued to work on his sculpture and to think about opportunities for exhibiting his abstract art in London and America, considering the relative merits of showing at Bilbo's Modern Art Gallery again or at Penrose's and Mesens's reopened London Gallery, or of using his prewar contacts with Alfred H. Barr, Jr, the former director of the Museum of Modern Art (MoMA) in New York, to exhibit in the United States.[70] At this moment, Schwitters was thus simultaneously engaged in the local opportunities offered by Ambleside and re-engaging with avant-garde networks beyond. And with communications improving after the war, he was also increasingly looking abroad for opportunities. But in order to follow up any international interest, he needed to travel, and so he began to apply for British naturalisation and a British passport.[71]

His plans to exhibit in the United States became more concrete as he discussed a one-man show of his collages and sculpture, involvement in a group collage show, and plans to rescue the Hannover *Merzbau* with Edgar Kaufmann at MoMA (see Schulz, pp.130–5).[72] At the same time, he was able to take an ironic pride in his success in the Ambleside flower show. He wrote to Ernst:

> Today opened here a flowershow. I sent 6 pictures of flowers, 2 of them were from last year. Mrs Vartis roses got the first prize and Mr Bickerstaff's Chrisanthemum the second. So I got two prizes. The only thing is that the prizes are low 1½ gns. But the honour! People here know now that I am able to paint flowers.[73](fig.13)

He also announced his election to the membership of the Lake Artists' Society, following his showing of portraits of Dr George Ainslie Johnston (fig.14) and Harry Bickerstaff in their exhibition.[74] Schwitters had an ambivalent attitude to his figurative painting, sometimes disavowing it as simply a way of making a living. At other times, he insisted on its importance to his practice, seeing the study of nature as a way of replenishing his imagination for his abstract work.[75] Orchard has argued that Schwitters's

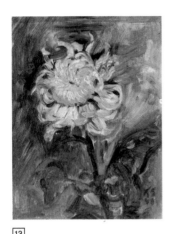

13
Chrysanthemum
1946
Oil on cardboard
34.3 x 25.8
Michael Werner Gallery, New York, London and Märkisch Wilmersdorf
CR:3293

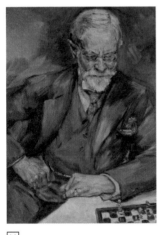

14
Untitled (Portrait of George Ainslie Johnston)
1946
Oil on cardboard
66.5 x 50
Armitt Library & Museum, Ambleside
CR:3297

definition of 'naturalistic' referred to 'a work produced in accordance with the laws and rules of natural creation' rather than recording nature's outer appearance, and in Norway and the Lake District his output increasingly 'explored natural laws in order to translate them into artistic forms'.[76]

In the Lake District, as well as producing figurative landscapes such as *Untitled (Smithy Brow, Ambleside)* (p.28) according to these principles, he created abstract assemblages incorporating natural objects. In works such as *Untitled (Flight)* and *Untitled (Wood on Wood)* (pps.26 and 27), as Elderfield has observed, the work 'is at one and the same time an illusionistic picture, which evokes the climate and atmosphere of nature, and a factual picture which refers to the natural world through representative tokens'.[77] Collages such as *47. 15 pine trees c 26* (p.30) and *c 77 wind swept* (p.71) also referred to the natural world in their titles and echoed its forms in their construction, the vertical construction of *pine trees* incorporating corrugated paper resembling tree trunks, and the collaged papers of *wind swept* arranged in a sweeping sideways trajectory as if blown by the wind (see Orchard, pp.60–1).

Alongside these works that drew on the natural world, Schwitters was also producing collages that played with the concept of hybrid émigré identity in their incorporation and displacement of international and local source material. As Wadley has observed, his frequent use of postmarks and envelopes in his Lake District collages indicate his dependence on correspondence, and *Untitled (Y. M. C. A. OFFICIAL FLAG THANK YOU)* (p.31) incorporates stamps and an envelope from MoMA alongside an English article about Germany and Norway, a YMCA flag and a fragment from an American cartoon.[78]

Schwitters had discussed collaborating with Mesens on a book about his Merz drawings and on a recording of his *Ursonate* before he left London, but these plans were delayed when he broke his leg in October 1946 and was confined to bed.[79] But, despite these burgeoning plans to perform and publish again in London, Schwitters was becoming increasingly critical of the British art world. Writing to Gabo in November 1945, he spoke of his response to a French publisher who had asked which important artists of the avant-garde lived in England:'I wrote him, I new [sic] only one important one, that is Gabo, but some interesting ones also, Ben Nicholson and his wife.'[80] But writing to his Hannover friend Friedrich Vordemberge-Gildewart in January 1946, although his admiration for Read remained undimmed, he was critical of the undeveloped and imitative nature of British art, criticising both Nicholson and Hepworth:

> Henry Moore is the great Englishman. I quake at his art-dealer greatness. Ben Nicholson is no better than Buchheister. K. Hepworth cannot compete with Arp. Why does she imitate such a very great artist.[81]

However, he continued to admire Julian Trevelyan's work, describing him as a 'very talented painter' to Otto Gleichmann in 1947.[82]

In March of that year, Schwitters returned to London to stage two Merz evenings at the London Gallery. Two producers from the BBC were invited in the

hope that they would record the *Ursonate*, but left halfway through the performance. Only twenty-eight people attended the two performances in all. Mesens described the evening: 'If I say there was a total lack of interest I am not exaggerating! ... Schwitters recited with all his magic and afterwards he was charming, never allowing himself to be discouraged.'[83] On returning to the Lake District, finally realising that his plans to salvage the remains of the Hanover *Merzbau* were unrealistic, Schwitters threw his energies into creating a new Merz building in the Lake District, which he worked on from June 1947 until his death on 8 January 1948 (see pp.128–9). Although he received notification of his successful application for British citizenship on 7 January 1948, this was never formally granted, and he died still a German artist in the midst of a small English community far from the international networks in which his art had developed.[84]

Accounts of the end of Schwitters's life have tended to focus on his death in obscurity and the lack of attention paid to his death by the British art world.[85] But if Britain was slow to recognise his importance, then this balance has subsequently been redressed by the ongoing interest in his life and work by British artists from the pop generation of Richard Hamilton and Eduardo Paolozzi to the present day (see Stout, pp.136–41).[86] Gabo's eloquent tribute to how Schwitters changed the way we see the world is perhaps even truer now than it was when he wrote it in 1948:

> In the midst of some animated conversation he would stop suddenly, sunk in deep contemplation. You would have thought that he was watching some miracle in nature. One could never guess what on earth had fascinated him in that insignificant piece of ground. Then he would pick up something which would turn out to be an old scrap of paper of a particular texture, or a stamp or a thrown away ticket. He would carefully and lovingly clean it up and then triumphantly show it to you. Only then would one realize what an exquisite piece of color was contained in this ragged scrap. It needs a poet like Schwitters to show us that unobserved elements of beauty are strewn and spread all around us and we can find them everywhere in the portentous as well as in the insignificant, if only we care to look, to choose and to fit them into a comely order.[87]

Titles of works used in the text are the titles that the works were exhibited under followed in brackets by the catalogue raisonné title, if different. See Karin Orchard and Isabel Schulz (eds.), *Kurt Schwitters: Catalogue Raisonné*, 3 vols, Ostfildern-Ruit, 2000–2006, hereafter CR. Items in Kurt und Ernst Stiftung on loan to Kurt Schwitters Archive, Sprengel Museum Hannover, will be referred to as KESS.

1
'Die Merzmalerei', *Der Sturm*, July 1919, quoted in John Elderfield, *Kurt Schwitters*, London and New York 1985, p.50 (translated from original German text).

2
E.L.T. Mesens, 'A Tribute to Kurt Schwitters', *Art, News and Review*, vol.10, no.19, 1958, pp.5–7; M.E. Burkett, *Kurt Schwitters: Creator of Merz*, Abbot Hall Art Gallery, Kendal 1979; Gwendolen Webster, *Kurt Merz Schwitters: A Biographical Study*, Cardiff 1997, pp.376–401.

3
Elderfield 1985, pp.197–223.

4
Sarah Wilson, 'Kurt Schwitters in England', in *No Socks: Kurt Schwitters and the Merzbarn*, exh. cat., Hatton Gallery, Newcastle 1999, unpag.

5
Anna Müller-Härlin, '"Remember Hannover, Berlin, Paris": Kurt Schwitters' alte und neue Freunde in London', in Karin Orchard and Isabel Schulz (eds.), *Merzgebeite: Kurt Schwitters und seine Freunde*, exh. cat., Sprengel Museum Hannover 2006, pp.183–94.

6
Nicholas Wadley, 'The Late Work of Kurt Schwitters' in *Kurt Schwitters in Exile: The Late Work 1937–1948*, exh. cat., Marlborough Fine Art, London 1981, p.63.

7
Herbert Read, 'Modern German Painting', *Listener*, vol.4, 29 October 1930, p.708.

8
See Iria Candela, 'The only English periodical of the avant-garde: Sidney Hunt and the journal "Ray"', *Burlington Magazine*, vol.152, no.1285, April 2010, p.239.

9
'Modern Photography', *Studio*, special autumn number, 1931, p.106.

10
See Tristan Tzara, 'Le Papier Collé ou le Proverbe en Peinture', *Cahiers d'art*, vol.6, 1931, pp.61–4 and Georges Hugnet, 'L'Esprit Dada dans la Peinture III – Cologne et Hanovre', *Cahiers d'art*, vol.7, 1932, pp. 358–64.

11
Schwitters published an artist's statement in *Cercle et Carré* in 1930 and exhibited five works in the group's only exhibition at Galerie 23 in Paris in 1930. His work was included in *Abstraction-Création*, no.1, 1932, p.33 and no.2, 1933, p.41. *Abstraction-Création* no.3, 1934, p.40 featured photographs of the Hanover *Merzbau*.

12
Herbert Read, *Art Now*, London 1933, plate 75, listed as collection Museum für Kunst und Landesgeschichte, Hannover. The work is now dated 1923–6, CR:1102.

13
Kenneth Clark, 'The Future of Painting', *Listener*, 2 October 1935, vol.14, pp.543–4.

14
Cordula Frowein, 'German Artists in Wartime Britain', *Third Text*, vol.5, no.15, 1991, pp.47–8. The Mayor Gallery showed Max Ernst in 1933 and Paul Klee in 1934; the London Gallery showed Herbert Bayer and Oskar Schlemmer in 1937.

15
Bernard Causton, 'Art in Germany under the Nazis', *Studio*, vol.112, no.524, November 1936, pp.235–46.

16
Stephanie Barron, *"Degenerate Art": The Fate of the Avant-Garde in Nazi Germany*, exh. cat.,Los Angeles County Museum of Art and the Art Institute of Chicago, 1991.

17
The Schwitters works exhibited were: *Aq. 42. Traum ?1920* (CR:763. Originally Nationalgalerie, Berlin; present location unknown); *L Merzbild L3 (Das Merzbild)* 1919 (CR:436. Originally Stadtmuseum Dresden; present location unknown); *Ringbild 1920-1* (CR:611. Originally Stadtmuseum Dresden; present location unknown) and *Mz 104 uneben 1920* (CR:669. Originally Nationalgalerie, Berlin; present location unknown), Barron 1991, p.349.

18
See Frowein 1991, p.50 and Keith Holz, *Modern German Art for Paris, Prague and London*, Ann Arbor 2004, pp.195–222, 234–6 for a detailed analysis of the political stance of the exhibition.

19
The two works exhibited by Schwitters were *The Golden Ear (Bild mit goldenem Ohr)* 1935 (CR:1825. Location unknown) and *Collage* (not identified). *Exhibition of Twentieth Century German Art*, exh. cat., New Burlington Galleries, July 1938, pp.43–4.

20
One review stated: 'Because Hitler has condemned works as degenerate, one is tempted to acclaim them with enthusiasm. But it is the critic's first duty ... to resist such temptations ... for the general impression made by the show upon the ordinary public must be one of extraordinary ugliness.' Raymond Mortimer, *New Statesman and Nation*, 16 July 1938, quoted in Frowein 1991, p.51.

21
Earl of Listowell, 'Modern German Art', *Listener*, vol.20, 14 July 1938, pp.76–7; 'Modern German Art', *Studio*, vol.116, July–December 1938, pp.160–4.

22
Peter Thoene (pseudonym for the Berlin-based Serbian art historian Oto Bihalji Merin), *Modern German Art*, Harmondsworth 1938.

23
The other works exhibited were *One One* (*eins eins*; CR:733), *Really very beautiful* (*wirklich sehr schön*; CR:1618), *Two red spots* (*2 Rote Flecken*; CR:1992) and *Napoléon* (CR:1621). See Angelica Zander Rudenstine, *Peggy Guggenheim Collection, Venice*, New York 1985, p.754.

24
The works exhibited were *blau in blau* and *wirklich sehr schön*. See *London Bulletin*, no.14, 1 May 1939, p.21.

25
See Jutta Vinzent, *Identity and Image: Refugee Artists from Nazi Germany in Britain 1933–1945*, Kromsdorf/Weimar 2006, pp.37–8.

26
Schwitters dedicated a collage, *for my friend Peri*, to the artist in 1941 (CR:2818).

27
Themerson describes their meeting for the first time at a Pen conference in 1943 (Stefan Themerson, *Kurt Schwitters in England*, London, p.10). However, the conference to which he refers was held in 1944. A collage dated 1943 is dedicated to Stefan and Franciszka Themerson (CR:3039), so perhaps Themerson met Schwitters on an earlier occasion and confused the dates.

28
Müller-Härlin 2006, p.185.

29
Naum Gabo to Kurt Schwitters, 30 March 1942, KESS que 06839817.

30
László Moholy-Nagy to Kurt Schwitters, 11 March 1942, KESS que 06839814.

31
Jutta Vinzent, 'Muteness as an Utterance of a Forced Reality': Jack Bilbo's Modern Art Gallery', in Shulamith Behr and Marian Malet (eds.), *Arts in Exile in Britain 1933–1945: Politics and Cultural Identity*, Research Centre for German and Austrian Exile Studies, London, vol.6, 2004, pp.305–6.

32
Schwitters exhibited *Memory of a Lady we Never Knew* (CR:2637. Location unknown).

33
See Chris Stephens, '"The morrow we left behind": Landscape and the Rethinking of Modernism 1939-1953', *Art History*, vol.35, no.2, April 2012, pp.217–33. Herbert Read described the exhibition as 'a brave attempt to rally the modern movement' in his review of the show in *Horizon*, vol.5, no.28, April 1942, p.267.

34
Ramsden was author of the 1940 survey *Introduction to Modern Art*.

35
Margot Eates to Kurt Schwitters, 29 April 1942, KESS que 06839821.The other works exhibited were titled *Sköyen* and *Isle of Man*. The works were probably *Bild abstrakt Skøyen I* (CR:2629) and *Untitled (Curving Forms or Isle of Man)* (CR: 2775)

36
Alfred Yockney to Kurt Schwitters, 7 July 1942, KESS que 06839835.

37
'Hamann told me that you are known to Nicholson, I would be very pleased to meet him too.' Kurt Schwitters to Naum Gabo, 17 March 1942, quoted in Müller-Härlin 2006, p.186.

38
Barbara Hepworth to Ben Nicholson, 4 May 1942, Tate Gallery Archive (hereafter TGA) 8717.1.1.266.

39
Nicholson wrote to Schwitters in February 1943: 'Schwitters have sent you off the collage I made for you – I hope you get it o.k. and like it o.k.' Ben Nicholson to Kurt Schwitters, 22 February 1943, KESS que 06837010.

40
Ben Nicholson to E.H. Ramsden, 15 May [1943], TGA 9310.

41
Barbara Pezzini, 'Aid to Russia and its Art', in *Aid to Russia*, exh. cat., Willow Road, London 2002, unpaginated.

42
The other works exhibited were *Blue and Gold* (*Aerated VII Blue and Gold*; CR:2889), *Brown and Green* (*Untitled [Brown and Green]*; CR:2765), and *Bas Relief* (not identified). Jan Gordon, 'Art and Artists' *Observer*, 7 June 1942, p.2. The review was transcribed in Schwitters's London address book, Address book 'LONDON', 1941–5, KESS que 06825082, T.

43
Schwitters dedicated a drawing *sssssssseinem Freunde Roland Peppenrose (Hisssssss Friend Roland Peppenrose)* to Penrose in 1940 (CR:2716). Peter Watson to Kurt Schwitters, 22 May [1942], KESS que 06838475.

44
Mesens 1958, p.7.

45
Neue Europaeische Graphik III, 1921, BM 1942, 1010.31.11.

46
Ben Nicholson to E.H. Ramsden, 26 December 1942, Margot Eates and E.H. Ramsden papers TGA 9310. Nicholson offered extensive suggestions about the scope and arrangement of the section in subsequent letters to Ramsden.

47
Address book 'LONDON', 1941–5, KESS que 06825082, T.

48
Schwitters was one of a group of artists who wrote to Clark from Hutchinson Camp asking for his help in securing their release from internment. Kenneth Clark Correspondence File for Interned Refugees, TGA 8812.1.4.182.

49
Kurt Schwitters, 'On the Bench', in Themerson 1958, p.43.

50
See Brian Foss, *Warpaint: Art, War, State and Identity in Britain 1939–1945*, New Haven and London 2007, pp.10–12.

51
Vinzent 2004, p.303, n.11.

52
Foss 2007, p.178.

53
See Foss 2007, pp.179–84 on Clark. John Rothenstein, Director of the Tate Gallery, was also an influential supporter of Clark's position; see Rothenstein, 'European Painting 1893–1943, *Studio*, vol.125, January–June 1943, p.110.

54
Webster 1997, p.142.

55
See Foss 2007, pp.14–16 for CIAD. Thomas Fennemore to Alistair Morton (Sundour Fabrics) and H.P. Juda (*International Textiles* magazine), 16 June 1943, KESS que 06840142.

56
Daily Sketch, 20 January 1944, p.2. 'Modern Art aka Surrealists' from Help Yourself, *Pathé News*, January 1944.

57
Herbert Read, 'Kurt Schwitters', *Paintings and Sculptures by Kurt Schwitters (The Founder of Dadaism and "Merz")*, exh. cat., Modern Art Gallery, London 1944, unpaginated.

58
Read 1944.

59
Kurt Schwitters to Herbert Read, 1 November 1944, KESS que 06839125, T001.

60
Kurt Schwitters to Edgar Kaufmann, 15 July 1946, KESS que 06839136.

61
Karin Orchard, '"It's namely someone else painting, it's not me." Kurt Schwitters's Paintings in Noway'. in *Schwitters in Norway*, exh. cat., Henie Onstad Art Centre, Ostfildern, 2009, p.101.

62
Ibid., p.102.

63
Kurt Schwitters to László Moholy-Nagy, 21 August 1944, KESS que 06839120.

64
The poems were 'Eve (Eve Blossom has Wheels)'; 'Fishbone (Small Poem for Big Stutterers)', 'FMMSBTZU (Part of a sound poem called "Sonata)' and 'The Flying Fish (A Phantastic Story)'. Typescript in KESS folder: Material Ernst Schwitters.

65
Bilbo's daughter, Merry Kerr Woodeson, states that Schwitters sold nothing from the show, 'Jack Bilbo and Seine "Modern Art Gallery"' London 1941–1946', in *Kunst im Exil in Gros brittanien 1933–1945*, Neue Gesellschaft für Bildende Kunst, Berlin 1986, p.51. But when planning to reconstruct the exhibition for America in 1946 Schwitters discussed how to replace the five or six works that had been sold from the show, although it is not clear if these sales were in 1944 or subsequently. Kurt Schwitters to Edgar Kaufmann, 15 July 1946, KESS que 06839136.

66
Cora Gordon, 'London Commentary', *Studio*, vol.129, January – June 1945, p.90. Bilbo was an assiduous compiler of press cuttings for the Modern Art Gallery exhibitions, but the *Studio* review is the only one pasted in his cuttings book (private collection), suggesting that no others were published.

67
Kurt Schwitters, 'London Symphony', 1942, in Themerson 1958, p.51.

68
Kurt Schwitters to Ernst Schwitters 19 July 1945, KESS que 06838720.

69
Kurt Schwitters to Ernst Schwitters, 5 August 1945, KESS que 06838721.

70
Kurt Schwitters to Ernst Schwitters, 7 October 1945, KESS que 06838726.

71
He wrote to Ernst about Read's and Penrose's support of his application in January 1946. Kurt Schwitters to Ernst Schwitters, 30 January 1946, KESS que 06838744.

72
See Karin Orchard, 'The Eloquence of Waste: Kurt Schwitters' Work and its Reception in America' in Susanne Meyer-Büser and Karin Orchard (eds.), *In the Beginning was Merz: From Kurt Schwitters to the Present Day*, exh. cat., Sprengel Museum Hannover 2000, pp.280–9.

73
Kurt Schwitters to Ernst Schwitters, 15 August 1946, KESS que 06838788.

74
Kurt Schwitters to Ernst Schwitters, 8 October 1946, KESS que 06838794.

75
Elderfield 1985, pp.19–20.

76
Orchard 2009, pp.103–4.

77
Elderfield 1985, p.202.

78
Wadley 1981, p.70.

79
E.L.T. Mesens to Kurt Schwitters, 6 November 1945, KESS que 06839899.

80
Kurt Schwitters to Naum Gabo, 11 November 1945, KESS que 06833126.

81
'Henry Moore ist der grosse Engländer, mir graut vor seiner Kunsthändler Grösse. Ben Nicholson ist nicht besser als Buchheister. K. Hepworth kann an Arp nicht heranreichen. Warum imitiert sie einen so ganzgrossen Künstler.' Kurt Schwitters to Friedrich Vordemberge-Gildewart, 5 January 1946, in Volker Rattemeyer and Dietrich Helms (eds.), *Vordemberge-Gildewart: Briefwechsel. vols.1 and 2*, Nuremburg 1997, p.236.

82
Kurt Schwitters to Otto Gleichmann, 2 February 1947, Quoted in Müller-Härlin 2006, p.189.

83
Mesens 1958, p.7. A satirical review of the evening described Schwitters as a 'surrealist Shakespeare' and parodied his poems, *News Chronicle*, 6 March 1947, quoted in Webster 1997, p.379

84
See Elderfield 1985, p.224.

85
Mesens 1958; Webster 1997, pp.376–401.

86
See Isabelle Ewig, 'Father of the Fathers of Pop: Kurt Schwitters', in Meyer-Büser and Orchard 2000, pp.290–5.

87
Naum Gabo, untitled text in *Kurt Schwitters*, exh. cat., Pinacoteca, New York 1948.

FIRST FLOOR
KURT SCHWITTERS

(a) COLLAGES

		(Prices in Guineas)
1a	Collage with red line	8
2a	Pink collage	—
3a	Collage with playing card	15
4a	Collage red orange	10
5a	Grey collage	8
6a	Collage yellow, blue red	10
7a	Out of the dark	12
8a	Collage grey, red	6
9a	Collage silver, red, green, yellow	5
10a	Black collage	5
11a	Light blue	5

(b) OIL PAINTINGS

1b	Still life with penny	25
2b	Red wire and half spoon	10
3b	Sur-face	10
4b	Blue paragraph	10
5b	Sköyen	40
6b	Beautiful still-life	15
7b	Abstract No. 2	50
8b	Light yellow hammer	25
9b	Dying swan	40
10b	Anything with a flying stone	50
11b	Three dark red tears	40
12b	Two black angels	10
13b	Esther	—
14b	Drama	75
15b	Coloured wood-construction	—
16b	Pen	60
17b	Clear bottom	60
18b	Golden and blue still-life	15

(c) SCULPTURE

1c	Every side.	60
2c	Petite Tour Eiffel	100
3c	High, long and oval	30
4c	Beauty	15
5c	Cicero	15
6c	Air and wire-sculpture	15
7c	Flower, leaf and leg	15
8c	Lying resignation	80
9c	Dome	90
10c	Dance	50

List of exhibited works from the catalogue for Schwitters's solo show at Modern Art Gallery, London, 1944

Kurt Schwitters, 'London Symphony' (1942), from Stefan Themerson, *Kurt Schwitters in England 1940–1948*, London, 1958

Pages 30 and 31 of Schwitters's London address book Undated [1941–5]

London Symphony (1942)

Halt, we are specialists.
To be let
To be sold
High class clothiers
Apply first floor
Artistic plumber
Enough said, we save you money.
Monarch hairdressing
Crime and Companion
A B C
Preston Preston Preston Preston
Bank
Bovril the power of beef
Bovril is good for you
John Pearce
Riverside 1698
What you want is Watney's
Dig for victory
Prize beers
Sell us your waste paper
Rags and Metals
Any rags any bones any bottles to-day
The same old question in the same old way
Milk bar
L M S
A B C
Tools of all kinds
All kinds of tools
Watney's Ales
Always something to eat
Monday to Friday
In a raid
Apply

51

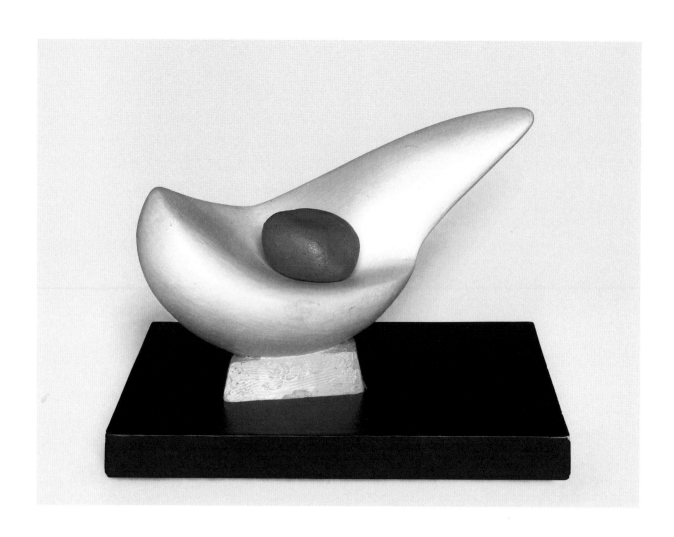

Untitled (Mother and Egg)
1945–7
Plaster, painted
CR:3251

Dancer
1943
?Bone and plaster, painted
CR:3050

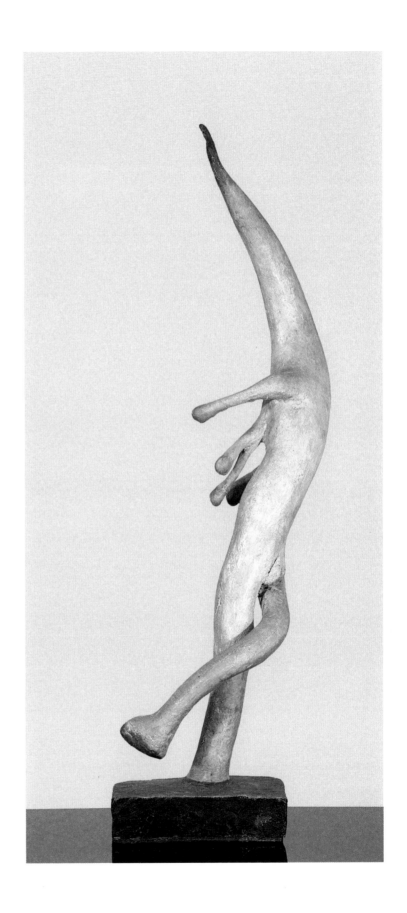

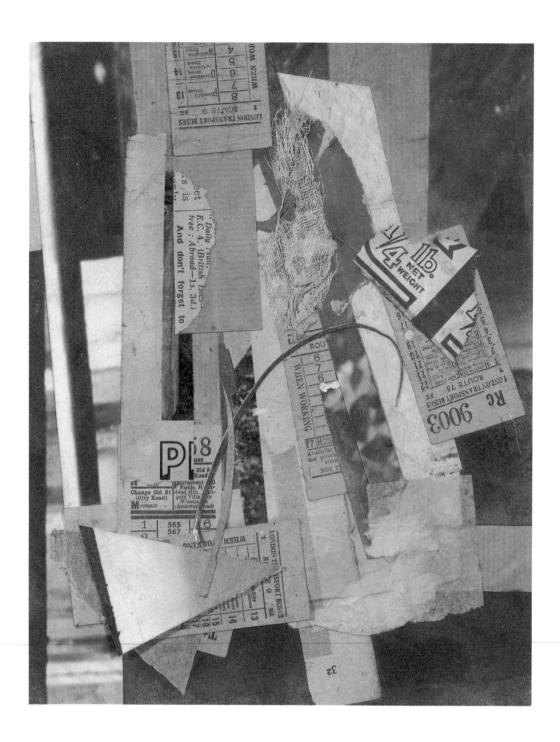

For Herbert Read
1944
Fabric, paper and cardboard
on cardboard
CR:3081

Untitled (Quality Street)
1943
Paper on paper
CR:3036

24

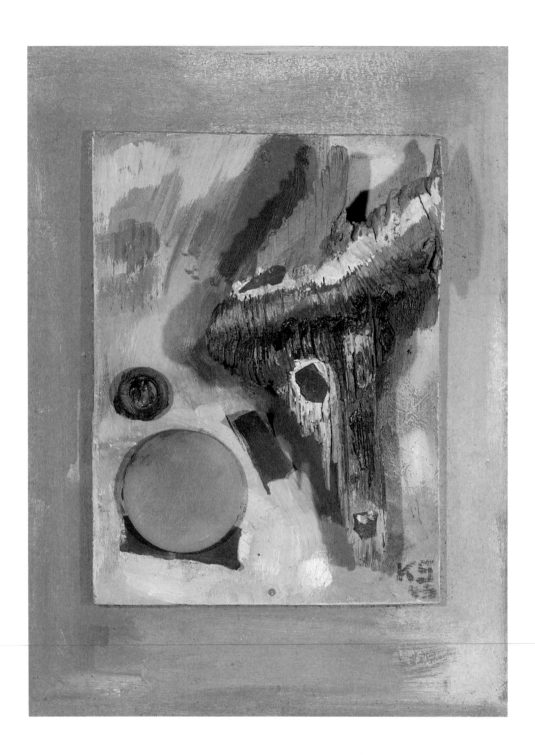

Untitled (Flight)
1945
Oil, wood, plastic and rubber on
wood on cardboard
CR:3137

Untitled (Wood on Wood)
c.1946
Oil and wood on wood
CR:3273

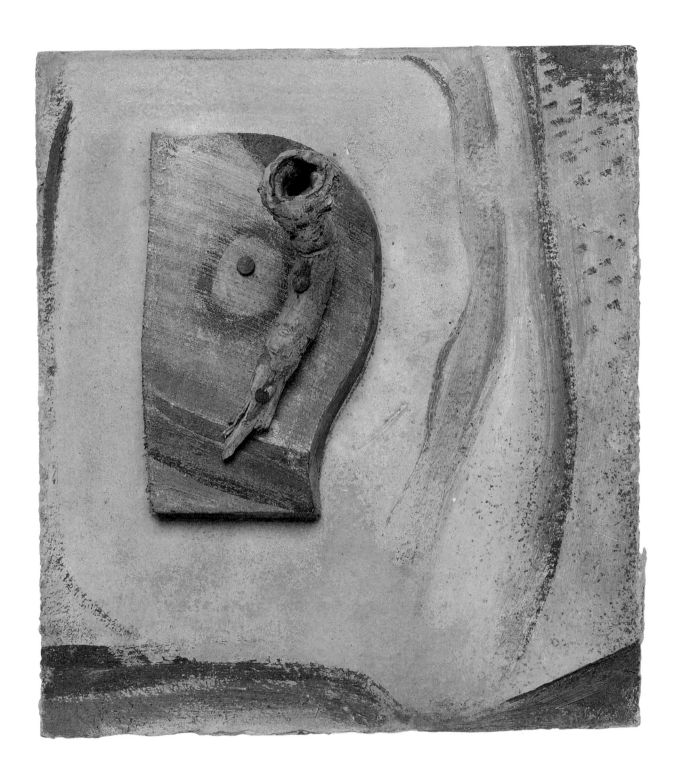

Untitled (Smithy Brow Ambleside)
1946
Oil on wood
CR:3280

Untitled
(Bridge House, Ambleside, Front View)
1945
Oil on cardboard
CR:3163

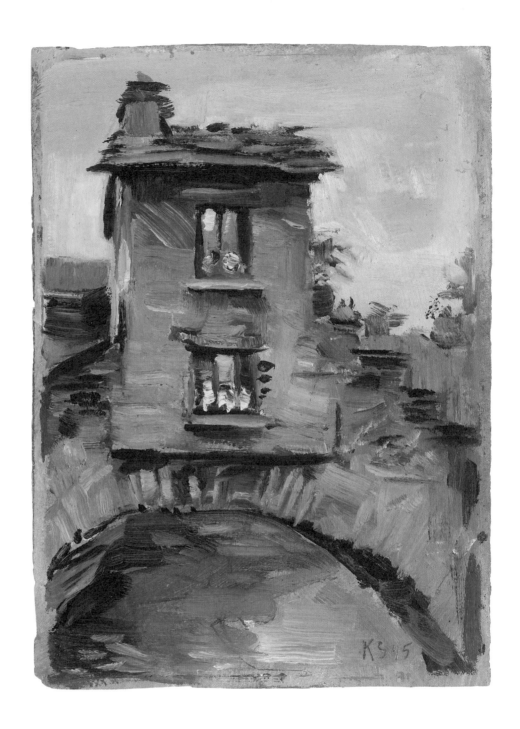

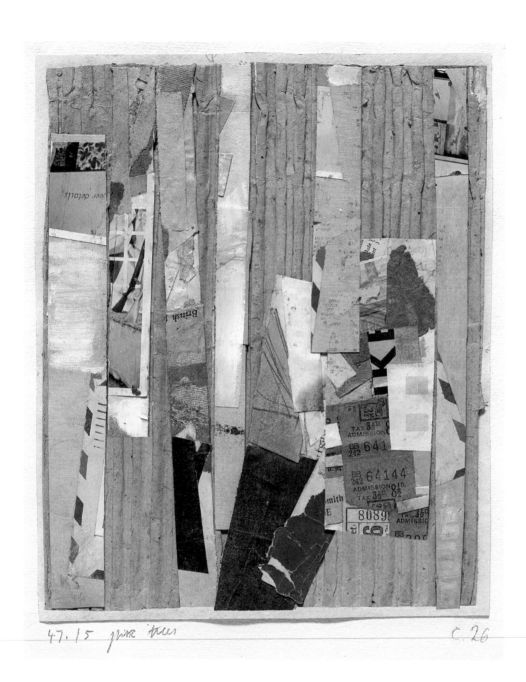

47. 15 pine trees c 26
1946, 1947
Oil, photograph, paper and
corrugated cardboard on cardboard
CR:3315

Untitled
(Y. M. C. A. OFFICIAL FLAG THANK YOU)
1947
Oil, paper and cardboard on wood
CR:3396

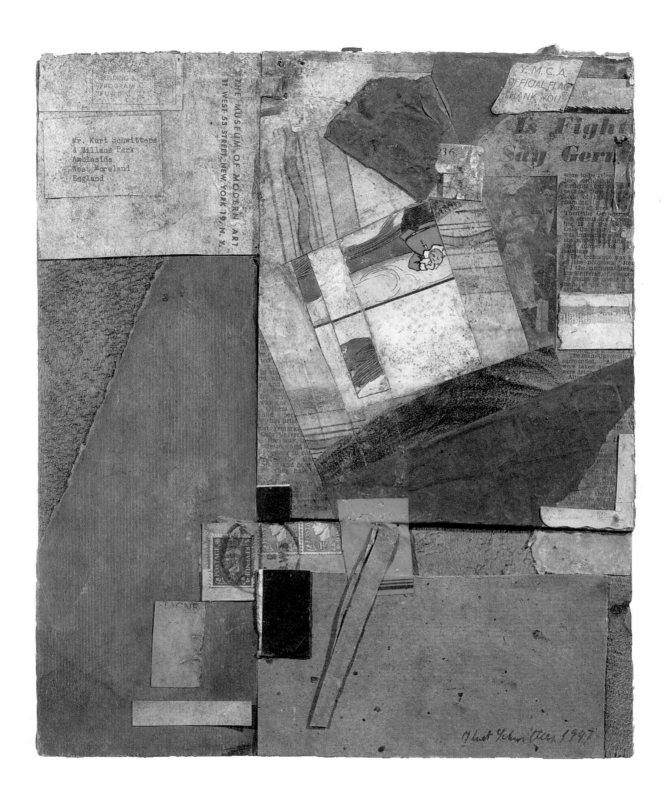

JENNIFER POWELL

SCHWITTERS

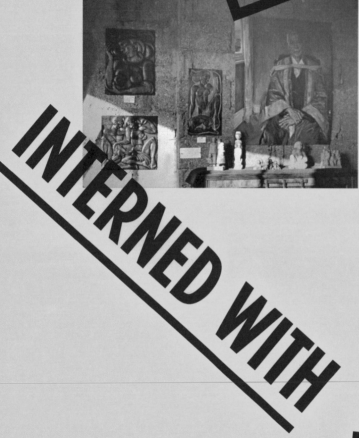

INTERNED WITH

FRIENDS

15
Photograph taken in Hutchinson
Camp, Isle of Man, November 1940,
showing Schwitters's portrait of an
unknown internee in a robe
Peter Daniel Collection

The room stank. A musty, sour, indescribable stink which came from three Dada sculptures which he had created from porridge, no plaster of Paris being available. The porridge had developed mildew and the statues were covered with greenish hair and bluish excrements of an unknown type of bacteria.[1]

This was Fred Uhlman's rather unflattering description of Kurt Schwitters's porridge sculptures on 2 October 1940. The works were studded with pebbles, wood and other pieces of debris,[2] and were resting on the plinth-like legs of a broken piano in Schwitters's makeshift attic studio in Hutchinson internment camp on the Isle of Man.[3] Uhlman had visited Schwitters that day to have his portrait painted. The result was a delicately observed oil painting of the émigré artist seated and slightly slumping in the corner of a room with two open books in his lap (p.37). For Uhlman 'it was not a masterpiece, but a good likeness and certainly the best of the dozen or more of his paintings on lino', and he duly paid Schwitters the five pounds asking price for the work.[4]

Uhlman and Schwitters were among over three hundred artists who came to Britain between 1933 and 1945 to escape Nazi oppression.[5] By the end of June 1940, the British government had called for all 'enemy aliens' to be interned: they numbered nearly 27,000.[6] Schwitters had been living in Lysaker, Norway, with his son and daughter-in-law. After the German invasion in April 1940, he fled with them to other parts of Norway and its neighbouring islands until finally boarding an icebreaker bound for Edinburgh. He arrived on 18 June and was immediately rushed through a succession of transit camps before being taken to Hutchinson, or 'P', camp in July, where he joined around 1,200 German and Austrian refugees.[7] He was finally released in November 1941.

The landscape of the Isle of Man remained largely unchanged in 1940 as internment camps began to be formed around existing buildings, and often around the flats of local residents who were ordered to vacate their properties at very short notice – much to their dismay.[8] The separation of the 'enemy aliens' was, however, clearly delineated by the barbed-wire fences that surrounded the camps. This became a key motif in the works of many artists who were caged in behind them. On 7 June 1940, the *Isle of Man Examiner* published calls from the local government that 'there is only one place for the enemy alien while the war lasts. That place is behind barbed wire.'[9] This sentiment was passionately rebutted by sixteen artists who wrote to the *New Statesman and Nation* two months later and declared that, 'Art cannot live behind barbed wire' – Schwitters was among the signatories.[10] Art, of course, did live on and Schwitters produced between 200 and 250 works during his internment.[11] In his drawings and paintings of the new landscape that surrounded him, he chose to look from his attic room beyond the wire, over the rooftops, and out towards the Irish Sea in works such as *Scenery from Douglas* 1941 (CR:2787) and *Untitled (Roofs of Houses in Douglas, Isle of Man)* 1941 (p.36).

Unlike the five other camps in Douglas, Hutchinson was set back from the main seafront promenade on a hillside. Its most prized feature was its large split-level lawn, which became a rendezvous point for the particularly high concentration of artists, writers and intellectuals who were housed there. The art historian and second leader of the camp's 'Cultural Department', Klaus Hinrichsen, described the lawn as being like an 'ancient Greek Gymnasium: not a square in Douglas'.[12] Erich Kahn captured this busy atmosphere of exchanges and learning in his print *Lecture on the Lawn II* 1940, which was presented to Hellmuth Weissenborn as a gift on the occasion of his release. It was signed on the reverse by fellow internees, including Schwitters. The image was also later printed in an issue of one of the camp's newspapers, which were punctuated with drawings and prints by the artists,[13] including an art work and short stories by Schwitters.[14] His impromptu and repeated poetry recitals and storytelling, and his personal eccentricities appeared to have raised the spirits of many figures in the camp,[15] as did the concerts, lectures, art classes and wide variety of other activities that were arranged by its inmates. Artists' supplies were limited, but this only encouraged their further ingenuity. Schwitters dismantled tea chests, tore up linoleum from floors, collected sweet wrappers, stamps and other debris; Weissenborn mixed margarine with graphite from pencils to create an ink for printing and like others in the camp scratched into the compulsory blue tint of his bedroom windows;[16] and Erich Kahn sketched on the back of Flag cigarette packets.

The artists were able to show their works in the two exhibitions that were staged in the camp in September and November 1940.[17] Schwitters may have been involved in both, although there is no surviving list for the first.[18] In the second, his large portraits of the political

commentator and intellectual Rudolf Olden and an unidentified sitter in academic robes took up prominent positions in a carefully considered hang that made full use of the available space (figs.15 and 16). Works were meticulously arranged, labelled and usually grouped by artist. There has been a tendency in writings and recollections about Schwitters's internment period to characterise it as one in which he turned away from the abstract and towards the representational.[19] He certainly produced a larger number of portraits, variously sketching and painting artists and friends including Kahn, Hinrichsen (p.39), Uhlman (p.37),[20] Siegfried Charoux (p.38), Ernst Blensdorf and Paul Hamann. He was mindful of the profits that this genre could bring him and later acknowledged that it also financially sustained him after his release.[21] Indeed, Schwitters's decision to show only portraits in the second of the two art exhibitions was arguably a commercial one. *The Camp* newspaper's coverage of the show promoted the fact that 'this time' the artists were offering their works for sale, and the accompanying catalogue pamphlet encouraged visitors to 'Place your order for your portrait.'[22]

Although they may not have been on show in the exhibitions, Schwitters continued to pursue his interests in organic abstractions and collage during his internment, as works from the period such as *Untitled (Curving Forms or Isle of Man)* 1941 (p.40) and *Pink, green, white* 1940 (p.90) demonstrate.[23] The abundance of artistic activity in the camp was in no small part due to the support of its captain, H.O. Daniel, who was described as 'a real friend of art – and of artists' by a former internee.[24] Such was these artists' affection for Daniel that on their release they presented him with a bound book of works by no fewer than nineteen artists that date from 1940 to 1941. This book is a testament to the diversity of media, subjects and styles that flourished within the camp.[25] Anomalous among them, however, is a single abstract work – a small oval picture by Schwitters, signed twice to suggest different orientations and composed of a subtle colour palette and paint textures (*Untitled [Abstract Oval Picture]* 1940) (p.41). That Schwitters chose this work for the book is surely an indication that the pursuit of abstraction continued to be important to him and was developing in tandem with his observational works. Indeed, having purchased the aforementioned portrait of himself from Schwitters in 1940, Uhlman later lamented in the postscript to his memoirs that, 'Alas, I never bought his collages for 10 shillings each.'[26]

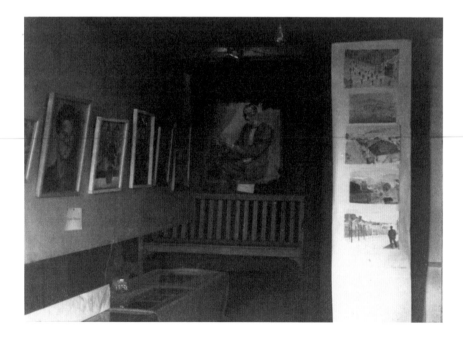

16

Photograph taken in Hutchinson Camp, Isle of Man, November 1940, showing Schwitters's portrait of Rudolph Olden
Peter Daniel Collection

1
Fred Uhlman, cited in C. Brinson, A. Müller-Härlin, J. Winckler (eds.), *His Majesty's Loyal Internee: Fred Uhlman in Captivity*, Edgware, Middlesex, and Portland, Oregon 2009, p.88.

2
Klaus Hinrichsen, 'Interned with Kurt Schwitters', BBC Radio 3 interview, 29 May 1988, Tate Archive, TAV 1499A.

3
Uhlman in Brinson 2009, p.88.

4
Ibid.

5
Jutta Vinzent, 'The Political, Social and Cultural Patterns of Migration', in J. Powell and J. Vinzent, *Visual Journeys: Art in Exile in Britain*, Chichester 2008, p.9. Vinzent provides a list of these artists in *Identity and Image: Refugee Artists from Nazi Germany in Britain 1933–1945*, Kromsdorf/Weimar 2006, pp.253–6.

6
Vinzent 2006, p.42.

7
Connery Chappell, *Island of Barbed Wire: Internment on the Isle of Man in World War Two*, London 1984, p.42. Hutchison was the seventh camp to open on the Isle of Man, in the second week of July 1940; there were eleven camps altogether.

8
Anon., 'Island's Second Detention Camp: Sixty Onchan Houses Requisitioned', *Isle of Man Examiner*, 24 May 1940, p.1. Sefton and Granville camps commandeered local hotels.

9
Anon., 'Internment of Aliens Demanded: Keys Take Action', *Isle of Man Examiner*, 7 June 1940, p.4.

10
'Refugees', *New Statesman and Nation*, 24 August 1940, pp.185–6.

11
See Karin Orchard and Isabel Schulz (eds.), *Kurt Schwitters: Catalogue Raisonné 1937–1948*, vol.3, Ostfildern-Ruit 2006.

12
Hinrichsen, 'Cultural Flashlights', in *The Camp Almanac 1940–1941*, no.13–14, December 1940, unpag.

13
Ibid. A print was also exhibited in the camp's second art exhibition in November 1940.

14
Schwitters's sketch of an unnamed sitter (since identified as Michael Corvin, editor of *The Camp*) and short story 'The story of the flat and round painter' appeared in ibid.

15
See, for example, Uhlman in 'The Story of "Captivity"', unpublished transcript, a translation of his diary written during internment with additional introduction and postscript, February 1979, p.6, IWM (for further details of Uhlman's three separate accounts of his internment, see Brinson and Müller-Härlin 2009, pp.123–4). Also, J. Blensdorf (wife of Ernst Müller-Blensdorf, a fellow internee) writing to Hinrichsen on 18 April 1994, TGA 20052/1.

16
Hellmuth Weissenborn, interview, IWM 003771/04. See also Hinrichsen's various descriptions of the windows in *The Camp*, including 'Nail, Knife and Razor Blade: The Windows of the Camp', *The Camp*, no.7, 3 November 1940, unpag.

17
See 'Art Exhibition' in *The Camp*, no.2, 29 September 1940, for the first exhibition. See 'Preview: The Second Exhibition' in *The Camp*, no.8, 13 November 1940, and 'Catalogue 2nd Art Exhibition', 19 November 1940, IWM, for a list of contributors and works in the second exhibition. A number of photographs of the latter and the cover sleeve for the catalogue illustrated by Erich Kahn survive in the Peter Daniel Collection.

18
Uhlman talks about this show in his diary entry of 14 September, but does not refer to Schwitters's involvement: Uhlman 1979, IWM. The 'Art Exhibition' and 'Preview: The Second Exhibition', ibid., discuss contributors to the first exhibition, but do not name Schwitters.

19
Hinrichsen, 'Interned with Kurt Schwitters', interview, 1988, and 'Visual Art Behind the Wire' in *Immigrants and Minorities*, vol.2, November 1993, pp.201–2.

20
Painted free of charge in exchange for use of Hinrichsen's office space in the Cultural Department as a studio.

21
See Schwitters's letter to Raoul Hausmann, 18 June 1946, cited in *Kurt Schwitters in Exile: The Late Work 1937–1948*, exh. cat., Marlborough Fine Art, London 1981, p.35.

22
'Catalogue 2nd Art Exhibition', 19 November 1940, IWM, 78/19/1.

23
Dr Fritz Hallgarten recorded that as well as portraits you could buy 'a collage for three pounds or four pounds', in an interview, IWM 003967/06.

24
Carl Ludwig Franck writing to Daniel shortly after his release, undated but c.1941, Peter Daniel Collection.

25
Peter Daniel Collection.

26
Uhlman 1979, 'Post Scriptum', pp.25–6.

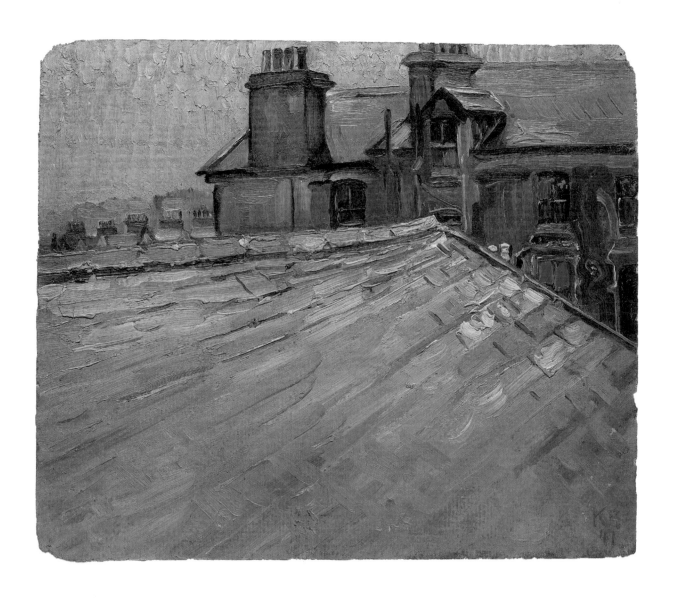

**Untitled
(Roofs of Houses in Douglas, Isle of Man)**
1941
Wax tempura on linoleum
CR:2790

**Untitled
(Portrait of Fred Uhlman)**
1940
Oil on wood
CR:2651

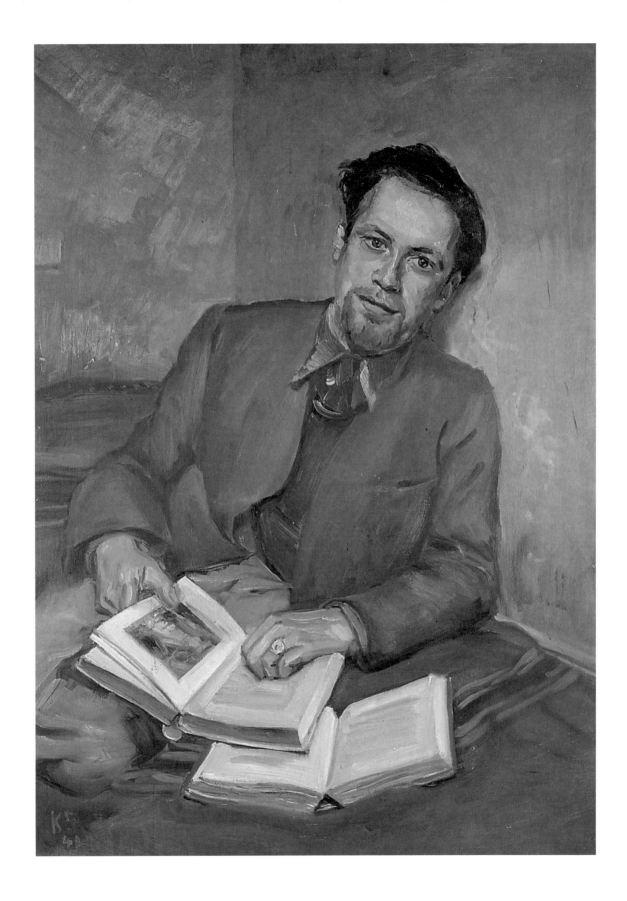

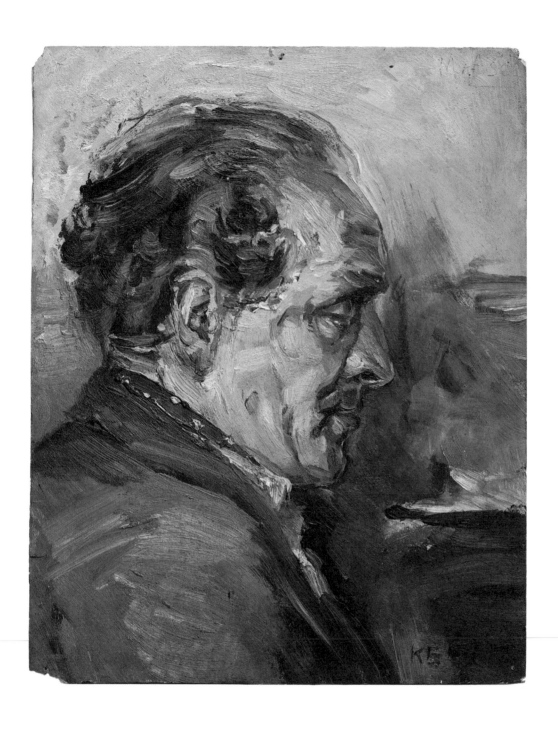

Portrait of the Sculptor Charoux
1940
Oil on cardboard
CR:2661

Untitled
(Portrait of Klaus Hinrichsen)
1941
Oil on wood
CR:2795

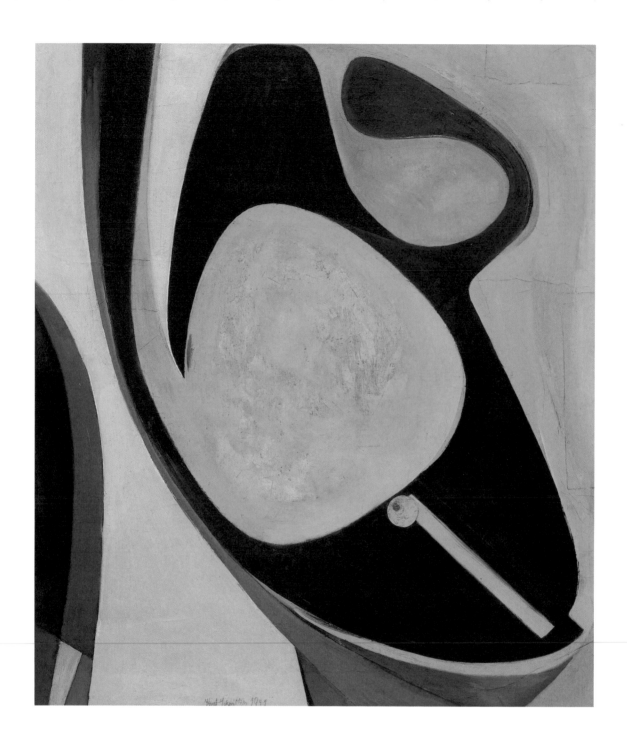

Untitled (Curving Forms or Isle of Man)
1941
Oil, cardboard and plastic? on linoleum on
board
CR:2775

Untitled (Abstract Oval Picture)
1940, 41
Oil on canvas
CR:2630

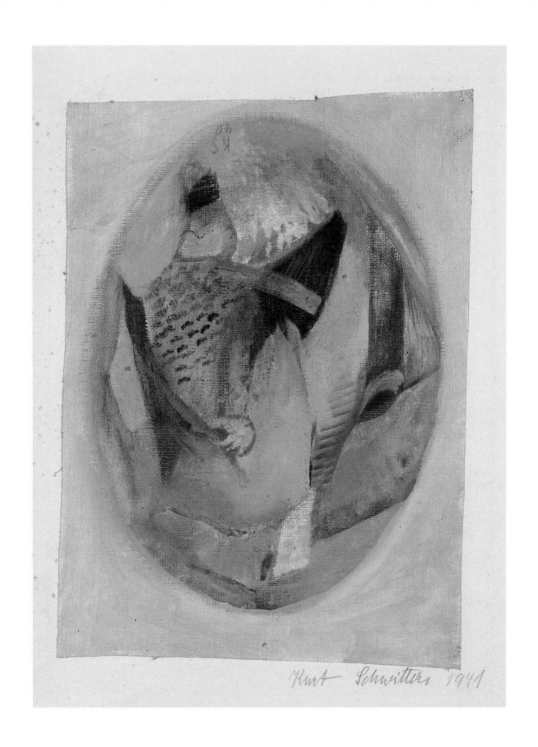

MEGAN LUKE

Togetherness in Exile

In August 1944, Kurt Schwitters returned home from a conference organised by the PEN literary club in London and, with some excitement, began to dash off a letter to his old friend László Moholy-Nagy. Both were exiles from Hitler's Germany: Moholy-Nagy had emigrated to the United States via London in 1937, the same year Schwitters had followed his son to Norway, where they remained until the German invasion in April 1940. When Schwitters eventually landed on British shores himself, he spent just over a year interned as an 'enemy alien'. Feeling cut off from the world beyond the barbed wire, he received crucial support from Moholy-Nagy as he attempted to secure a visa to travel to America. Though these efforts ultimately proved unsuccessful, the two friends quickly resumed their correspondence a few months after Schwitters was released in November 1941.[1]

Freed from his extended internment, Schwitters found himself marooned in London in the wake of the Blitz. Any acquaintances from the Continent who had made their way there – Piet Mondrian, Walter Gropius, Naum Gabo, to name but a few – had moved on long ago. That late August afternoon at the PEN club, then, he must have felt as if he had seen a ghost when he suddenly encountered Moholy-Nagy's ex-wife from the Bauhaus days, the photographer Lucia Moholy. In his letter he tells his friend how he had searched for Lucia for over a year once he had learned she was still in town, how he had even pestered a stranger in an art gallery who turned out to be a striking doppelgänger, how he felt too timid, after this episode of misrecognition, to believe that the real Lucia now appeared before him, and how, once they had exchanged pleasantries, both found themselves at an utter loss for something to talk about. 'Now I have to report to you that I live', Schwitters continued to Moholy-Nagy, 'I live, paint, and modellise [i.e., sculpt by modelling]. I do not write very much in the moment, and I believe that at the moment my best things are my small sculptures. They are so small that they may be easily be transported, so that

I could easily have an exhibition of them in [the] USA.'[2] With this brief statement – one of the very few he ever made about the sculpture he fabricated in England – the letter ends abruptly, a draft that remained unfinished and unsent.

These sculptures are indeed remarkable for the small scale that Schwitters stresses in this letter, as well as for their brazenly polychrome surfaces that show little regard for tasteful or systematic harmonies of colour. He regularly used paint to coat a casing of rough plaster that, in turn, did not so much trace the internal armature of a given work as thoroughly obscure it. This structure was often supplied by a found object like a twig, a rock or a bone. The surfaces of these works – a mixture of the viscous and tacky materials of oil paint and plaster – do their utmost to distract us from fixing a clear mental image of their underlying form as conceptually separate and distinct. Schwitters intended that these objects would thereby collapse conventional distinctions that had long separated the artistic media of painting and sculpture, together with their attendant claims on our perceptual faculties. As he subsequently put it in a letter to Alfred H. Barr, Jr, then the chair of modern painting and sculpture at the Museum of Modern Art (MoMA) in New York: 'I modellised the colour and form of the surface with paint, so that modellising and painting become only one art.'[3] These objects confound habitual approaches to the pictorial and spatial arts, which might assume that painting is something that is primarily seen, something that conjures a space or an illusion independent from our own environment, whereas sculpture is something corporeal that shares a space with our bodies and other things. We cannot rely upon these assumptions when approaching his English sculptures, and instead we are asked to reflect consciously on the specific overtures these objects make to us as we attempt to establish some kind of rapport. Does their small size encourage us to pick them up and hold them even as we are impelled to look at their colours from a distance? Do their unpredictable colour combinations invite us to dwell on their changeable appearance, dependent upon lighting conditions and our own physical movement from one vantage to another?

As our options for how to approach these objects appear to multiply, not only do we question their status within the traditional parameters of the arts of painting or sculpture, but we are made to feel equally unsure of what it is, exactly, that we ultimately behold. Here Schwitters's description of his reunion with Lucia Moholy makes vivid the particular context in which he developed his sculptural technique following his release from internment. In his letter to Moholy-Nagy, he poignantly narrated his situation in exile in London as a series of missed encounters, unfulfilled searching, and uncanny apparitions of his past life. Recounting how he finally recognised Lucia at the PEN club, he writes that 'she looked still like Lucia, but less than the wrong [woman] from before. Anyhow we sat together and did not know what about to speak.' Resemblance was too uncertain and mutual recognition too little guaranteed to regain the community that had once existed between them. Exile had made the familiar strange, and vision proved to be an unreliable guide as he navigated both a foreign land and his memories of home. In this state of perceptual uncertainty and alienation from his past self and present surroundings, Schwitters completely redefined his sculptural practice, which had long

been dominated by his *Merzbau*, the monumental transformation of the entire interior of his studio and its adjacent rooms in his home in Hanover that, in these last years, he declared to be his 'life's work'.[4] He had been forced to leave this all-consuming environment behind with his relocation to Norway, where he attempted to reconstruct it from scratch in a little structure he built himself on his landlord's property in the Oslo suburb of Lysaker – only to have to abandon this space too with yet another border crossing in advance of the approach of war. Now, as we consider the small, transportable sculptures he made in England, we ought to realise that the intimacy that their scale and modelled surfaces appear to solicit is far from untroubled by this history. What could it possibly mean to behold sculpture when the conditions that once seemed so necessary for this encounter had been so thoroughly undone?

When Schwitters sought to merge painting and modelling into a single process, his aim was not to coordinate individual arts into a *Gesamtkunstwerk*, like so many parts making up an overpowering and totalising whole; rather, he preferred to find what it was that they might share, to destabilise the boundaries that purported to define the identity of a given medium or genre. For two decades prior to his exile, abstract composition and the found object had served as the common denominators for an art he termed Merz. Painting, drawing, sculpture, architecture, theatre and poetry could all be formed through collage rather than with the traditional materials that had distinguished these arts from each other. And the artist's individual expression of a rhythmic equilibrium, rather than the task of representation, would be the force that organised these heterogeneous fragments of everyday debris into works of art.[5] As Schwitters travelled to Norway for increasingly longer stays to take up landscape painting in the years leading up to his eventual exile, the word 'Merz' began to fade from his vocabulary, and by the time he wrote to Moholy-Nagy and Barr, the shared terrain he envisioned between the arts of painting and sculpture had clearly shifted. For one thing, the found material incorporated into many of his small sculptures was organic matter rather than the detritus of mass culture. What is more, these works no longer obtained their colour through the garish printed matter of advertising and consumer packaging. Instead, he employed oil paint, which he had long ago claimed 'reeks of rancid fat' in a provocative response to critics who felt his early Merz collages were nothing more than abject accumulations of trash. Manipulating paint as if it were clay or paste, he appeared capable, at last, to acknowledge, even relish, its base materiality.[6]

As Schwitters adjusted his choice of materials for his late sculpture, his focus shifted to the surface of the art work as the site where the world of an object meshes with our own. Colour and form were not opposed terms in his remarks to Barr, but equally subject to the process of modelling. This technique was additive, building up a form with wet, clinging materials that conformed to the given shape of a found object or interior construction, rather than by carving one away in stone or assembling it by nailing disparate parts together. The irregular contours of a work like *Untitled (Ochre)* 1945–7 might suggest that some piece of matter shaped by forces of nature rather than artistry lay at its core, yet it is impossible to deduce from the surface of the sculpture the shape of that generative form with any certainty (fig.17). Even when we can

17

Untitled (Ochre)
1945–7
Plaster and stone, painted
9.5 x 22.6 x 15
Tate. Purchased 1990
CR:3249

[18]

Untitled (Painted Stone)
1945–7
Stone, painted
3.5 x 31.3 x 8
Tate. Lent by Geoff Thomas 1991
CR:3258

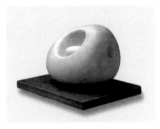

[19]

Barbara Hepworth
Nesting Stones
1937
Serravezza marble
Length 30.5
Hiroshima Prefectural Art Museum

[20]

Untitled ("Melting" Sculpture)
1945–7
Wood, stone and plaster, painted
9.5 x 8.3 x 7.5
Kurt und Ernst Schwitters Stiftung on
loan to Sprengel Museum Hannover
CR:3256

clearly see the form that serves as the basic structure for a given work, as in *Untitled (Painted Stone)* 1945–7, Schwitters deliberately works to estrange us from it through his application of paint, here deployed in rings of gold, pink, aquamarine, white, ochre, orange and silver around its entire surface (fig.18). This combination of colours in bands of varying thickness implies no order or consonance, nor does it orient the object in space, as it can just as legitimately rest on one face as the other. It is impossible to screen out the gaudy interference of painted colour to see the stone that gives the work its form.

Here Schwitters's artistic intervention works against the conceit of 'truth to materials', which had dominated discussions about modern sculpture in England prior to the war. Closely tied to a revival in the technique of direct carving, this concept held that sculpture ought to make visible and explicit the properties particular to stone or wood – such as their hardness, resistance or heft – as if the sculptor had released something latent in his or her materials that would heighten their visibility. Schwitters's little objects do not accord with these terms, and they stand in uneasy relation to the work of contemporaries such as Henry Moore and Barbara Hepworth (fig.19).[7] Moore, for example, felt the task of the sculptor was 'to think of, and use, form in its full spatial completeness. He gets the solid shape as it were, inside his head – he thinks of it, whatever its size, as if he were holding it completely enclosed in the hollow of his hand.' Like Schwitters, Moore turned to small pieces of driftwood, pebbles, and bones as a starting point for many of his sculptures after the war, yet he prized these found treasures less for their material properties than for their weathered forms, which he felt he could translate into bronze or stone and enlarge at will. For Moore, the small object would always affirm the mastery of the sculptor, whose ability to recognise a compelling form and control its monumentality was 'a mental thing rather than a physical thing. It's in the mind rather than in the material.'[8] According to the critic Adrian Stokes, the hand-held shape thereby became a metaphor for a sculptural idiom that was essentially dependent on 'modelling', one that asserted the mastery of a mental conception of form over material specificity. He contrasted this entirely subjective approach to 'carving', exemplified by Hepworth's sensitivity to the surface, which aimed to make manifest how her materials always retain a measure of independence from cognition.[9] Schwitters's late sculptures, however, stand quite apart from either Moore or Hepworth's paradigm: their small scale stresses the contingency of form on the beholder's unfixed, shifting vantage, whereas their coloured and textured surfaces attract our attention only to frustrate our expectations that they ought to reveal all those qualities that we imagine exceed our grasp, whether because they are hidden within an inner core or are embedded in the materials of a given work. Indeed, a miniature work like *Untitled ('Melting' Sculpture)* 1945–7 gently mocks these ambitions for a supreme clarity of form and an expressive surface, as its very body appears about to slide off its meagre base and into a formless mass of plaster and paint masquerading as something softening under its own weight (fig.20).

These objects simultaneously court and deflect our impulse to seek recognition, which relies on the promise that identity is stable, that resemblance is possible, and that representation can be decoded. Schwitters's anecdote about

his estrangement from Lucia Moholy becomes an allegory for how any faith in this promise is radically foreclosed to the exiled subject. The sculptures he fabricated in this context provide us the opportunity to feel what it might be like to experience the world from such a destabilised perspective. In this sense they come closest to the miniature plaster figures Alberto Giacometti produced in the 1940s after he fled Paris for Geneva on the eve of the German occupation (fig.21). With these works, Giacometti had tried to give form to a memory of catching sight of his beloved at a distance, standing across a street as he approached with 'the immense blackness of the houses above her'.[10] The possibility for recognition is held in tight suspense, under threat from both the process of making the sculpture and the act of beholding it. Had Giacometti attempted to render this woman at any further remove, the work itself might crumble into dust beneath his touch; and, when apprehending this sculpture, were we to draw too close, all we would see are formless lumps of plaster. Yet even this narrow margin for recognition does not appear available to us through Schwitters's late sculptures. Though we might attempt to relate his small objects to those he made in Germany or to search for affinities with the work of his contemporaries, they nevertheless eschew the historian's inclination to link them with a coherent narrative of the artist's past or working milieu.

Perhaps this is why, despite his resolute commitment to abstract sculpture throughout his life, Schwitters began to toy with varying degrees of figurative depiction in his studio in Barnes on the outskirts of London. Works that appear to resemble other, already familiar objects, seem all the more strange as their hold on representation remains ambiguous, falters and fails to cohere. Several sculptures, such as the phallic *Fant/Good-for-Nothing* 1944, make explicit allusions to parts of the human body only to confound them through a skin of colour that defies any naturalism (p.52). *Dancer* 1943 is singular for its attempt to represent a figure in its entirety, which Schwitters built up from a branch or, possibly, an animal bone (p.23). The limbs of this creature seem to reproduce like a cluster of polyps, its red-tipped extremities appear raw, almost bloodied, and its disjointed, twisting leg and unsteady posture underscore this corporeal vulnerability. In short, while we cannot help but see this leaning, anti-statuesque object as a 'body', anything more specific we cannot say. With the sculptures that Schwitters made after he quit London for the town of Ambleside in the Lake District in June 1945, he attenuated their ties to representation still further, diminishing his reliance on the base and testing the limits of their very capacity to be recognised as sculpture, let alone as stand-ins for other objects in the world. For instance, as much as we might regard *Untitled (Stone)* 1945–7 as an analogue for a fist, one that would fit perfectly into the cup of the hand if we reached out to touch, its hastily painted colour pre-empts such metaphoric projection and keeps our probing fingers in check (p.53). Scale and contour lures us in, while colour requires that we step back and look. This object may be both painting and sculpture, but our senses of sight and touch fail to work in concert when we attempt to analyse its form. At the same time, colour thwarts even our capacity to see this object literally, as a simple stone and nothing else besides. With the utmost economy of means, this incomplete coat of paint is all it takes to foil our search for likeness and, simultaneously, to transform an unformed thing into a sculpture.

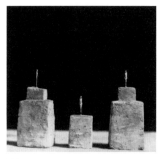

Alberto Giacometti
Figurines reproduced in *Cahiers d'art*, nos.20–1, 1945–6 (photograph by Marc Vaux)
Tate Archive

Untitled (Merz Column)
1923–5
Installation, including paper, cardboard, metal, plaster, wood, cloth and cow horn and laurel branch
Dimensions unknown
Destroyed (1943)
CR:1199 (Abb. 6)

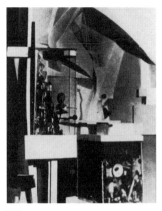

Untitled (Golden Grotto and Grotto with Doll's Head, Part of Merzbau)
1933
Installation
Dimensions unknown
Destroyed (1943)
CR:1199 (Abb. 27)

Merzbau (detail view: *Great Group*)
1933
Installation, including paper, cardboard,
plaster, glass, mirror, metal, wood and
electric lighting
393 x 580 x 460
Destroyed (1943)
CR:1199 (Abb. 22)

But what did Schwitters take sculpture to be? When he attempted to reproduce the *Merzbau* in Norway, he closely followed the form the Hanover space had assumed over six years of work prior to his exile. The new structure was to perform a memorialising, even revivifying function – one that would bridge the rupture of separation and embody the continuity of his practice and aesthetic concerns. Schwitters's studio in Hanover had once been a space strewn with the found materials he had amassed for his collages and assemblages, permeated by the smells of glue as it warmed and the refuse he had collected from the street. When he first turned his attention to sculpture, he consolidated these materials into free-standing dada objects, increasingly ambitious columns, and evocative 'grottoes' (fig.22). He eventually encased these objects, sculptures, and cavities within a crystalline wooden construction, leaving just a small selection visible behind glass (fig.23). In sharp contrast to the textural and coloristic diversity of the grottoes and, indeed, the entirety of his work in collage, the sculptural construction of the *Merzbauten* in Hanover and Lysaker consisted of intersecting beams and planes, painted white and sanded smooth with only very rare accents of primary colours (fig.24). Here the material that Schwitters sought to form was not so much wood or plaster, but space. His constructions would divide and bend this space, conceived less as a predetermined enclosure and more as a field riven by the confrontation of various forces, of the dance between the movement of the beholder and that of light. When Schwitters did occasionally create free-standing sculpture independent of this environment in the 1930s, he stayed close to its model. Completely white and uniform in texture, these works recall the monolithic columns of the *Merzbau*'s origins as they extend its attempts to constitute space through a dynamic intersection of planes serving as blank screens for the mutable play of light and shadow. In his first year in Norway, he continued to make sculpture in this vein; indeed, *Small Twisted Sculpture* 1937 is a direct reprise of a sculpture (now lost) he completed in France in the months just before he emigrated (fig.25, overleaf).[11]

Schwitters's situation in England was very different from what it had been in Norway, where his family had travelled annually since their first visit as tourists in 1929. He had chosen to remain in Norway to avoid Gestapo interrogation concerning the resistance activities of his son and friends, whereas he was forced to flee to Britain, arriving in an utterly alien country following a harrowing escape from certain imprisonment.[12] When we see Schwitters take up the formal idiom of the Hanover *Merzbau* for the only time in England with *Untitled (Little Dog)* 1942–5, the work no longer confronts us with a belief that continuity with his past work could be maintained (fig.26, overleaf). The smooth white surfaces and angular protrusions are still there, as are the planes set obliquely to each other to give a sense of a form twisting in space, but now they have been reduced to a formal echo, a kitschy knick-knack. Schwitters had long attacked kitsch as the hollow imitation of authentic artistic expression, rendering what was challenging or shocking more palatable to the public: 'The absolute imitator, the *Kitscher*, has the most friends among the public; with his works, a large public feels so settled, so at home, so much among friends, that it feels content.'[13] Irrevocably severed from any concept of home and his own artistic past, Schwitters now engages in a self-pastiche as if the *Merzbau* had been made by another artist entirely, cannibalising

the form but draining it of the 'elementary force' of its creativity. Within the *Merzbau*, he had once envisioned that 'imaginary planes emanate from the directions and movement of the constructed surfaces as directions and movement in space', and that 'the suggestive effect of the sculpture is based on the fact that you intersect these imaginary planes yourself as you enter the sculpture'.[14] Now this dynamic relationship between beholder and sculpture is cemented by a dog begging for food or mugging for a handshake – a performance for approval not unlike that staged by the *Kitscher* himself.

As Schwitters emphasised to Moholy-Nagy, the sculptures he made in England were eminently portable and deliberately rootless. Unlike the site-specific structures of the *Merzbauten* in Hanover and Lysaker, they were capable of emigrating ever westward, across the Atlantic if necessary. Indeed, it soon became clear to him that their mobility would be their salvation, a lesson for the exile himself. As disorientating as homelessness was, in times of war an excessive attachment to place could well be one's undoing. When Schwitters wrote to Moholy-Nagy, he did not yet know that the Hanover *Merzbau* had been hit and destroyed by a bomb during an Allied raid the night of 8 October 1943. He learned of this catastrophe only when he received word that his wife Helma, who had remained behind in Germany to care for their elderly parents and protect their property, had died of cancer almost exactly one year later.[15] To compensate for these twin tragedies, which had obliterated the deepest ties he still had to home, Schwitters wrote: 'I worked on and developed my abstract sculptures. It was good that I did these small sculptures because the *Merzbau* had been bombed.' And he repeatedly insisted that they marked a turning point in his approach to sculpture: 'I am developing a new kind of sculpture from found forms. Very small. Not ornamental like the *Merzbau*. Similar to the *MZ* [*Merzzeichnungen* – i.e., collages].'[16] This statement challenges the common assumption that the *Merzbau* was a logical extension of collage into 'empty' space, a conceptual matrix that is merely given, existing independently from and prior to our bodily experience in time. He stressed that his sculptures in England should thereby assume a key role in our very ability to distinguish his pictorial compositions fabricated with the useless debris of mass consumption from his site-specific experimentation with the phenomenology of spatial perception.

I believe that when Schwitters claimed his latest sculptures were 'not ornamental like the *Merzbau*', he wanted to emphasise their detachment from any place or purpose, much like the very rubbish he had culled from the streets for his collages. Such refuse was free to drift, to acquire a patina, to shed a connection to a functional past, and to assume a new identity within another context. In April 1946 Schwitters received word from friends in Hanover that perhaps some parts of the *Merzbau* could yet be salvaged. He wrote back with the idea that he could 'excavate the remains of the fragments, just as one does with ancient stones, and sell them in America', elaborating that perhaps these remnants 'could be fitted together to yield a sculpture again'. Although nothing of the *Merzbau* could, in the end, be recovered, here he considers how ruined fragments could be reconfigured endlessly into new wholes, whose status as 'finished' was, in fact, merely provisional – no longer bound to a particular place and time but rather perennially destined for 'elsewhere'. At the same

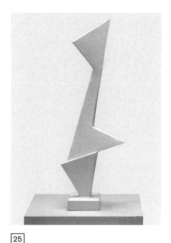

25

Small Twisted Sculpture
1937
Wood and plaster, painted
98.4 x 34.4 x 17.3
Sammlung NORD/LB in der Nieder-
sächsischen Sparkassenstiftung,
on loan to Sprengel Museum
Hannover
CR:2322

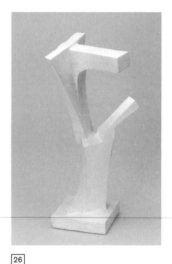

26

Untitled (Little Dog)
1942–5
Sculpture, wood and plaster
45.5 x 20 x 18
Sammlung NORD/LB in der Nieder-
sächsischen Sparkassenstiftung,
on loan to Sprengel Museum
Hannover
CR:2978

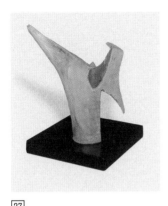

Untitled (Painted Plaster and Wood Form)
1945–7
Plaster, wood and bone, painted
22.3 x 16 x 16
Tate. Lent by Geoff Thomas 1991
CR:3246

time he began to build up new sculptures from found animal bones, thereby collapsing different processes and temporalities: 'I buy a bone, let a dog gnaw away what he thinks is worth gnawing, and rebuild the gnawed remains with plaster according to the rules of movement in art. That produces no bones but rather sculptures.'[17] (fig.27) The role of found objects in his earliest Merz pictures from 1918 to 1922 had been to affirm the power of his composition to discipline their wanderings, to fix their meaning within an integrated and discrete whole, and to shed any vestiges of their prior use value. Over time, Schwitters came to question the priority of composition, allowing for the beholder's contribution to his art in his development of the immersive environment of the *Merzbau*. With his sculptures in England he extended this critique, dismantling the presumed hierarchy between material and form by insisting on their radical discontinuity. When curators at MoMA decided against exhibiting these new sculptures because they planned to include a large number of his Merz pictures in their ambitious survey of collage, he argued: 'In reality my sculptures are worked through, they are the best of my work and quite new for Amerika [sic]. It would take a long time of explaining. They are not compositions like the pictures and collages, they are constructions. Anyhow they are a new development, while my collages are 28 years old, when I made them.'[18]

A work like *Untitled (Togetherness)* 1945–7 is, then, neither collage nor *Merzbau* (p.55). Both painting and sculpture, it is part of a 'new development' that is nevertheless built on ruins, fragments and bones. This was a development born of dislocation, which brought with it both a longing for recognition and a lack of confidence in its recuperation. Though the verticality of this sculpture might summon to mind a monumental column lifted proudly on a pedestal, what we actually see is a form that is not united in itself. Split in two, together and apart, its coloured shafts are lodged in a bed of lumpy plaster filling the lid of a cast-off cardboard box. In fact, where the sculpture ends and the frame of the base begins is by no means clear: one of these forms, made of a sliver of rock painted red and topped with a white cap, already sits on a cylindrical base wrapped in a ring of hard green plastic. Its neighbour too appears internally divided, as the colour on one side makes a red base for a yellow crest, while from another angle, the monochrome white coating affirms that this same body is all of a piece. Is this sculpture an image of union or isolation? Is the space in-between an agent of division or does it become a body in its own right, rendered visible, almost palpable? Schwitters's late sculptures are not easily reconciled into anything like a logical series, but they all raise these questions, which point to the ambiguity of identity, place and community. As we make an uneasy peace with the fact that definite answers will inevitably evade us, we can think back once more to the same PEN club conference dedicated to the 'freedom of expression' where Schwitters had his failed reunion with Lucia Moholy. For it was there that he also encountered a new friend, another émigré, the Polish filmmaker Stefan Themerson, whose remarkable account of his impressions of the Merz master confirms that these sculptures, of all his works, aimed to contend with the paradoxes of exile and the violent upheaval of war:

> There were writers from all over the world there, in the hall – and there were sounds of aeroplanes above the roof. Two hours earlier a bomb had

fallen on a nearby house. You don't need to think about it too dramatically. This was a customary occurrence in those days; two hours had been enough to move away those who needed to be moved away, whole or in pieces, and the place looked peaceful, and the sky, now made visible by the removal of the higher part of the building looked bright … The same morning, while passing the bombed site on his way to the French Institute, [Schwitters] had picked up from among the ruins a piece of convulsed iron wire, a foot or two long. 'I always take everything I find interesting', he told me later. And now, sitting in the hall beside me, he was bending it into a space-sculpture while Mr E.M. Forster was delivering his speech. There were some distinguished writers there who, seeing him so occupied, thought he was an electrician or a plumber who had got lost and strayed into their Pen by mistake. Nevertheless, there, at that meeting, it was he, Schwitters, who was practicing what the speakers were preaching.[19]

1
Contact was reestablished with a letter from Moholy-Nagy, 11 March 1942, Kurt und Ernst Schwitters Stiftung at the Kurt Schwitters Archive, Sprengel Museum Hannover (hereafter KESS) For information on Moholy-Nagy's efforts with the US government on Schwitters's behalf, see letter from Käte Steinitz, 12 December 1940, KESS. For more details on his internment in Britain, see Jennifer Powell's essay in this volume.

2
Letter to László Moholy-Nagy, 21 August 1944, KESS (English in the original).

3
Letter to Alfred H. Barr, Jr, 1 November 1945, Museum of Modern Art (MoMA) Archives, New York, Exhibition #1400, File 11 (English in the original).

4
Letter to Christof and Luise Spengemann, 25 April 1946, reprinted in Ernst Nündel (ed.), *Wir spielen, bis uns der Tod abholt*, Frankfurt 1974, p.194.

5
See, for example, 'Merz', translated into English in Robert Motherwell (ed.), *The Dada Painters and Poets: An Anthology*, New York 1951, pp.55–65.

6
'Sauberkeit (Für Leute, die es noch nicht wissen)', reprinted in Friedhelm Lach (ed.), *Das literarische Werk*, vol.5, Cologne 1981, p.88. See also Sarah Wilson, 'Kurt Schwitters in England', *Kurt Schwitters*, exh. cat., IVAM Centre Julio González, Valencia 1995, pp.520–7.

7
Schwitters met Hepworth and Ben Nicholson in May 1942, exchanging collages with Nicholson at that time. Over the course of his years in England, however, he remained disappointed in their art: 'Hepworth can't measure up to Arp'; 'I think personally, there is only one artist worthwhile in England: Gabo. In a big distance there is Ben Nicholson or Henry Moore. The average English artist is nothing.' See letters to Friedrich Vordemberge-Gildewart, 5 January [sic] 1946, reprinted in Volker Rattemeyer and Dietrich Helms (eds.), *Vordemberge-Gildewart: Briefwechsel*, vol.2, Nuremberg 1997, p.236 and to Katherine Dreier [c. January 1947], Katherine S. Dreier Papers/Société Anonyme Archive, Beinecke Library, Yale University, Box 31, Folder 926.

8
Statement by Henry Moore in 1964 cited in Alan Wilkinson (ed.), *Henry Moore: Writings and Conversations*, Berkeley 2002, p.207.

9
For valuable context regarding the interest in truth to material and direct carving in England, see Penelope Curtis, 'Barbara Hepworth and the Avant Garde of the 1920s', *Barbara Hepworth: A Retrospective*, exh. cat., Tate, Liverpool 1994, pp.11–28. For more details about Schwitters's reception by Herbert Read that elaborates his difference from Moore, see Megan R. Luke, 'Sculpture for the Hand: Herbert Read in the Studio of Kurt Schwitters', *Art History*, vol.35, no.2, April 2012, pp.234–51. On Stokes's distinctions between the work of Moore and Hepworth, see Alex Potts, *The Sculptural Imagination*, London and New Haven 2000, pp.148–53.

10
Giacometti to Pierre Dumayet, cited in Yves Bonnefoy, *Alberto Giacometti: A Biography of his Work*, trans. Jean Stewart, Paris 1991, p.272.

11
See photographs in *Kurt Schwitters: Catalogue Raisonné*, vol.2, Ostfildern-Ruit 2003, cat. nos. 1767 and 1768. In March 1936, he travelled to Meudon and Paris to visit Nelly van Doesburg and Hans Arp and Sophie Taeuber-Arp, where he completed as many as five sculptures. These were kept by Nelly van Doesburg for safekeeping but are all lost today.

12
For details, see Gwendolen Webster, *Kurt Merz Schwitters*, Cardiff 1997, especially p.299ff.

13
'Merz' (1924), in Lach 1981, p.187. For more on the inauthenticity of kitsch, its mass appeal, and as a marker of class difference, see also Schwitters's critique of architectural neo-classicism (and a veiled retort to Le Corbusier), 'Über griechische Tempel' ('On Greek Temples'), written 6 April 1928, in Lach 1981, pp.294–8.

14
Letter to Alfred H. Barr, Jr, 23 November 1936, MoMA Archives, Exhibition #1400, File 42.

15
Edith Tschichold telegraphed word of Helma's death in late December 1944; Marguerite Hagenbach confirmed the destruction of the Merzbau in February 1945. See Webster 1997, pp.344–9.

16
See letters to Hans Richter, 29 March 1946, Getty Research Institute, Los Angeles, Yves Poupard-Lieussou Papers, Box 5, Folder 2 (English in the original) and to Friedrich Vordemberge-Gildewart, 5 January [sic] 1946, Rattemeyer and Helms 1997, p.236.

17
Letter to Christof and Luise Spengemann, 17 July 1946, reprinted in Nündel 1974, pp.206–7.

18
Letter to Edgar Kaufmann, 15 July 1946, KESS. After several delays, *Collage* opened after Schwitters's death on September 1948.

19
Stefan Themerson, *Kurt Schwitters in England*, London 1958, p.10. (See Chambers, p.18, note 27 for Themerson and Schwitters's first meeting.) This story resembles Klaus Hinrichsen's first recollection of Schwitters's arrival at Hutchinson camp as he 'sat down the next day on a bench on the grass field and continued to carve with a pocket knife an abstract sculpture form the branch that had accompanied him from Norway together with a white mouse' (*Kurt Schwitters Almanach*, vol.8, 1989, p.100).

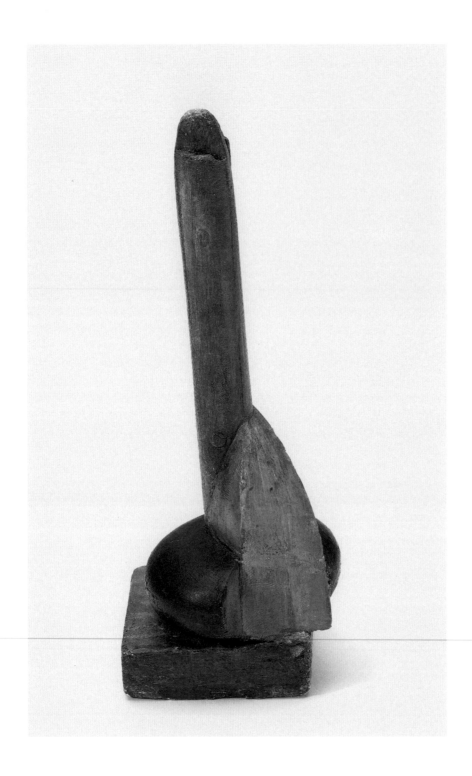

Fant/Good-for-Nothing
1944
Wood and plaster, painted
CR:3130

Untitled (Stone)
1945–7
Stone, painted
CR:3259

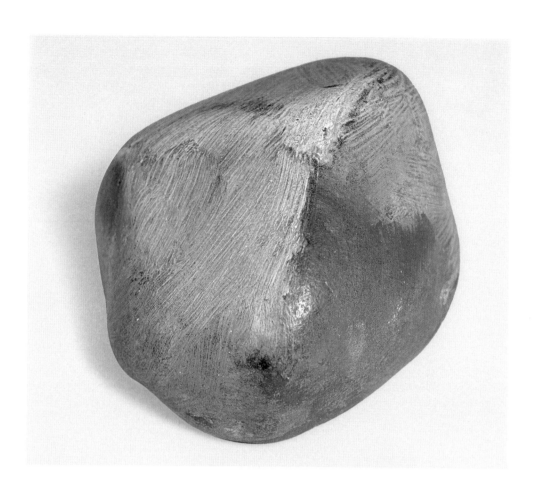

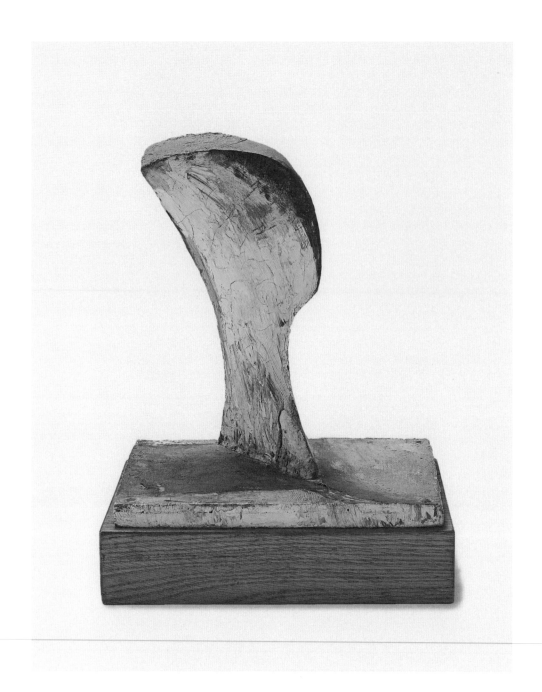

Untitled (Construction on a Sheep Bone)
1945–7
Wood, bone, nails and plaster, painted
CR:3247

Untitled (Togetherness)
1945–7
Stone, cardboard and plaster, painted
CR:3244

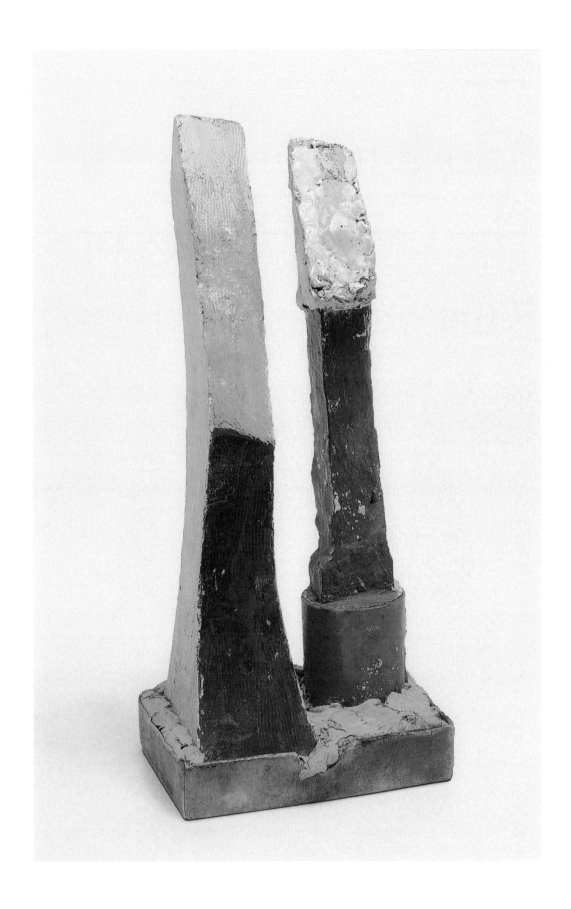

KARIN ORCHARD

'British made': The Late Collages of Kurt Schwitters

'I can see from the work I am doing now, that in my old age I will be able to go on developing Merz. After my death it will be possible to distinguish 4 periods in my Merz work: the *Sturm und Drang* of the first works – in a sense revolutionary in the art world – then the dry, more scientific search for new possibilities and the laws of composition and materials, then the brilliant game with skills gained, that is to say, the present stage, and ultimately the utilization of acquired strengths in the intensification of expression. I will have achieved that in around 10 years.'[1] Six months after Kurt Schwitters, in Norway at the time, wrote this letter to his wife Helma, and two days after his arrival as a refugee in Edinburgh on 18 June 1940, he turned fifty-three. He was in good health and in the prime of life; he viewed his work at the time as a 'brilliant game with skills gained' and anticipated that his creative powers would increase over the next ten years: 'I am still extremely young and have merely become stronger in my art.'[2]

But in the coming years bouts of serious ill health and various accidents caused Schwitters to age prematurely, and in early 1948 he died in a hospital in Kendal in England's Lake District. Looking back, Joyce Kahn wrote that in 1945 'he was already a sick man at this time, looking older than his years'[3]; and his friend Käte Steinitz, who had emigrated to the United States commented that after 1945 'every letter is a catalogue of illnesses and accidents, but with never a complaint. As is his way, he recounts what has happened to him in tones of astonishment and mild irony.'[4] As always, everything in his life, even the illnesses, became part of his total Merz world view: 'My heart asthma has become Merz asthma', Schwitters wrote, playing on the fact that the German *Herz* (heart) rhymes with Merz.[5] Despite numerous setbacks, his energy and positive outlook were undaunted and he pursued his projects with the same unflagging determination right to the end of his life: 'none of it – broken leg, arm and lungs – has dented my spirit, and if anything I am painting better now, not worse'.[6]

28

Mz 300 mit Feder.
Mz 300 with Feather.
1921
Feather, fabric, net, paper
and canvas on paper
16 x 13
Private collection, on loan to
Sprengel Museum Hannover
CR:0867

Schwitters's zest for life – undiminished by having to flee from the Nazis, undiminished by exile, internment, isolation and impoverishment – manifested itself in his immense productivity. The number of collages he made in the last years of his life seems to be particularly extraordinary, although it should not be forgotten that he did not sell any of these works, with the result that almost all of them have survived in the estate of his companion Edith Thomas and in that of his son Ernst. At the same time, he was clearly greatly encouraged to go on producing new collages and to rework and assemble earlier collages because – besides various activities in London (see Chambers, pp.9–14) – in 1946 he entered into discussions with the Museum of Modern Art, New York, regarding both a proposed solo exhibition of his work and his participation in an international group exhibition of 'collages' that was initially planned for the summer of 1947. As it turned out, both exhibitions were to be repeatedly postponed, but by this time Schwitters had already selected and sent thirty-nine collages to the museum. Some of these were subsequently shown in the large-scale collage exhibition which in the end ran from 21 September to 5 December 1948, after his death. The other collage exhibition that Schwitters himself planned and for which he selected the exhibits – twenty-six collages and constructions, mainly from 1946 and 1947 – opened on 19 January 1948 at the Pinacotheca Gallery in New York, shortly after his death. By force of circumstances, it became the first exhibition in Schwitters's memory.

He had no doubt been similarly productive in the early 1920s, when his Merz art was at a high point – in 1922, according to his own numbering system for his collages, he reached 'Mz. 600'. But large numbers of his prewar works were sold, given away and exchanged, decimated during the war or otherwise lost, with the result that only a fraction of his earlier production is known today. However, it is certain that the number of collages made in England is much greater than those made in Norway, which have also largely survived. In Norway, Schwitters was above all influenced by the Nordic light and the majestic landscape of mountains and fjords, which saw him take a new direction in his art. He now increasingly turned his attention to painting and sketchlike drawings, in both abstract and naturalist compositions. Collage played only a small part in his thinking at this point; in all likelihood this was also partly due to the lack of urban *objets trouvés* that might have appealed to him. And during the seventeen months he spent as an internee on the Isle of Man, paint, image supports and plaster were more readily available than inspiring chance finds in the streets of the camp. This changed as soon as he was released from internment and arrived in London in late 1941. The British metropolis – 'Big city. Very big. Like a Hannover that has shot up'[7] – prompted yet another turnaround in his artistic interests, which now particularly included collages and small sculptures. The last phase of his anticipated 'periods' was under way.

THE LATE WORK

Can the output of an artist in his fifties be described as late work? Or, in Schwitters's case, does it appear in this light only as a consequence of his early death? What in fact are the characteristics of late work? What is the role of 'late work' in postmodernism? As a rule, the division into different phases of artistic creativity is not defined by the artist in question, but retrospectively by

art historians or critics. It is therefore rather astonishing to find Schwitters – in such an objectively distanced manner, almost prophetically – discussing the '4 periods' of his own work, which still hold good today. Ever since Vasari, art history has been presented as artistic progress. In artists' biographies, the last phase of their work often occupies a problematic position; the late work is seen as the pinnacle of a life's work, as an expression of maturity and fulfilment, which – regardless of the artist's age – can come about only shortly before the artist's death. Age is reputed to bring a certain wisdom and feeling for the truth, with an individual's life experience culminating in a sense of independence and authenticity. Equanimity and transcendence are said to characterise the work of an artist's last years. In the age of the avant-garde, which included Schwitters, the often 'advanced' modernity of an artist's late work was noted and admired – the loose brushwork and autonomous colour schemes in the work of Titian and Frans Hals, for instance, or the *non finito* in that of Michelangelo. Art critics applauded earlier artists who broke the rules and flouted tradition in their late work as role models who appeared to have anticipated future developments.

But what if an artist refuses to make compromises in his last years? Or what if his late style involves repetition and convention, unresolved contradictions and a desire for affirmation? Edward W. Said has explored this other side of ageing in his collection of essays *On Late Style*.[8] In the last phase of an artist's life, reduced physical strength and illness can lead to a new idiom that takes the form of a furious gesture, of uneasy, deliberately unproductive production in the face of approaching death and what Theodor W. Adorno has called the 'powerlessness of the I confronted with Being'.[9] This kind of late work is disjointed, perfunctory and repetitive. Said again quotes Adorno: 'In the history of art, late works are the catastrophes.'[10] This negative catastrophe cannot be averted, for there is nothing beyond the end, no transcendence or unity. The only way out is to go deeper. The negativity of some late work is an act of mourning for a now lost totality: 'There is therefore an inherent tension in late style that abjures mere bourgeois aging and that insists on the increasing sense of apartness and exile and anachronism, which late style expresses and, more important, uses to formally sustain itself.'[11]

CRITIQUE

Which category does the late work of Kurt Schwitters come into? In his own view, it constituted an 'intensification of expression' and a 'brilliant game'; he felt that he had 'become stronger' in his art. Later critics and certain biographers have regarded the work he made in exile as evidence of his creativity failing and coming to an end. The harshest condemnation was issued by Werner Schmalenbach with reference to what he called Schwitters's 'nature paintings'.[12] He was critical of Schwitters's stylistic pluralism, which had always been a feature of his work, but which was more noticeable in the work he made in England. Schmalenbach saw this as a sign of 'a latent weakness in Schwitters's work' and of the 'tragic decline of his work in these years. His paintings could not shake off the weakness to which the artist had resigned himself and which was ultimately also due to his physical weakness.'[13] Nicholas Wadley, however, resisted the notion that the difficult circumstances of Schwitters's last years had a detrimental effect on his work. In his view, paradox had always been a

Untitled (MAGIC SED!)
1941–2
Paper on paper
13.1 x 10.5
Tate. Accepted by HM Government in lieu of inheritance tax and allocated to Tate, 2007
CR:2819

C 22 profound lights
1946
Charcoal, cellophane, cardboard and paper on paper
26 x 21 .4/20.6
Kurt und Ernst Schwitters Stiftung on loan to Sprengel Museum Hannover
CR:3313

hallmark of Schwitters's art and life: 'everything is right, including the opposite' – to quote Schwitters himself.[14] John Elderfield also identified clear strengths in the late work, which in his opinion was 'less of a deterioration than a re-evaluation. In an important sense the late assemblages are the most audacious works that Schwitters ever made.'[15] Nevertheless Elderfield also adds that the late works 'sometimes appear unbearably slipshod' and suffer from Schwitters's refusal to 'adhere to the structures that had underpinned his work for so long, although (as in the past) these would have ensured that his results were both more consistent and more ordered'.[16] However, in the meantime the advent of postmodernism and stylistic pluralism has cast a rather different light on Schwitters's supposedly incoherent and often apparently paradoxical methods. Siegfried Gohr takes the view that 'it is only in recent years that it has been possible to see the full complexity and uniqueness of his persona and work, which cannot be comprehended if it is merely regarded as a byway to the highway of Modernism'.[17] Schwitters refused to bow to the tyranny of style – Per Kirkeby even sees an absence of style in his work,[18] which in effect means that he is one of the first truly postmodern artists and in many ways ahead of his own time.

MERZ THEORY

What was Schwitters's own view of his works in the 1940s? Oddly enough, he makes no reference to any differences between his current work in the 1940s and his early work, from the late 1910s onwards, although they are ostensibly very different. In a letter to Lotte Gleichmann in 1946 he wrote: 'My new pictures are no more different to the old ones than one hen is from another hen. Tempora mutantur, but I can't. Ever since 1918 I have never been able to change.'[19] And in a letter to Friedrich Vordemberge-Gildewart he says: 'But I paint and paste. People call me the rubbish painter. "Rubbish" is *merde*, or rather, garbage. And it does seem more and more that my Merz drawings dominate my art. I paste things in almost exactly the same way as in 1917. Endlessly.'[20] In comparison to the stylistic caprices of a Picasso or a Max Ernst, Schwitters's development was indeed very rigorous – for 'Merz is consistence'[21] – yet this is not to say that there is neither change nor progress in his work.

Following his experiences during the First World War, Schwitters decided to create something new from the rubble of the old world and henceforth concentrated on collages: 'You can also shout with items from rubbish heaps, and that is what I did, by pasting and nailing them together.'[22] Although Braque and Picasso are credited with inventing modern collage techniques around 1912, they only ever integrated these into their paintings and never turned them into an art form in its own right. In the hands of Schwitters, Hannah Höch, George Grosz, John Heartfield and the other dadaists, disparate materials from all sorts of sources retain their own integrity and are combined to create an entirely self-sufficient composition. Collage and montage become groundbreaking, structural concepts in modernism; they speak the language of fragmentation and sections, which draws on both high and low cultural codes. Although found objects rescued from the sorry detritus of reality become formally identifiable signs, they still retain their documentary character and always reflect a historical connection to the time of their own origins. The radical revaluation of materials in artistic works requires a paradigmatic change, whereby art and life, art and

ordinary living become one. This was the shocking new principle of modernism. Kurt Schwitters formulated his Merz theory in the early 1920s: for him, all the elements and materials in his collages and constructions, regardless of their origins, acquired artistic significance through 'appreciation' – before that, they were 'of no importance'.[23] His aim was to take materials and items mainly from ordinary life and to establish relationships between them. 'Merz means creating connections, preferably between all the things in our world.'[24] Schwitters's underlying idea was to remove the 'autotoxins' from the selected materials – which had been chosen solely for aesthetic reasons – by means of what he himself called 'disformulation': 'The artist creates his work by selecting, distributing and disforming materials. The disformulation of materials can already occur in their distribution on the picture plane. It is reinforced by dissection, bending, overlaying and overpainting. In Merz art the lid of a box, a playing card, a newspaper cutting become planes; twine, brushstrokes or pencil marks become lines; wire mesh, overpainting or glued down sandwich papers become a glaze; cotton wool becomes softness.'[25]

A comparison of these thoughts on Merz from the early 1920s and the concept of Merz that Schwitters set out in the 1940s (in English, with his own idiosyncratic spelling) in a manuscript entitled 'Abstrakt art', reveals no significant changes or contradictions.

> A MERZ picture starts with the material, every possible material for painting, and uses it as paint. The MERZ picture sticks its material together after the rhythm of a compositional scheme and does not bother about the fact, that parts of its materials to begin with had been done for quite another purpose. A busticket has been printed for controlling the passenger, the MERZ picture uses it only as colour. You must not read it on the picture the 3 for example is only a line consisting of two bows. If necessari this may be painted partly over, or there may be put another thing about a part of it over part of it. Deciding for the composition is the rhythm. The picture is finished when you cant take away or put on it anything without disturbing the present rhythm. Of course such a composition does not represent anything outsides itself. Therefore the title does not mean much ... The material gives a certain mouvement, another may assist or fight it, and the composition collekts all single mouvements to a rhythm. Perhaps one can feel the rhythm of london and give in an abstrakt picture a simular rhythm.[26]

The only thing that stands out here is the greater emphasis on pictorial rhythm, an artistic principle that had taken on more importance for Schwitters since his greater involvement with music and musical composition. In his own view the underlying theory of Merz had not changed; it had only undergone certain stylistic changes and had made progress in various respects.

LATE COLLAGES
Some of the late collages – with their restrained coloration and composed harmonies and rhythms – are indeed closely related to the early, classic collages. Take, for instance, *c 77 wind swept* of 1946 (p.71). This work does its

title justice, with the composition as it were running diagonally from the upper left to the lower right as though a strong wind were gusting across the paper. It consists entirely of a small number of carefully chosen pieces of paper and card and a single, small piece of white fabric towards the top of the right-hand edge of the composition. The pieces of paper and card, some torn but mainly cut, in shades of ochre, white and grey, are pasted onto firm brown card, which, in the lower left corner, abandons its subservient function as an image support and forms a significant part of the collage. The piece of white doily in the upper left is the only organic ornamental element, albeit partly concealed under a parcel label. The brown and ochre-coloured pieces of paper in the upper realms of the collage are presumably wrapping paper. On the right there is an upside-down bus ticket, on which the words 'Parcel' and 'Child' can easily be made out; below this there is a piece of tissue lining from an envelope. Two narrow parallel lines cut through the centre of the composition; on the upper strip there is a small scrap of paper with the clearly visible letters 'st' – the abbreviation for 'street' in English. The decipherable elements in this composition predominantly come from the realms of travel and mobility (bus ticket, street) and the postal service (envelope, label, wrapping paper) – all realms of life that were of great importance to Schwitters, in his isolated existence, as forms of contact with the outside world. These nuanced shifts and subtle games with no more than different types of paper and a small number of linguistic indicators, with no absolute imposition of meaning, are also found in his early collages. The composition here has momentum and rhythm instigated by the diagonals yet also interrupted by small elements running counter to them, such as the torn piece of dark brown paper in the lower half of the composition with a triangular continuation in the upper left, or the piece of white paper running crosswise above the bus ticket. And it is these counter-elements and the 'roughness' of the seemingly hasty gluing of the composition's components – with corners curling up and protruding – that ultimately set this late, classic-looking collage apart from comparable compositions made in the 1920s.

The difference is more apparent if one compares *c 77 wind swept* with another diagonal composition, the untitled collage of 1927 (fig.31). This composition has a highly sophisticated, harmonious air; the orange-red tones of the various papers are carefully matched and form a well-ordered composition with numerous parallel lines. The materials coalesce in a smooth, cleanly pasted surface. The potentially disturbing – torn – papers are so discreet (either transparent or in similar hues) in their effect that they do not detract from the overall harmony of the composition.

However, there is only a small group of late collages that fundamentally adhere to the ideals of Schwitters's early, classical principles. By far the majority of the collages that have survived or are known from his time in England are much more disparate in their construction. In the confined quarters of the internment camp, Schwitters evidently did not find interesting enough materials, and he started to make collages with found papers again only after his arrival in London. In one series of collages, for instance, he worked intensely with examples of art from the past, a realm with which he had not previously engaged in his own work. He found his materials in illustrations from art books and cheap

31

Untitled (Merz, Diagonal)
1927
Paper on paper
15.5 x 15.4
Private collection
CR:1518

prints of works by old masters, which he used as image supports. In contrast to his earlier collages, parts of the image supports are now not pasted over and, as such, become meaningful elements in the finished composition. This also gives these collages a strong sense of space and creates the effect of layering in the materials. In the collage *Untitled (The Doll)* 1941–2 (p.68) the image support is a monochrome reproduction of a painting by the nineteenth-century Bavarian genre painter Franz von Defregger. Of the original depiction of a peasant father repairing a broken toy for his children, while his wife is doing the family's washing, only the figures' feet, at the lower edge of the painting, are still visible. Covering the painting and almost filling the composition – like a second image support – there is an upside-down, black-and-white photograph of a Norwegian fjord with a wide, bright horizon, taken by Schwitters's son Ernst. Catching the eye at the lower edge of this image, the words 'WHAT IS MORALE?' are written in bold letters on an orange background; this is countered in the upper right by a colour picture, again upside down, of a soldier and a woman. At the left edge of the collage there is a bus ticket and a colour illustration from a magazine of a plate of food; at the right-hand edge there is a red-and-green wrapper from an English chocolate bar, 'Terry's Oliver Twist'. Although the colours of the few, readily identifiable items in the collage appear not to match particularly well, they are carefully positioned around the edges of the composition, leaving a large expanse free for the white, billowing clouds. This collage is notable for the stark contrasts between the monochrome ground and the brightly coloured snippets of easily legible images. Spatiality is bafflingly indeterminate due to the unclear relationship of above and below, in front and behind, with the centre of the composition – an 'empty' area – not focusing attention on any specific meaning. The metaphorically questioning, moral raised finger points to a happy, smiling couple but also to Oliver Twist begging for more – associations and connotations alluding to a very real problem for Schwitters and everyone else in wartime London, where food rationing was now in force.

Untitled (The Doll) exemplifies many of the features that are typical of the late collages Schwitters made in England. On one hand, there are the unusually clear allusions to politically and socially relevant themes, as in *(Untitled) The Hitler Gang* or *Mr. Churchill is 71* (pp.69 and 70). This new, explicit reference to significant contents was no doubt a consequence of the ongoing critical situation to which even self-avowed 'non-political' artists such as Schwitters had to react. Magazines such as *Picture Post* and *Life*, with their colour photojournalism and coloured advertising images, provided Schwitters with a fund of new materials and a brighter palette of colours. He started to make collages in larger formats and increasingly introduced strongly coloured, photorealistic elements into his compositions (*left half of a beauty*, p.124). He had comics – 'funnies' – sent from the United States and used them in his collages, as for instance in *Untitled (Y. M. C. A. OFFICIAL FLAG THANK YOU)* (p.31): 'I like them now. I use them as material for Merz Drawings.'[27] Above all Schwitters used materials from his immediate surroundings and life situation in his works, including travel tickets and typically British wrappers and packaging from chocolate bars, sweets and other foodstuffs (*Untitled [Bassett]* CR:2946; *Ty. P. HOO TEA*, fig.32). His collages in effect became a kind of journal, documenting his circumstances. By 'working through' reproductions

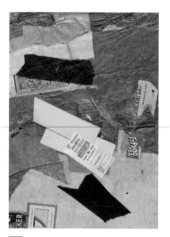

32

Untitled (Ty. P. HOO TEA)
1944
Gauze, cellophane, sheet,
paper and cardboard on paper
37.8 x 26.7
Kurt und Ernst Schwitters Stiftung
on loan to Sprengel Museum Hannover
CR:3089

like an old master
1942
Paper and fabric on canvas
26.9 x 21.5
Sprengel Museum Hannover
CR:2941

Zebra
1947
Oil on paper
21.3 x 17.2
Private collection
CR:3650

of works of art from the past, Schwitters engaged with art history, which often led to ironic confrontations of modern urban materials and classical traditions, as for instance in *Die heilige Nacht, von Antonio Allegri, gen. Correggio, worked through by Kurt Schwitters* (p.67) and *like an old master* (fig.33).

Another feature of his abstract, late works, which is also seen in the collages, is the use of oil paints. His 'pointillist' dots of colour were to become a hallmark of his work, and are still seen in his last works. They give his compositions an air of lightness and liveliness, and connect with (and adapt) the painterly aspect of his early Merz works. Schwitters had developed this technique in Norway when he took up certain aspects of painting again; his aim was now to achieve a synthesis of abstract and naturalist art, and landscape painting provided him with a useful point of departure. He complemented the 'random materials' of Merz art with the materials of naturalistic oil painting. *Zebra* (fig.34), once owned by Edith Thomas, is an unusual example of his work from that time. Strictly speaking, it is not a collage; it is a black-and-white reproduction of a photograph showing only the torso of a female figure bending over and catching a ball. This sporting figure is dressed in shorts and a striped pullover – giving the picture its title. Lines of pale brushmarks have been added to the picture, running evenly across the figure's chest, dark shorts and legs, as though extending the striped pattern of the pullover. Because the chosen detail of the original image does not include the head, the figure is dehumanised and suggests a metamorphosis from human to animal. In this use of a single sheet, Schwitters was returning to a technique he had used in the 1920s, which he himself had called 'i-drawing' and which is in fact a form of readymade. This process involves selecting a detail from a found image. The artist's input consists solely of the choice of an original image and the selection of the detail. In a classic i-drawing, the detail is mounted, unchanged, on an image support, to which the artist adds a signature, a date and a title. However, this over-painted reproduction of 1947 is not a late i-drawing. In this work, as in all the other works discussed here, it is clear that Schwitters, with the self-assurance of the mature artist, was drawing on and recombining elements from the fund of methods and techniques he had developed throughout his life.

We see here 'the utilization of acquired strengths in the intensification of expression' that Schwitters himself had predicted. The late collages have a greater number of layers of meaning than the early works. The various components – paper collage, pure painting and real items – interconnect more closely and form illusory spatial depth, yet still retain their own autonomy, as did the components in the surrealist works that Schwitters had produced in Norway.[28] It is a brittle, implosive style, with an instable, very haptic surface that always seems to be threatening to disintegrate, upsetting the balance of the composition. This high-wire technique gives the works a high degree of tension and a distinctly modern feel; the sophisticated elegance of the early collages is now a thing of the past. More than any of his earlier works, these collages convey a powerful sense of spontaneity and arbitrariness; although this necessarily means that less attention is paid to technical details in the production process, the results are all the more profound in their expression, which is not to say that they are either brooding or melancholy.

Schwitters described himself as 'citizen and idiot', and it is this remarkable combination of sentimental, conventional, feeling person and avant-garde artist that underpins the singularity of both his work and his personality. In Norway this was particularly evident in his abstract and naturalistic paintings; in England it is seen in his use of over-painting and in the ongoing development of his collages and material pictures. It was only here, thrown back on his own resources, far removed from the high-minded expectations of his fellow artists and on his own in the London art world, which had itself been decimated by war – 'Here I am like a question mark on abstract art'[29] – and later on in rural Ambleside, that his other 'I', another Schwitters, came to light. He deliberately sought out marginal situations: he stayed in Hanover rather than moving to Berlin, he emigrated to Norway rather than Paris or the United States, he moved to the Lake District rather than staying in London. Right up until the end of his life, his chosen role as outsider and stranger also gave him immense artistic freedom.

Translated by Fiona Elliott

1
Kurt Schwitters to Helma
Schwitters, 23 December
1939, Lysaker, Kurt und Ernst
Schwitters Stiftung at the Kurt
Schwitters Archive, Sprengel
Museum Hannover (hereafter
KESS), no. que 06839105.

2
Kurt Schwitters to Edith
Tschichold, 4 March 1945, in
*Kurt Schwitters. Wir spielen,
bis uns der Tod abholt.
Briefe aus fünf Jahrzehnten*,
ed. Ernst Nündel, Frankfurt
(Main), Berlin and Vienna
1974, p.180.

3
Joyce Kahn, 'Schwitters
in Barnes', in *Oasis*, no.6,
1972, pp.52–3, online edition
published in August 2003 by
poetrymagazines.org.uk.

4
Kate T. Steinitz, *Kurt Schwitters. Erinnerungen aus den
Jahren 1918–1930*, Zurich
1963, p.151.

5
Kurt Schwitters to Christof
and Luise Spengemann, 25
June 1947, in Nündel 1974,
p.282.

6
Steinitz 1963, p.151.

7
Kurt Schwitters to Christof
and Luise Spengemann, 17
July 1946, in Nündel 1974,
p.205.

8
Edward W. Said, *On Late
Style: Music and Literature
against the Grain*, New York
2006.

9
Said 2006, p.10.

10
Theodor W. Adorno, *Essays
on Music*, Berkeley, Los
Angeles and London 2002,
p.567.

11
Said 2006, p.17.

12
Werner Schmalenbach, *Kurt
Schwitters*, Cologne 1967,
pp.158–9.

13
Schmalenbach 1967, p.171.
At a later stage he revised
his opinion, at least of
Schwitters's abstract work,
and put it on a par with his
early work, but he does not
discuss its artistic aspects.
See Werner Schmalenbach,
'Kurt Schwitters', in *Kurt
Schwitters in Exile: The
Late Work 1937–1948 /
Kurt Schwitters im Exil: Das
Spätwerk 1937–1948*, exh.
cat., Marlborough Fine Art,
London 1981, pp.8–14.

14
Kurt Schwitters to Käte
Steinitz, 26 February 1940, in
Nündel 1974, p. 159; Nicholas
Wadley, 'The Late Works
of Kurt Schwitters', in ibid.,
pp.63 and 75.

15
John Elderfield, *Kurt Schwitters*, Düsseldorf 1987, p.233.

16
Ibid., p.234.

17
Siegfried Gohr, 'Die Statur
des Künstlers. Kurt Schwitters', in *Kurt Schwitters.
Ich ist Stil. I is Style. Ik is
stijl*, exh. cat., Museum der
bildenden Künste Leipzig
and Stedelijk Museum,
Amsterdam, Rotterdam 2000,
pp.19–30, here p.20.

18
*Schwitters: Norwegian
Landscapes, the Zoological
Garden's Lottery and More
Stories*, ed. Per Kirkeby, Hellerup 1995, p.13.

19
Kurt Schwitters to Lotte
Gleichmann, 10 October
1946, in Nündel 1974, p.240.
See also pp.242 and 276.

20
Kurt Schwitters to Friedrich
Vordemberge-Gildewart, 5
January 1946, in Volker Rattemeyer and Dietrich Helms
(eds.), *Vordemberge-Gildewart: Briefwechsel,* vol.II,
Nuremberg 1997, p.236.

21
Kurt Schwitters, 'Merz', in
Der Sturm, XVIII, no.3 (June
1927), p.43, quoted in *Kurt
Schwitters. Das literarische
Werk*, vol.5, ed. Friedhelm
Lach, Cologne 1981, p.187.

22
Kurt Schwitters, in *Gefesselter Blick. 25 kurze
Monografien und Beiträge
über neue Werbegestaltung*,
ed. Heinz and Bodo Rasch,
Stuttgart 1930, p.88, quoted
in Lach, vol.5, p.335.

23
Kurt Schwitters, 'Die Bedeutung des Merzgedankens in
der Welt', in *Merz 1. Holland
Dada* (Hanover 1923), quoted
in Lach, vol.5, p.134.

24
Schwitters, ibid.

25
Kurt Schwitters, 'Die Merzmalerei', in *Der Zweemann*,
I, no.1, 1919, p.18, quoted in
Lach, vol.5, p.37.

26
Kurt Schwitters, *from MERZ
25. Abstrakt art*, 1940s,
KESS no. que 06840156.

27
Kurt Schwitters to Käte
Steinitz (writing in English),
20 February 1946, in Steinitz
1963, p.153.

28
See Karin Orchard, ' "It's
namely someone else
painting, it's not me." Kurt
Schwitters's Paintings in
Norway', in *Schwitters in
Norway*, exh. cat., Henie
Onstad Art Centre, Høvikodden, Ostfildern 2009,
pp.100–7, here pp.102–3.

29
Kurt Schwitters to Christof
and Luise Spengemann, 17
July 1946, in Nündel 1974,
p.207.

Die heilige Nacht, von Antonio Allegri, gen.
Correggio, worked through by Kurt Schwitters
1947
Paper, ribbon, cardboard and photograph
on cardboard
CR:3616

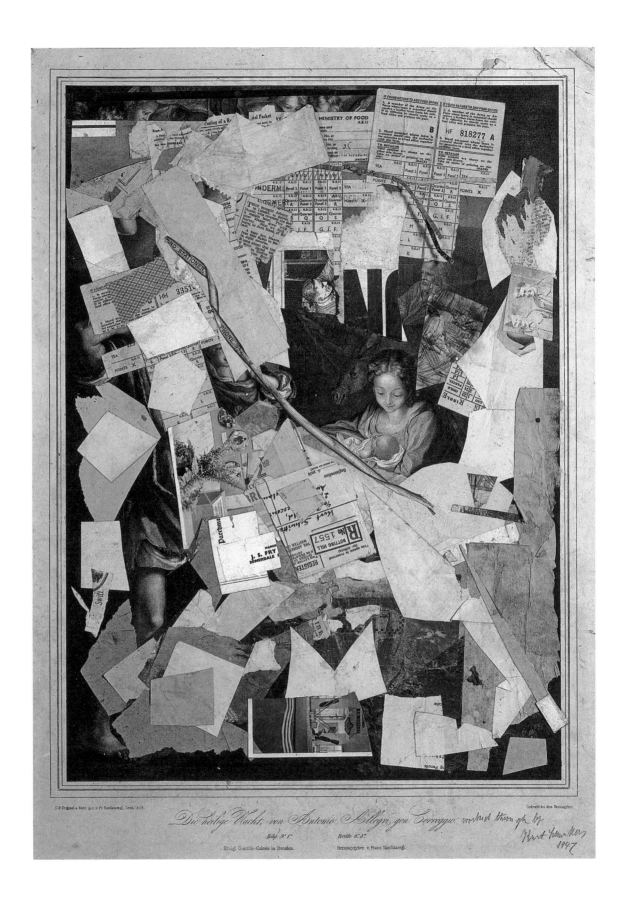

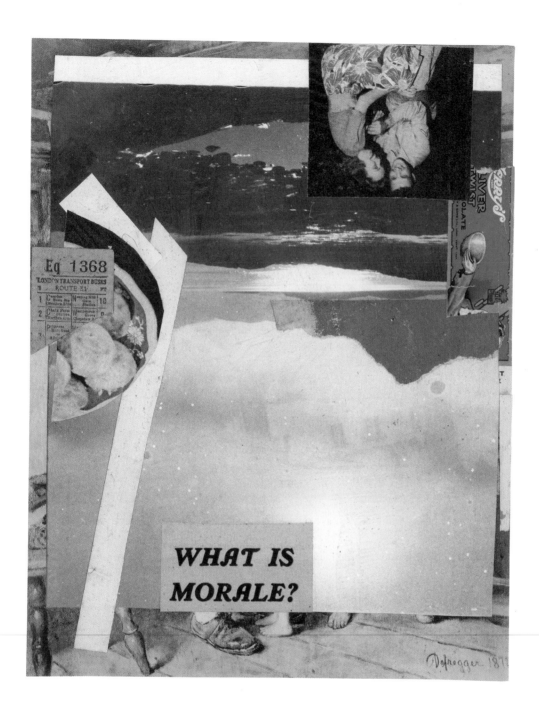

Untitled (The Doll)
1941–2
Paper and photograph on cardboard
CR:2827

Untitled (The Hitler Gang)
1944
Oil, canvas, cardboard and paper on paper
CR:3086

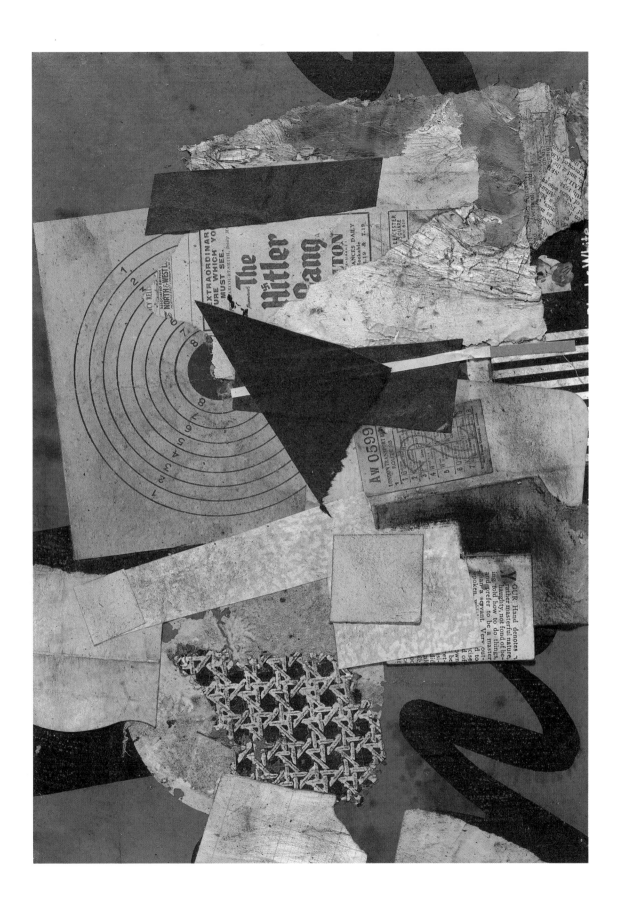

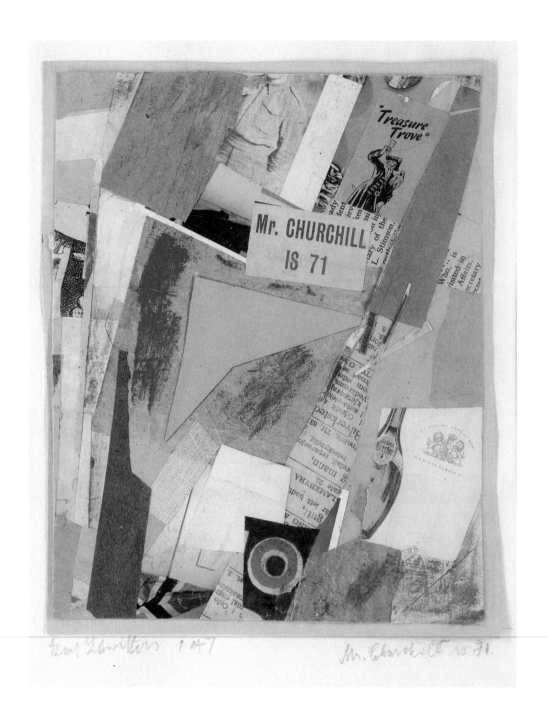

Mr. Churchill is 71
1947
Gouache, paper, fabric, cardboard
and photograph on cardboard
CR:3544

c 77 wind swept
1946
Paper doily, fabric, cardboard
and paper on cardboard
CR:3349

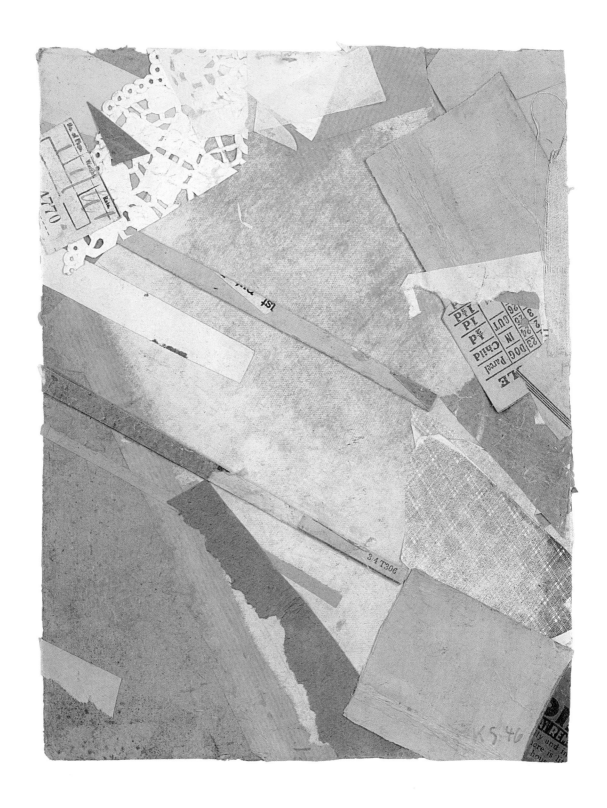

MICHAEL WHITE

SCHWITTERS

TWITTERS

35

Schwitters performing the Ursonate,
London 1944

36

Extract from the *Daily Mirror,* 30 July 1936,
British Library, London

his wisecracks are not as
to be. Anyhow, they mean
the U.S.A.

her Coughlin, Canadian-
on the air every Sunday
ho used to be a supporter

est tells his audience of
ort the New Deal, not to
Father Coughlin resolutely
the White House.

extraordinary figure of all
nsend, white-haired old
to California to spend his
aw his life savings swept
merican upheaval.

a scheme called Rotating
give every man or woman
reached the age of sixty
, on condition that every
thing saved.

the millions of dollars
ed by a turnover tax. Mil-
ave fallen for the scheme,
ollars have poured in as
m clubs to further the

E. BUT IT IS SHAKING

shakes America Take
nce . . .

EY WINN

You know him
well. Already he
has made thou-
sands of friends
(and perhaps a
few enemies, too)
through his provo-
cative articles in
the "Daily Mirror."
He is among the
cleverest of Bri-
tain's young novel-
ists, and his latest
book, "Communion
on Earth," has just
been published.
During August
he will be our
"guest critic" of
people, places and
present-day hap-
penings.

n on Monday His novel
led—

nality Parade

the same day the Moslem was bathing himself
in a tank when something fell into the water
beside him.

It was the snake!

The man leapt out of the water and ran for
his life.

That same night, while he was sleeping in
his hut the snake rustled softly in. The
Moslem never woke again . .

* * *

*All of which proves that it's a good thing
not to throw stones, and it's an even better
thing not to throw stones at snakes.*

* * *

Songster

Songster Week End was observed during the
week-end, a musical programme being given by
the Songster Brigade under the leadership of
Songster Leader N. Ellis. Prayer was offered
by the Songster Secretary whilst Songster Mrs.
Walker read the lesson. Items were given by
the Songster Brigade, the Band, Songster H.
Birch (recitation), trombone solo Songster S.
Townsend, recitation Songster Mrs. Ellis. The
arrangements were in the hands of Songster
Leader Ellis assisted by the Songsters.

Bimbimm !

There are queerer ways of earning money,
than by writing for the newspapers. For in-
stance, there is the pursuit that Mr. Kurt
Schwitters follows. He writes poetry. Here is
a selection from one of his works published in
a book called "Transition."

**"Bumm bimbimm bamm bimbimm
Bumm bimbimm bamm bimbimm
Bumm bimbimm bamm bimbimm
Bumm bimbimm bamm bimbimm."**

Honest, this is genuine !
If you don't believe me—"Bamm !" to you !

Escape

The mob looted a British-owned garage from
which a number of new cars were stolen. The
managers, Mr. Bunn and Mr. Batt, have
escaped to Gibraltar.—News Item.

* * *

*Well played, Bunn !
Congratulations, Batt !*

* * *

Correspondence

July 29, 1936.

Thx Suprxmx Typxwritxr Co.,
 Xvxsham,
 Worcxstxrshirx.
Dxar Sir,
 Wx rxpxat xmphatically thxrx arx no lxttxr
"x's" (thx fifth lxttxr in thx alphabxt) on thx
typxwritxr you havx supplixd us with. Sxnd
us immxdiatxly a thundxring big supply of
lxttxr "x's." This BLARSTXD corrxspondxncx
is gxtting on our nxrvxs.
 Yours sincxrxly,
 Hxrbxrt Jonxs (Managxr),
 THX SURRXY STXXL COMPANY.

"Bumm bimbimm bamm bimbimm
Bumm bimbimm bamm bimbimm
Bumm bimbimm bamm bimbimm
Bumm bimbimm bamm bimbimm."[1]

With these mere ninety-one characters, Kurt Schwitters was introduced to his largest ever British readership in the million-selling newspaper the *Daily Mirror*, nearly five years before he even arrived in the country (fig.36). Of course, when he did step off a Norwegian icebreaker in Edinburgh in 1940, nobody was mindful of his reputation in modern cultural circles; the prior appearance of this snippet of the *Ursonate*, his epic sound poem, in a mass-circulation paper had been merely for its pillory. However, it reminds us that many people's first encounter with Schwitters was as a writer rather than as an artist and that, from the launch of his one-person art movement, Merz, after the First World War, he had cannily used printed and recorded media to disseminate his ideas and to advance his career.

Schwitters gave his first performances outside of Germany on a dada tour of the Netherlands in 1923. Writing shortly beforehand to its instigator, Theo van Doesburg, he raised the question of intelligibility:

> People will anyhow want to hear me recite my Anna Blume poem, and I would do it in German, English and French, one right after the other. Also I could recite the poem 'Wall' (just one word), 3 number poems (if you tell me the numbers in Dutch), and some phonetic poems, which, without sense and without language, can be understood by any Dutchman: Ddssnnr – Je – M – Mp – Mpf – Mpft – Mpftl, etc.[2]

As Schwitters pointed out, what most people knew of him at this point was his 1919 poem 'An Anna Blume' ('To Anna Blume'), whose notoriety indeed was the subject of the very first book publication on the artist.[3] Schwitters could not only recite it in different languages, it already existed in a number of published translations, including English.[4] The success Schwitters had in getting noticed in the Netherlands with his sound poems only confirmed for him the importance of the strategy of appealing across linguistic borders to the universal befuddlement of all. It was what got him his first major press mention in the United States. A reporter at a recital at the Sturm Gallery in Berlin picked out Schwitters for

special mention, writing in detail how from his mouth came 'only a very soft buzzing, like that of a moth, gradually it grows louder, and we hear a mixture of chirping, spitting, squealing, squabbling, schreeching, interrupted by the "tweet-tweet" of some sort of bird. This, I believe, is called "Waldstimmung" (In the Forest).'[5]

Through the later 1920s Schwitters worked intensively on ways of publishing sound poetry, in particular the *Ursonate*. It even appeared in 1925 in the form of a gramophone record as issue thirteen of his *Merz* magazine. He subsequently published parts of it throughout Europe, experimenting with a variety of printed forms to capture its phonetic qualities. Sections of it featured in the British avant-garde journal *Ray* in 1927.[6] In the same year, a very large amount of the poem appeared in the international journal *i10*, along with an extensive account by Schwitters of how to read it. Fenner Brockway, the peace campaigner, was *i10*'s contact in Britain, but not much is known about the journal's British readership.[7] Instead, the source for the *Daily Mirror* was *Transition*, a journal of experimental literature produced in Paris by the American couple Eugene and Maria Jolas. Their promotion of the writings of James Joyce had certainly attracted a wide audience in Britain for the publication, and parts of the *Ursonate* featured in it in 1927, 1932 and 1933.[8]

Despite these foretastes, what Schwitters had not counted on until his arrival in Britain was the lingering German character of his sounds. Although he produced a large amount of writing in English after 1940, he was never at home in the language. To old acquaintances he wrote: 'English jokes are not German jokes. English wordplay is not German wordplay. The translation has to be very loose. And the public has to be very understanding.'[9] These comments were made directly after his performance of the *Ursonate* at the Modern Art Gallery, at the opening of his solo exhibition in Britain in 1944. His son, Ernst, took an extensive series of photographs on the occasion, one of the rare visual records we have of Schwitters performing the poem. Herbert Read, who wrote an introduction for the exhibition catalogue, explained to visitors Schwitters's importance as a poet as well as an artist, interestingly comparing his use of language to *Finnegans Wake*, but to little avail.[10]

There was just one final performance of the *Ursonate* at the London Gallery in 1947. As one audience member, Stefan Themerson, recalled, 'two gentlemen from the

B.B.C. were invited and came. The idea was that they would record the UR SONATA. Just record it. Schwitters read his UR SONATA, but the gentlemen left in the middle.'[11] In the meantime, Schwitters had struck up correspondence with his old Dada friend and sound poetry pioneer Raoul Hausmann, from whom he had not heard in over a decade. There followed an intense exchange of letters, in which they described to each other in broken English how they had each escaped Nazism and ended up in remote parts of Britain and France. This correspondence also included poems and photographs sent as tokens of friendship, leading Hausmann to suggest a new project based on their exchange. First titled *Schwittmail*, it was to take the form of a publication comprised of the mutual 'rewording' of each other's texts and poems.[12] Subsequently named *Pinhole Mail* and finally just *PIN*, the project ultimately failed to find a publisher.

Previous dreams of universal communication had been destroyed by war and exile. The two stranded avant-gardists, two key members of the German avant-garde, who could no longer bear to use their native language to write to one another but struggled in others, called out instead in ways they had learned decades before: Schwitters crowed from his Lakeland nest, 'Ji üü Oo Aa / Brr Bredikekke', and Hausmann tweeted back from the equally isolated Limousin, 'Pitsu puit puittituttsu uttititi ittitaan ...'.[13]

1
Kurt Schwitters, 'abloesung', *Transition*, no.22, February 1933, p.38–9, quoted in Cassandra (William Connor), 'Keep it Dark', *Daily Mirror*, 30 July 1936, p.12.

2
'Jedenfalls wird man von mir das Anna-Blume-Gedicht hören wollen, und ich würde es nacheinander in Deutsch, Englisch und Französisch vortragen. Sonst könnte ich das Gedicht "Wand" (aus einem Worte), 3 *Zahlengedichte*, wenn Sie mir die holländische Zahlen sagen, und *Lautgedichte* vortragen, die ohne Sinn, ohne Sprache, jedem Holländer verständlich sind. Ddssnnr – Je – M – Mp – Mpf – Mpft – Mpftl – u.s.w.' Kurt Schwitters, letter to Theo van Doesburg, 13 September 1922, Van Doesburg Archive, The Hague, cat. no.185.

3
Christof Spengemann, *Die Wahrheit* über *Anna Blume*, Hanover 1920.

4
The first published translation of 'An Anna Blume' was into Hungarian in the journal *MA* in 1920, which was reprinted together with French and English translations in the second edition of Kurt Schwitters, *Anna Blume. Dichtungen*, Hanover 1922. A Dutch translation was published in *Merz* shortly after the tour of the Netherlands.

5
Gabriele Reuter, 'Literary Teas in Germany', *New York Times*, 5 October 1924.

6
See Iria Candela, '"The only English periodical of the avant-garde": Sidney Hunt and the journal "Ray"', *Burlington Magazine*, vol.152, no.1285, April 2010, pp.239–44 for the most extensive account of this publication.

7
Arthur Lehning, the editor of *i10*, makes mention of a review of the publication in 'an English weekly' (but does not specify which) in his introduction to a 1979 reprint edition, *Internationale Revue, i10, 1927–1929*, Amsterdam 1979, unpag.

8
Interestingly, parts of the *Ursonate* feature in issues of *Transition* that include sections of Joyce's 'Work in Progress', which was to become *Finnegans Wake*. See issue nos. 8 (November 1927), 21 (March 1932) and 22 (February 1933).

9
'Englische Witze sind nicht deutsche Witze. Englische Wortspiele sind nicht deutsche Wortspiele. Die Übersetzung hätte sehr frei zu sein. Und das Publikum hätte sehr verständnisvoll zu sein.' Kurt Schwitters, letter to Edith Tschichold, 10 December 1944 in Kurt Schwitters, *Wir spielen, bi suns der Tod abholt: Briefe aus fünf Jahrzehnten*, Frankfurt and Berlin 1986, p.177–8.

10
Herbert Read, 'Kurt Schwitters', *Paintings and Sculptures by Kurt Schwitters (The Founder of Dadaism and "Merz")*, exh. cat., Modern Art Gallery, London 1944, unpaginated.

11
Stefan Themerson, *Kurt Schwitters in England*, London 1958, p.28.

12
For an overview of the project, see Jasia Reichardt, 'The Story of PIN' in Raoul Hausmann and Kurt Schwitters, *PIN*, London 1962, pp.2–18.

13
Schwitters sent Hausmann his *Obervogelgesang* (Super Bird Song) with a letter of 25 July 1946. Hausmann replied with *Oiseutal* (Birdlike) on 31 July 1946. Both poems were subsequently printed in the edition of *PIN* published by Gabberbochus Press in 1962.

PLATES

P.77

P.129

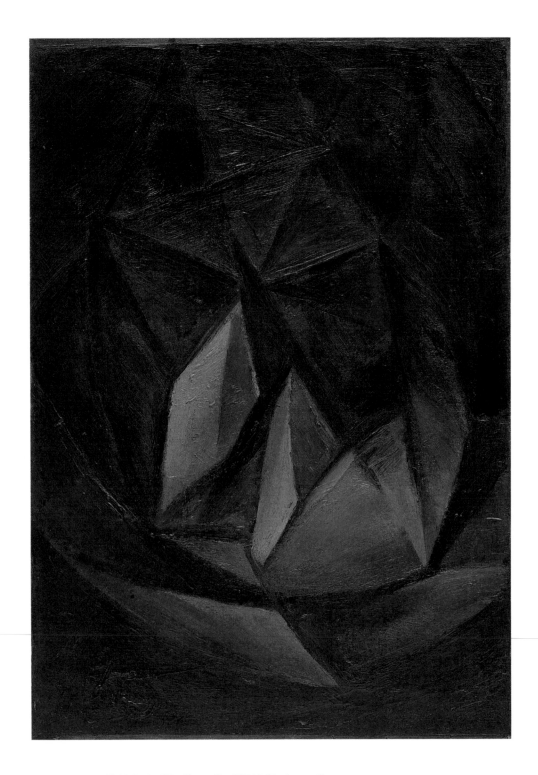

Abstraktion No 16 (Schlafender Kristall)
Abstraction No 16 (Sleeping Crystal)
1918
Oil on canvas
CR:0246

Merzbild 1 A (Der Irrenarzt)
Merzpicture 1 A (The Psychiatrist)
1919
Oil, paper, canvas, cardboard, wood,
wire, metal, coin and cigarette on canvas
CR:0425

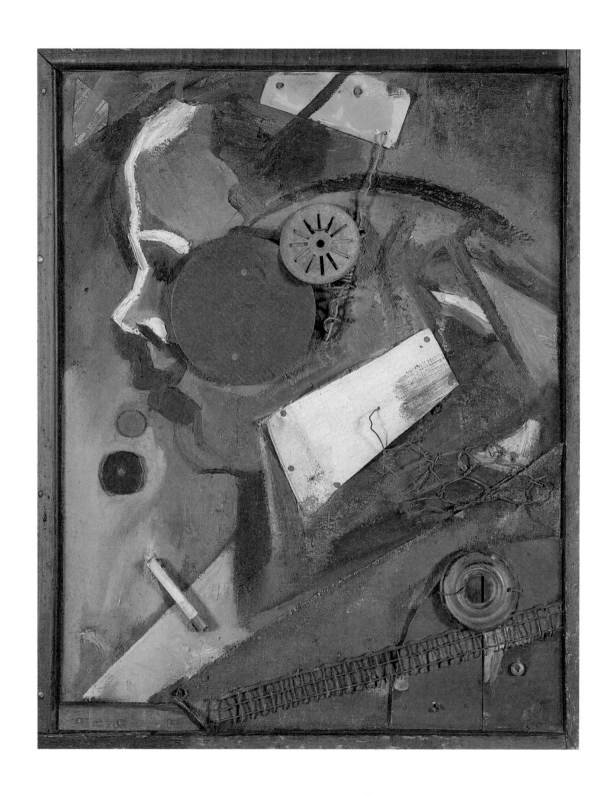

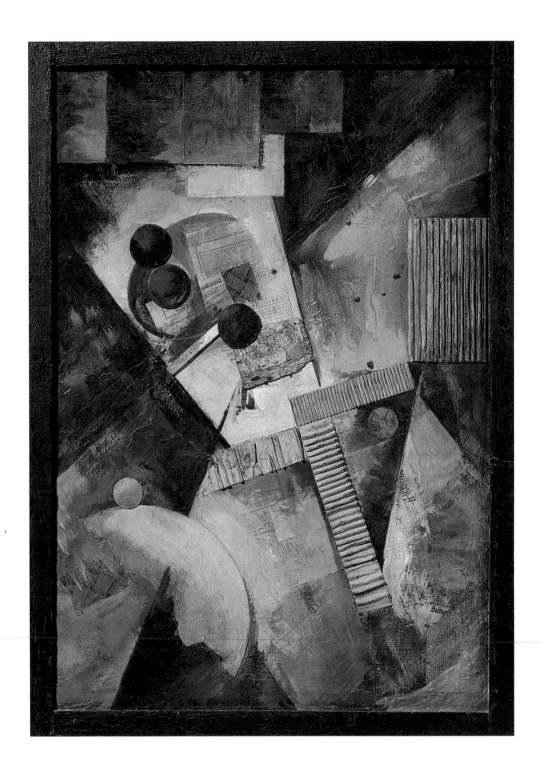

Ja-was?-Bild
Yes-what? Picture
1920
Oil, paper, cardboard and
wood on cardboard
CR:0604

Bild mit Raumgewächsen/Bild mit 2 kleinen Hunden
Picture with Spatial Growths/Picture with 2 Little Dogs
1920, 1939
Oil, paper, cardboard, fabric, wood, hair,
ceramic and metal on cardboard
CR:0614

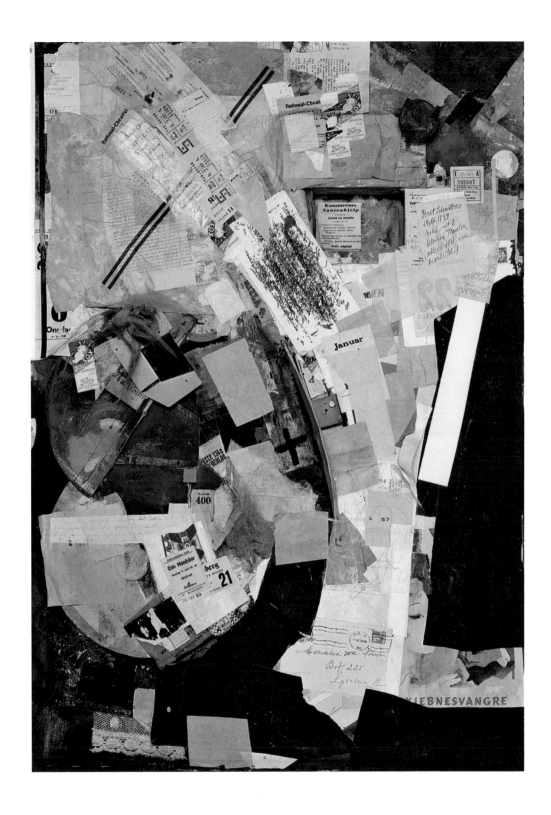

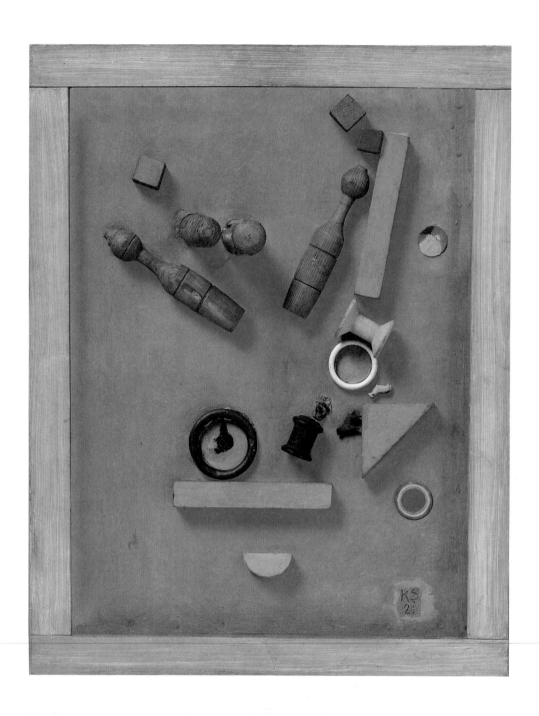

Merzbild 46 A. Das Kegelbild
Merz Picture 46 A. The Skittle Picture
1921
Oil, wood, metal and cardboard
on cardboard
CR:0781

KÖRTINGBILD
THE KÖRTING PICTURE
1932
Oil, wood, tree bark, metal and algae on
canvas
CR:1826

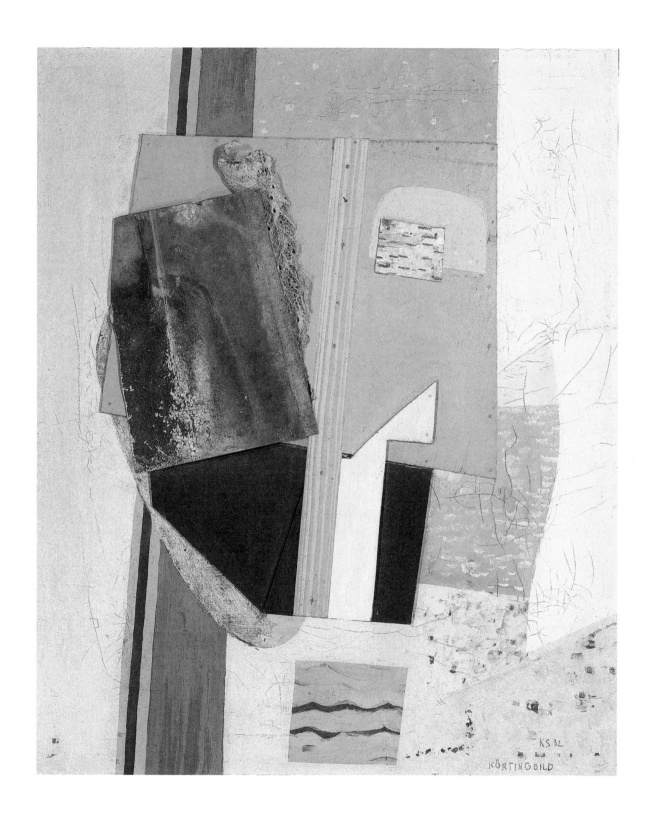

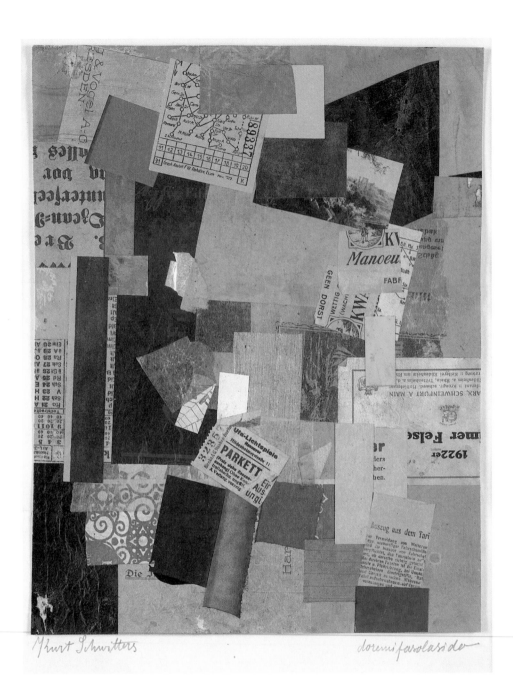

doremifasolasido
c.1930
Paper on paper
CR:1737

Untitled (With an Early Portrait of Kurt Schwitters)
1937–8
Paper and cardboard on cardboard
CR:2262

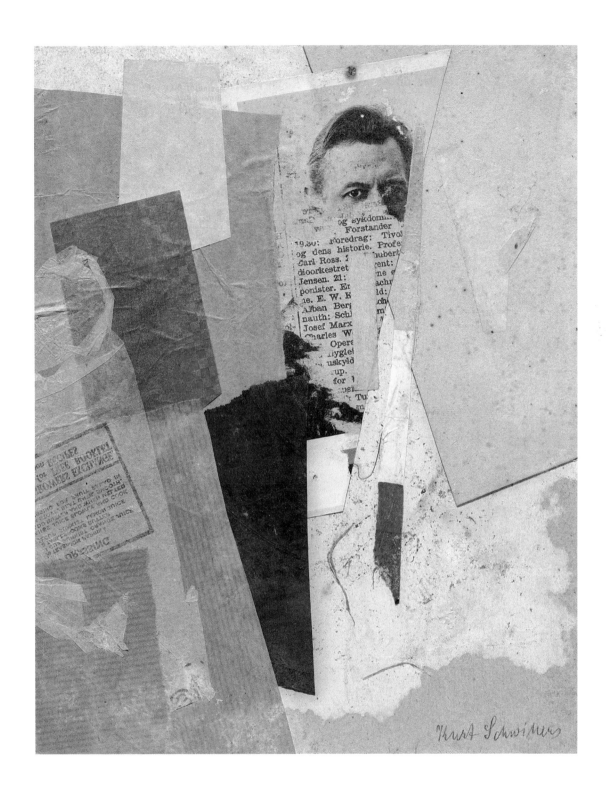

Kurt Schwitters

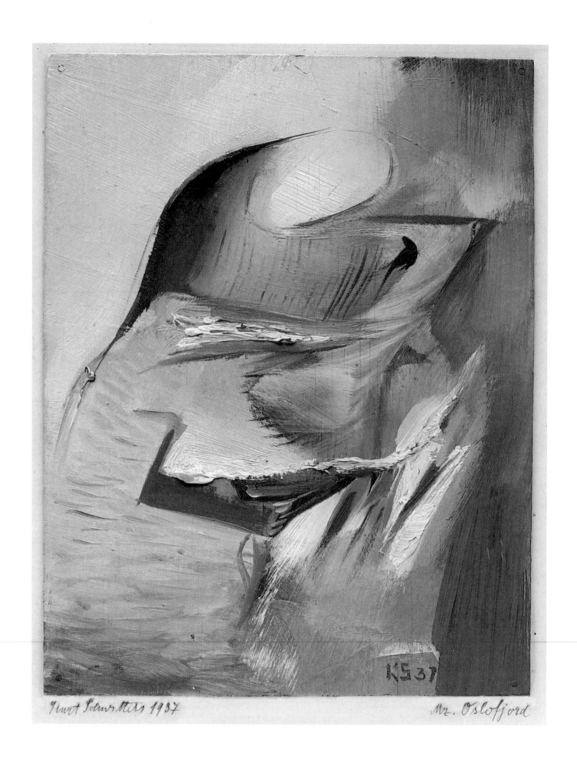

Mz. Oslofjord
Mz. Oslo Fjord
1937
Oil on plywood
CR:2124

Das Gewitterbild.
The Thunder Storm Picture.
1937–9
Oil and wood on plywood
CR:2120

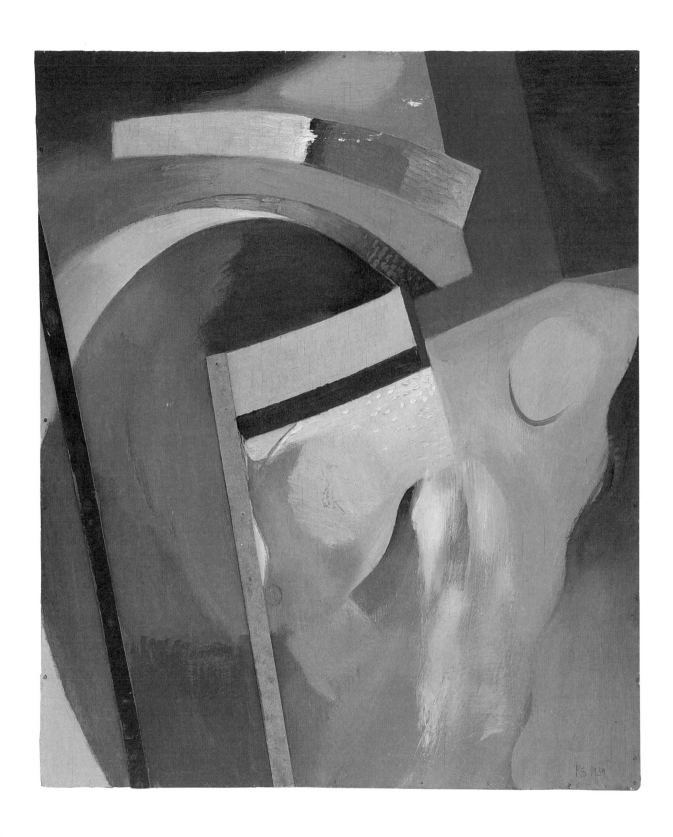

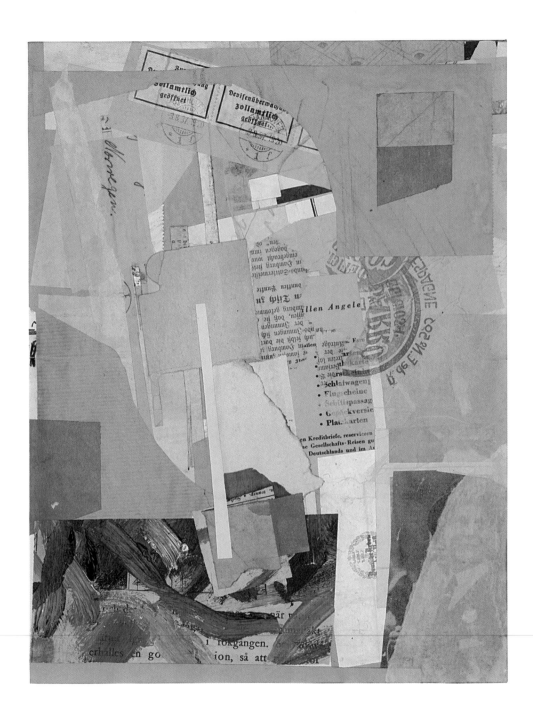

Untitled (Opened by Customs)
1937–8
Paper, greaseproof paper and cardboard
on paper
CR:2267

Phantasie über Dächern
Fantasy on Roofs
1939
Oil, wood, cardboard and metal on wood
CR:2486

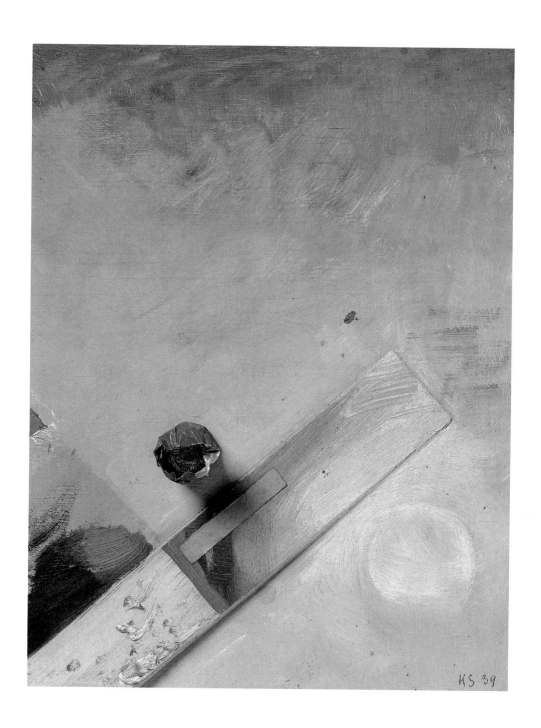

Pink, green, white
1940
Paper on paper
CR:2690

British made
1940–5
Paper, fabric, cellophane, cardboard
and oil on paper
CR:2708

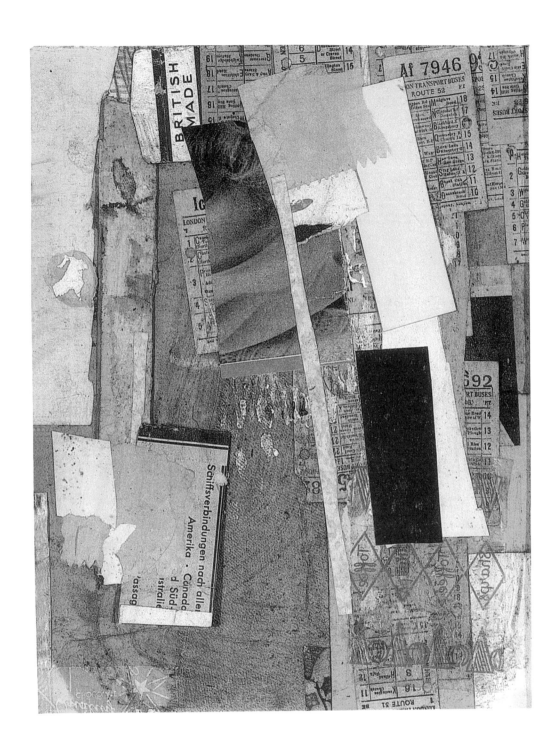

Untitled (The Wounded Hunter)
1941–2
Paper on cardboard
CR:2826

Untitled (This is to Certify that)
1942
Paper on paper
CR:2947

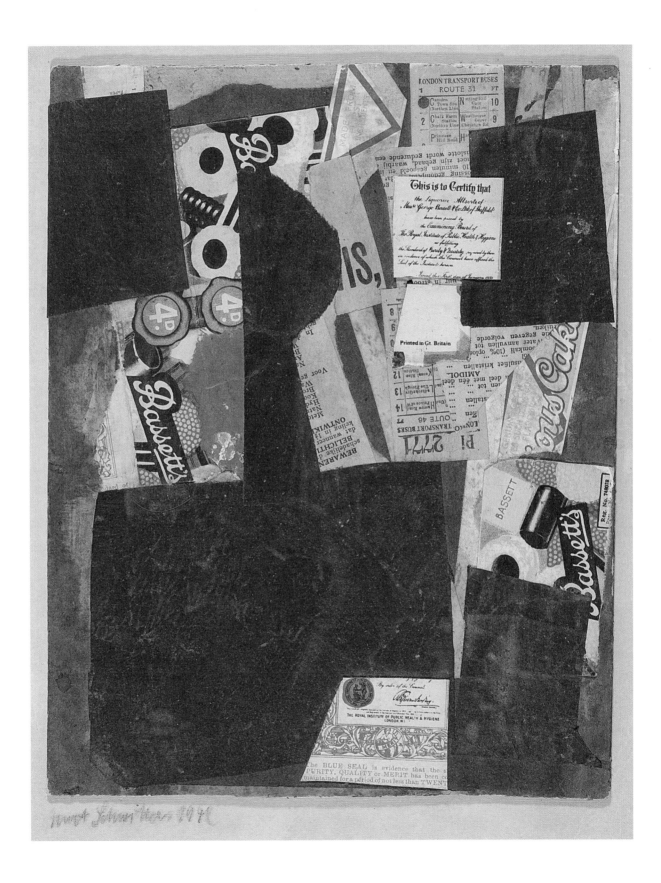

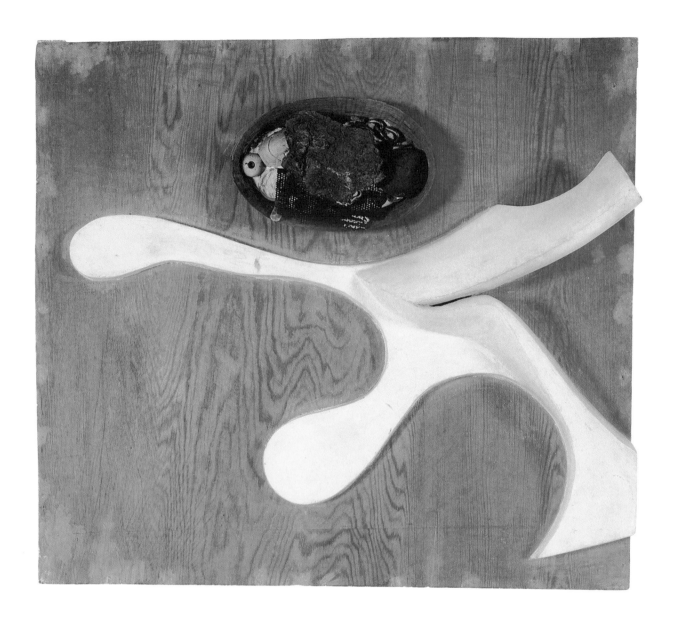

Untitled (The Basket Picture)
1940
Paint, wood, plaster, tree bark, lobster shell,
metal chain, rubber, wicker basket and mixed
material on wood
CR:2625

AERATED V
1941
Oil, wood and ping-pong ball on plywood
CR:2764

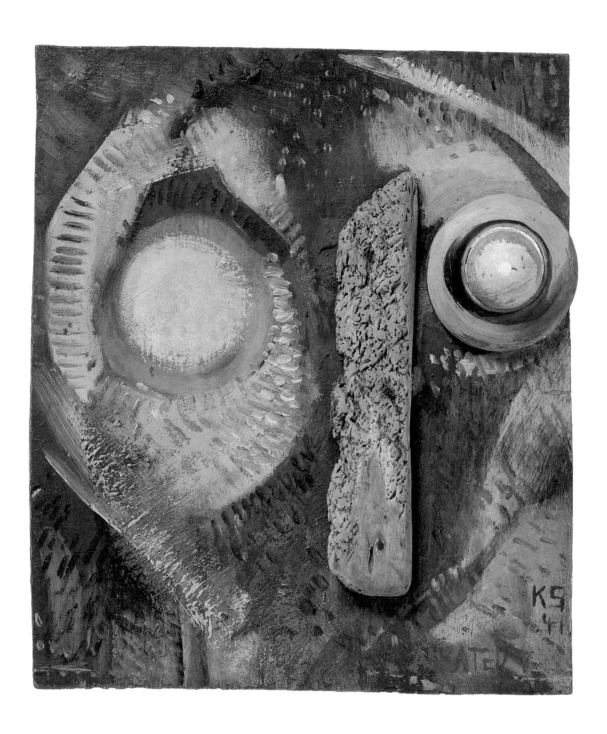

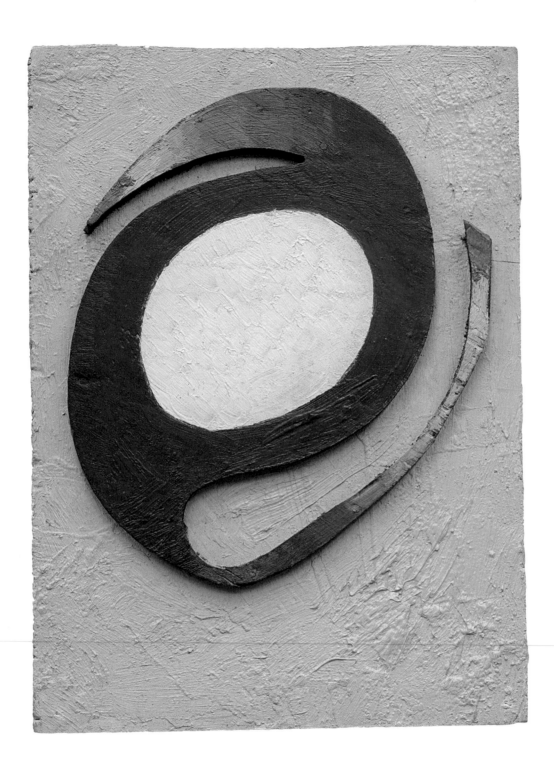

Blue Paragraph
1941–4
Oil and wood on wood
CR:2770

Untitled (White Construction)
1942
Oil and wood on wood
CR:2901

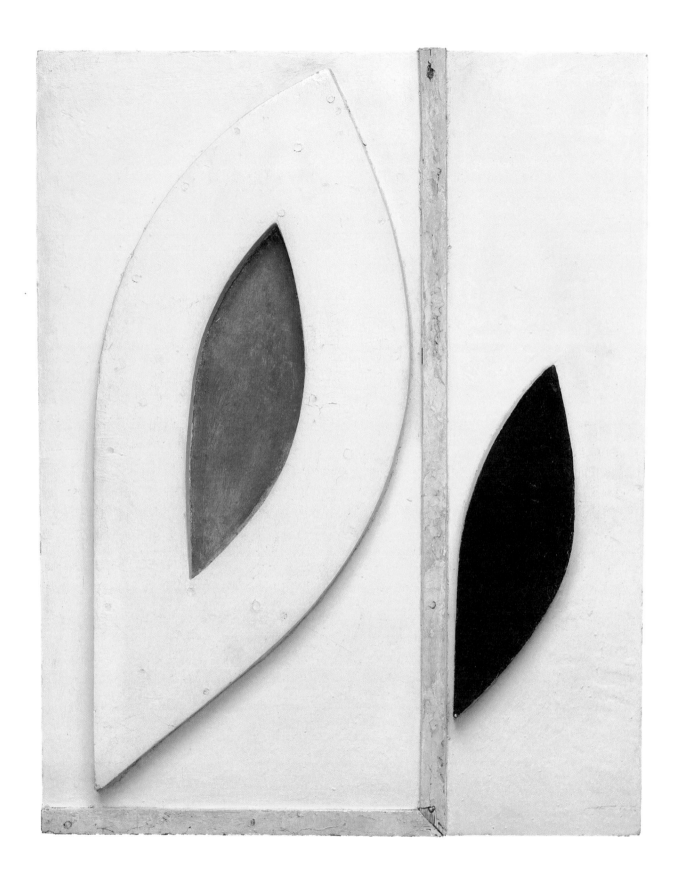

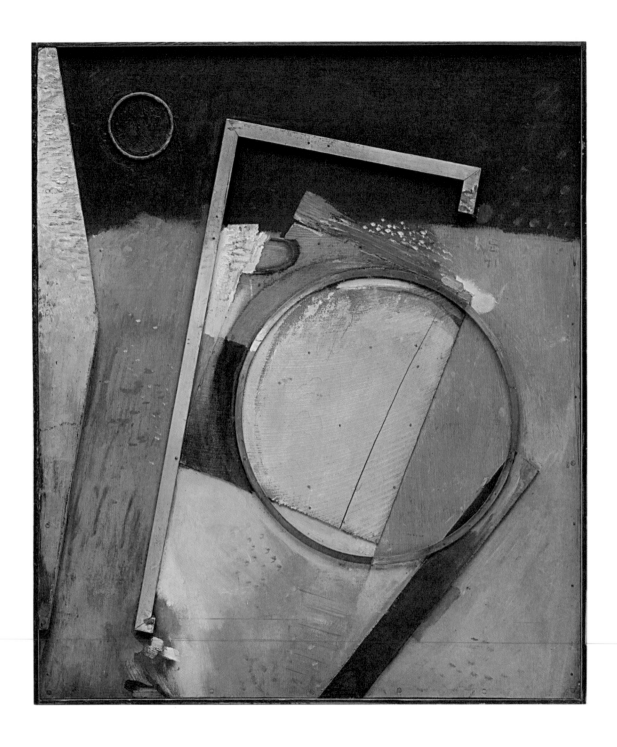

Untitled (Picture with Ring and Frame)
1941
Oil, wood frame and rubber ring on plywood
CR:2760

Untitled (Picture with White Slat)
1943
Oil and wood on canvas
CR:3000

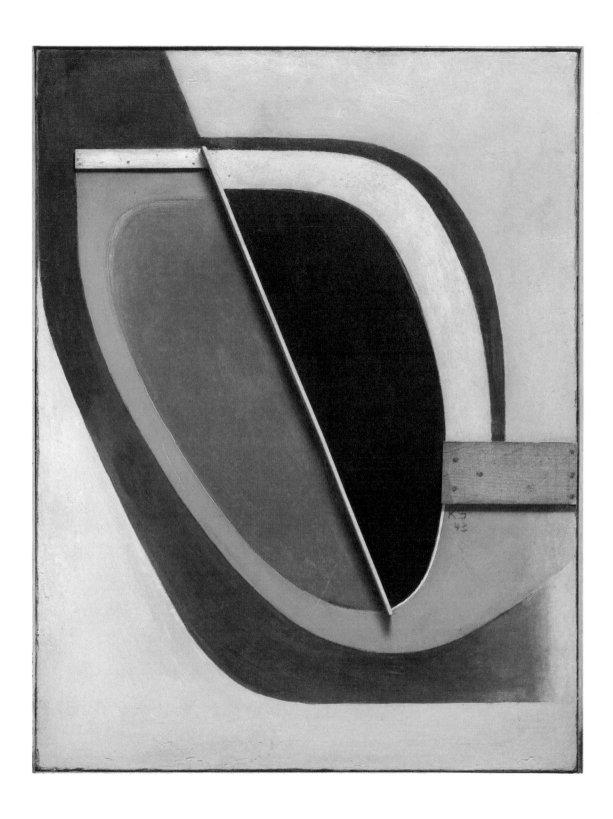

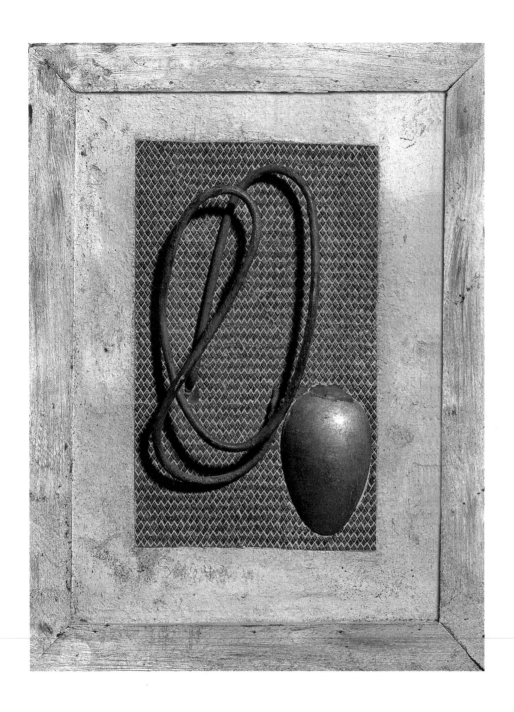

Red wire and half spoon
1942
Oil, wire, metal (spoon fragment) and
plastic on paper on canvas
CR:2893

Untitled (Relief within Relief)
1942–5
Oil and wood on wood
CR:2908

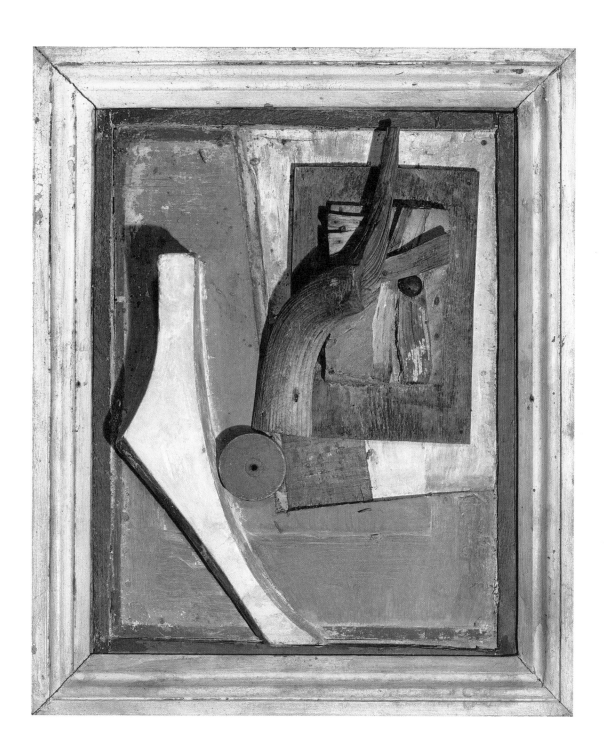

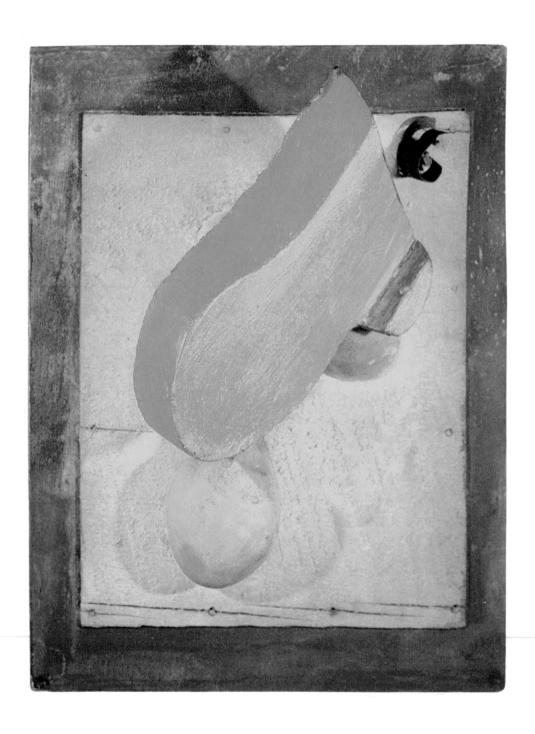

Surrealistic.
1943
Oil, tree bark, wood on metal on wood
CR:3004

Take
1943
Oil, paper, wood, linoleum, fabric,
leather and scrubbing brush on paper
CR:2993

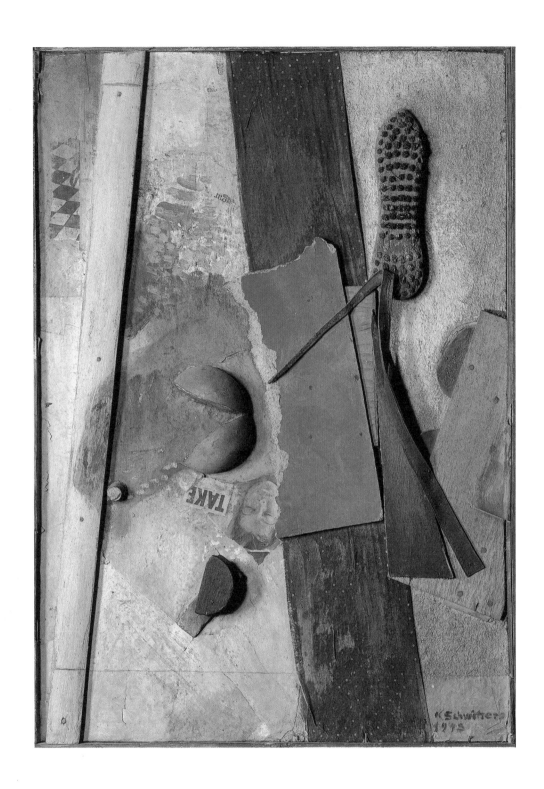

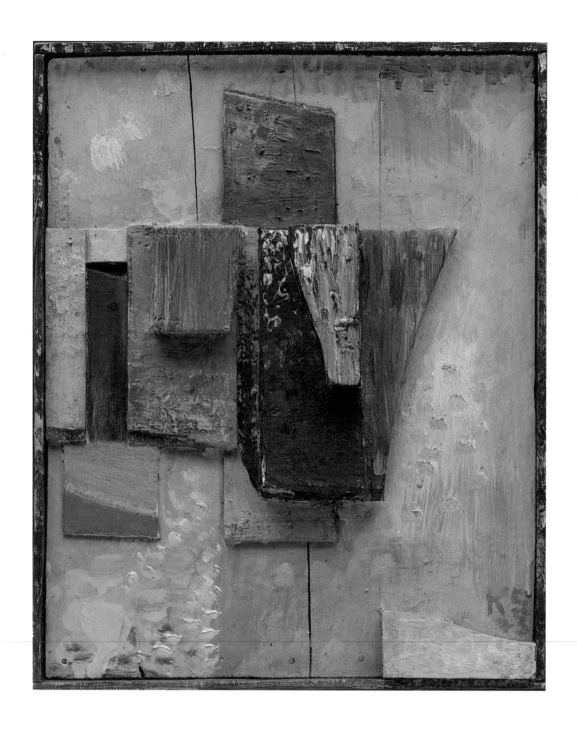

Coloured wood construction
1943
Oil and wood on wood
CR:3003

Anything with a stone
1941–4
Oil, paper, cardboard, wood, stone and plastic
on plywood
CR:2766

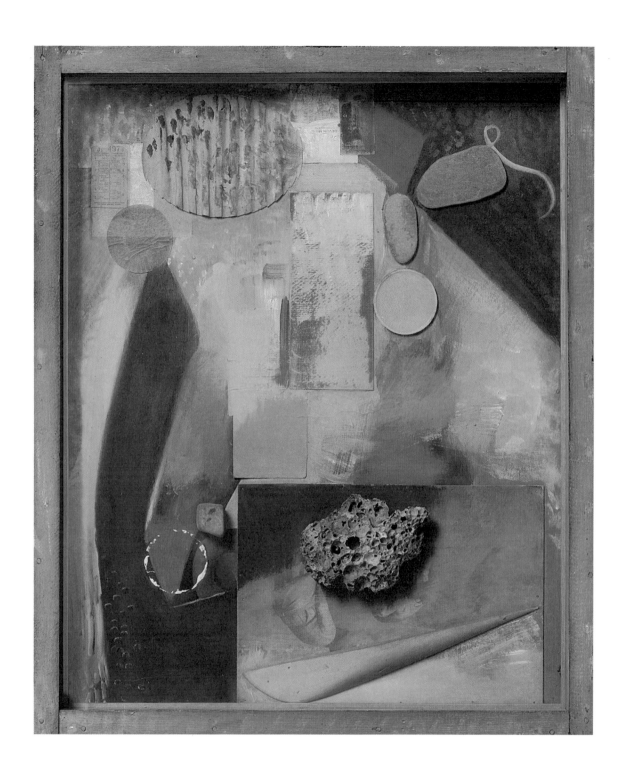

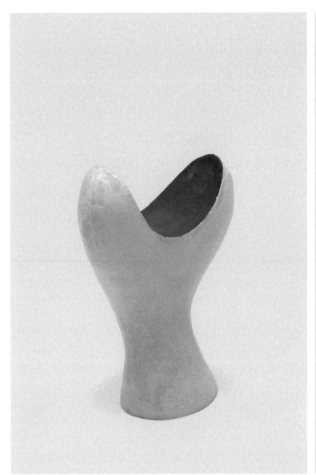 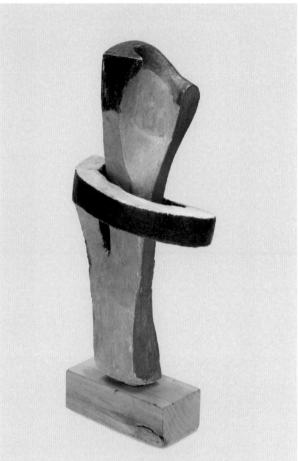

Untitled (Opening Blossom)
1942–5
Plaster, painted
CR:2982

Untitled (The All-Embracing Sculpture)
1942–5
Wood, iron and plaster, painted
CR:2984

Untitled (Elegant Movement)
1942–5
Wood, iron and plaster, painted
CR:2987

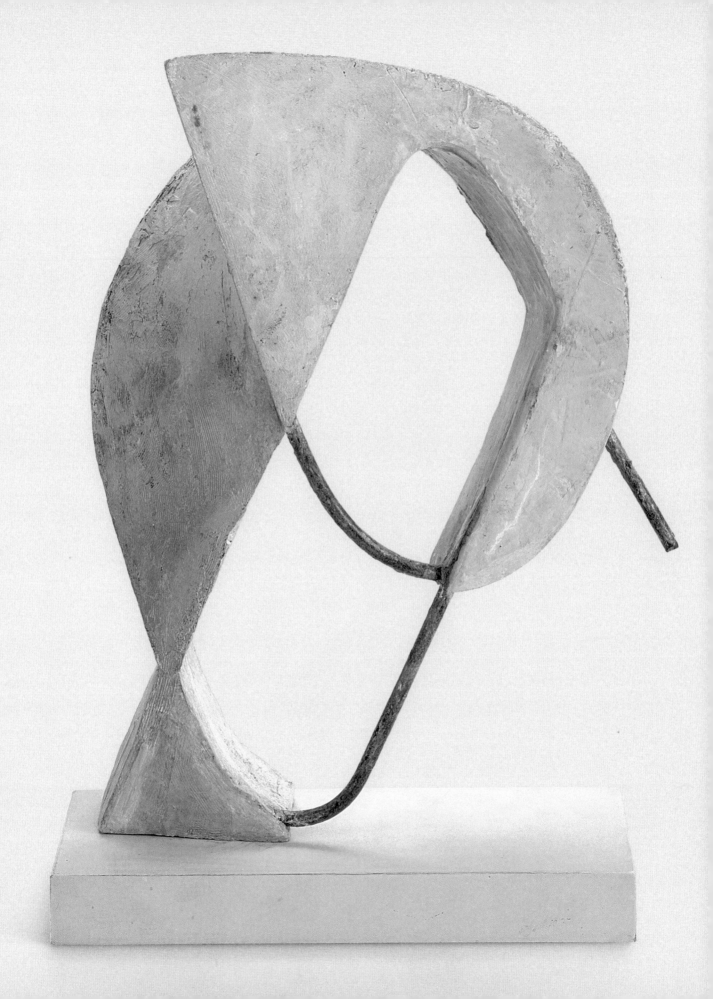

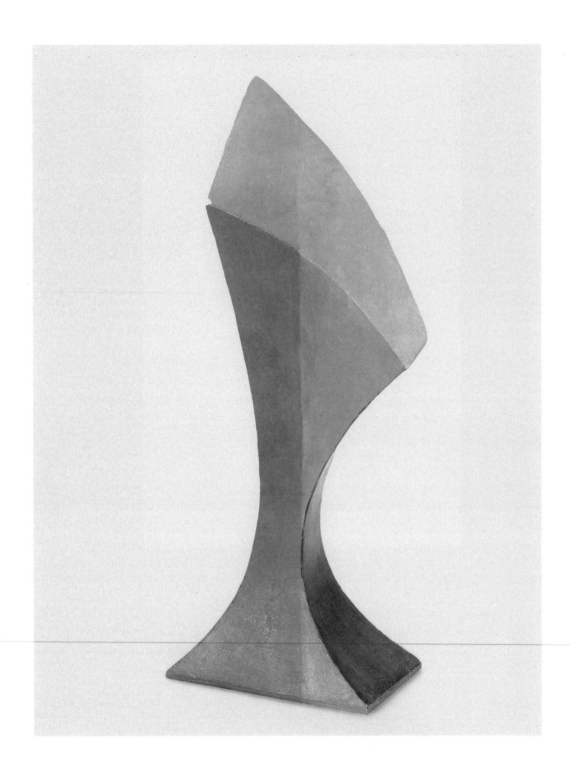

Untitled (Solid Sculpture)
1942–5
Plaster, painted
CR:2981

Speed
1943
Wood and plaster, painted
CR:3049

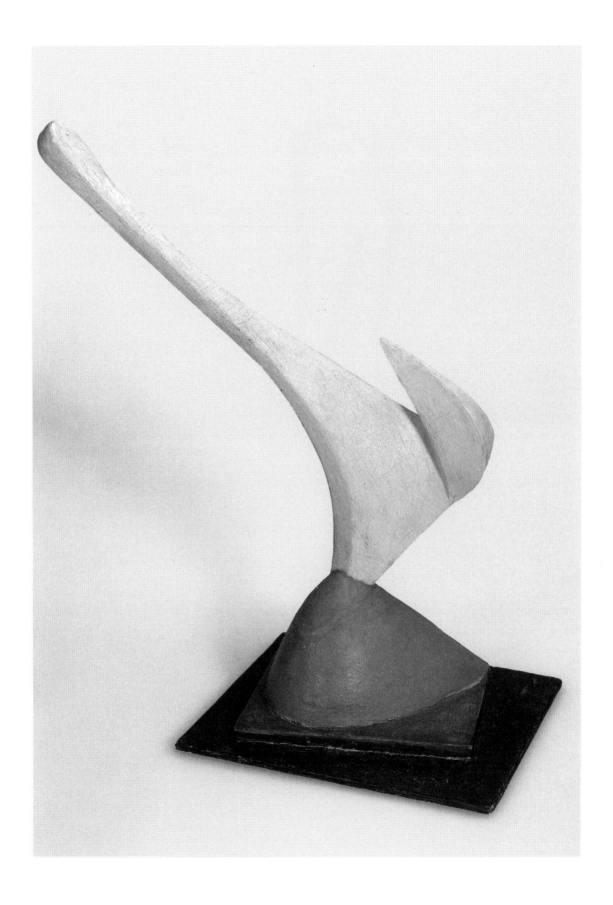

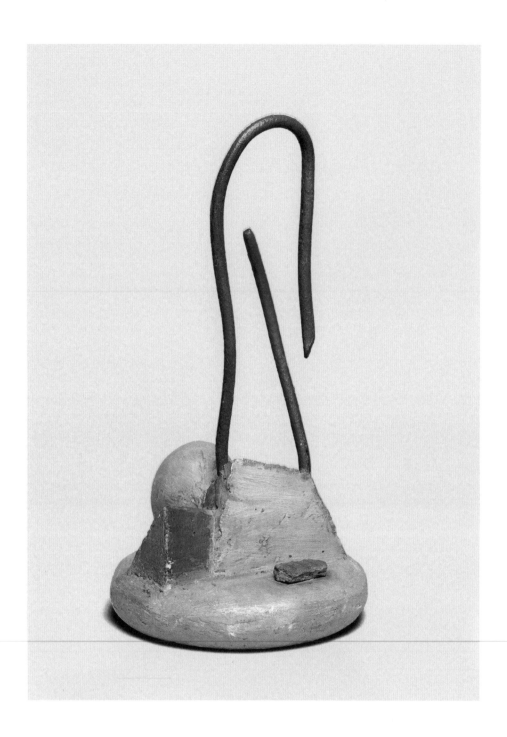

Untitled (Red Wire Sculpture)
1944
Wood, wire, clay, ceramic, stone, dried fruit
and plaster, painted
CR:3132

Untitled (Lofty)
c.1945
Plaster, painted
CR:3242

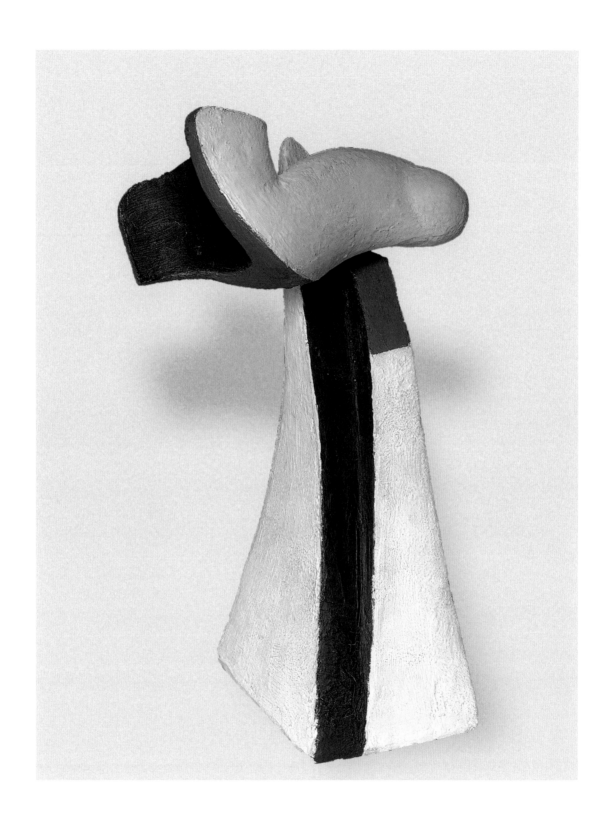

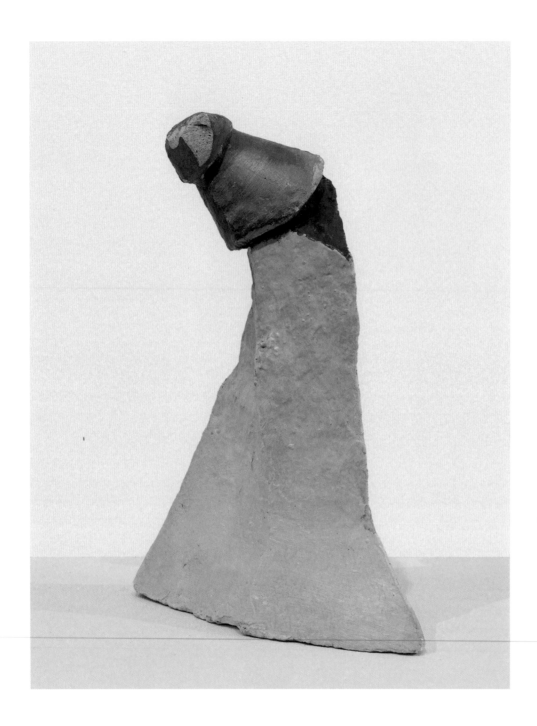

Untitled (The Clown)
1945–7
Plaster and stone, painted
CR:3243

Chicken and Egg, Egg and Chicken
1946
Wood? and plaster, painted
CR:3395

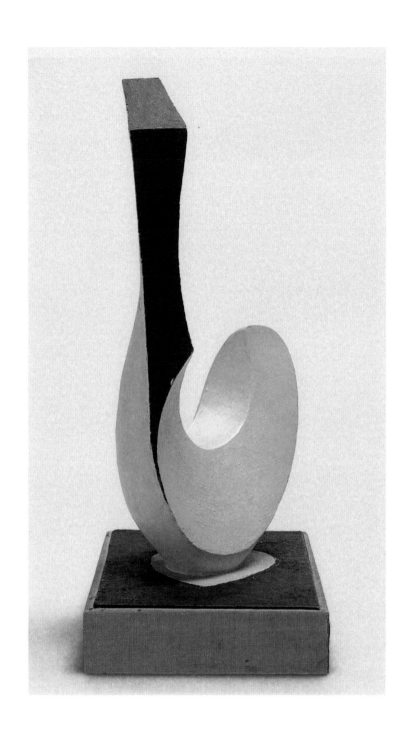

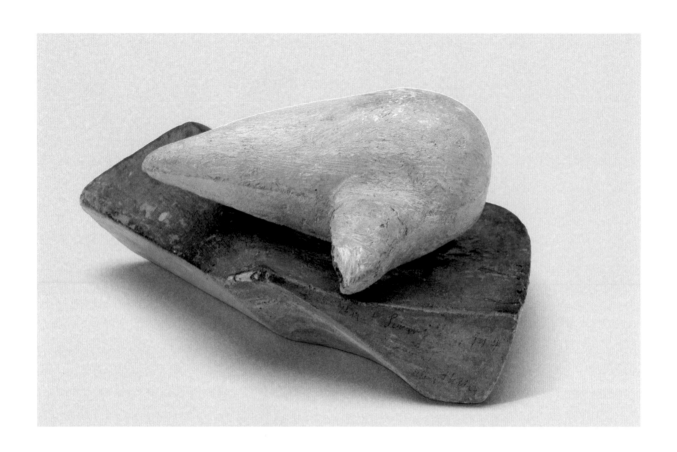

Two forms in rhythm
1947
Wood, stone and plaster, painted
CR:3663

Untitled
(Fragment from the *Merz Barn*, Elterwater 1)
1947
Stone, bamboo and plaster, painted
CR:3660

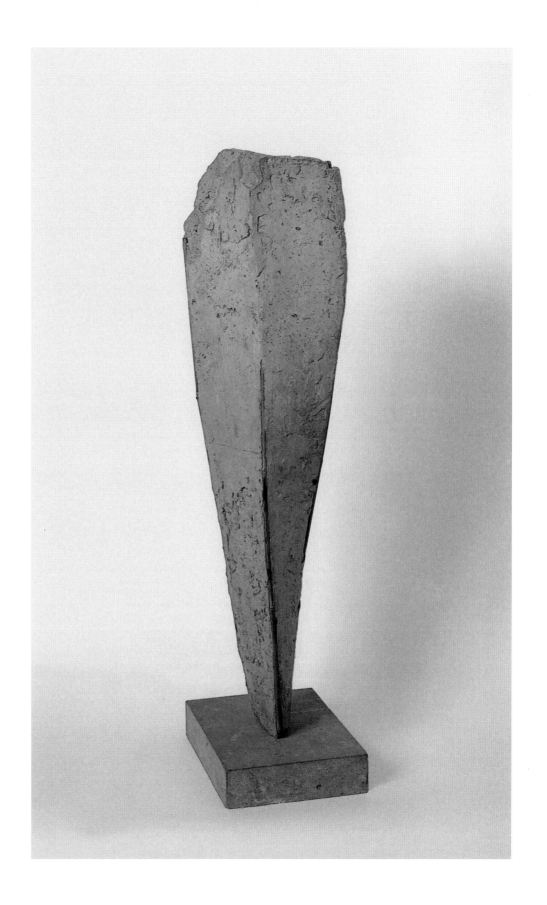

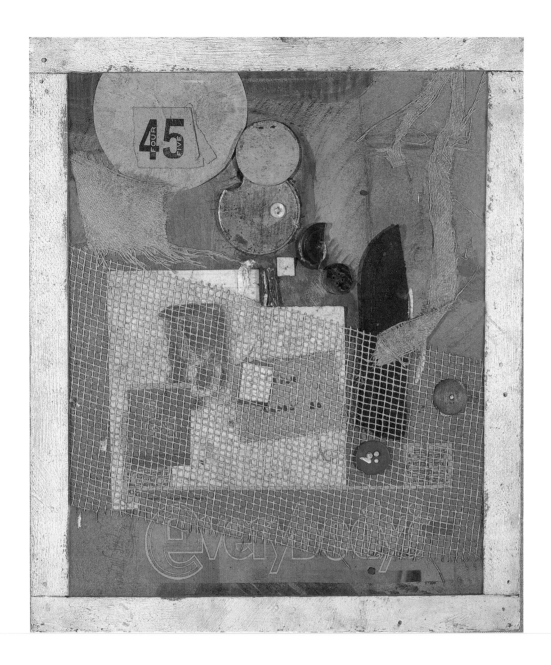

Untitled (Everybody's)
?1945
Oil, fabric, buttons, netting, paper, leather,
plaster, cardboard and metal on cardboard
CR:3134

Untitled (ROSS, with Penny)
1945–7
Feather, plastic foil, coin and
paper on cardboard
CR:3218

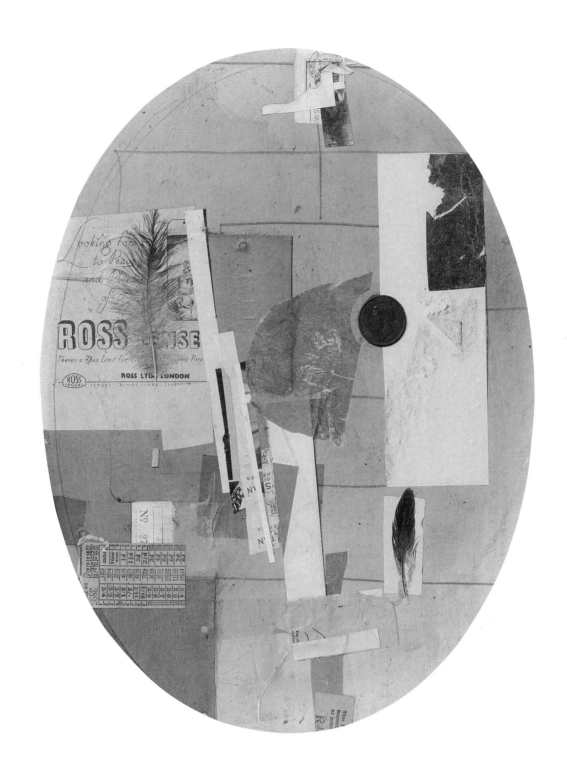

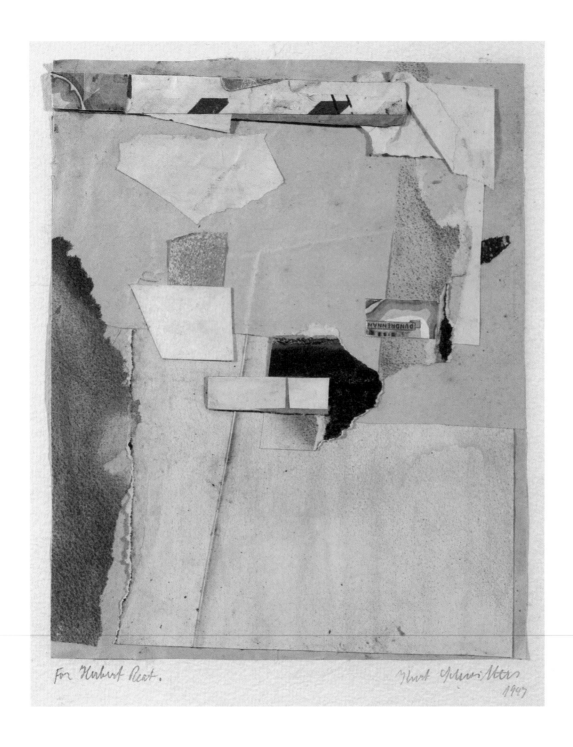

For Herbert Reat.
1947
Paper and cardboard on paper
CR:3486

C 21 John Bull.
1946, 47
Gouache, fabric, paper lace
and paper on paper
CR:3312

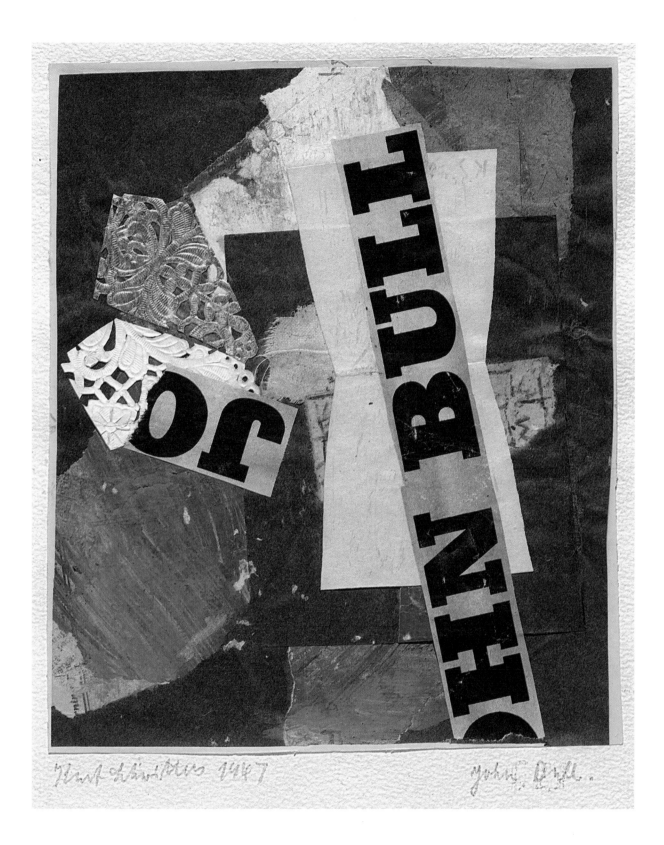

Kurt Schwitters 1947 John Bull.

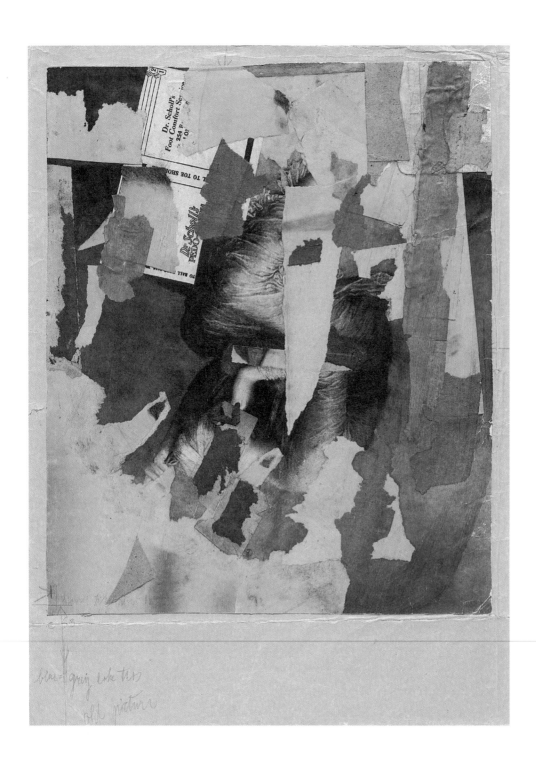

c 63 old picture
1946
Paper on paper
CR:3344

This was before H. R. H.
The Late DUKE OF CLARENCE &
AVONDALE. Now it is a Merz picture. Sorry!
1947
Leather, paper and cardboard on paper
CR:3620

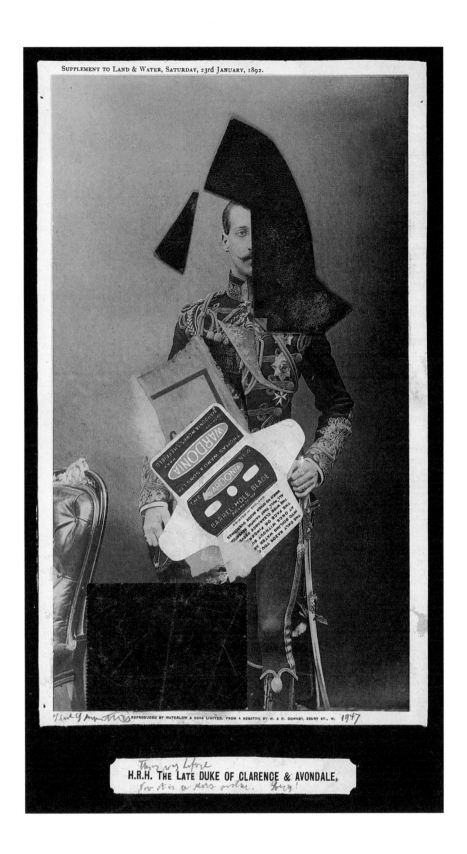

Mz x 20 Big Fight
1947
Paper on paper
CR:3450

47 12 very complicated
1947
Oil, canvas and paper on paper
CR:3461

47 12
very complicated

Kurt
Schwitters 47

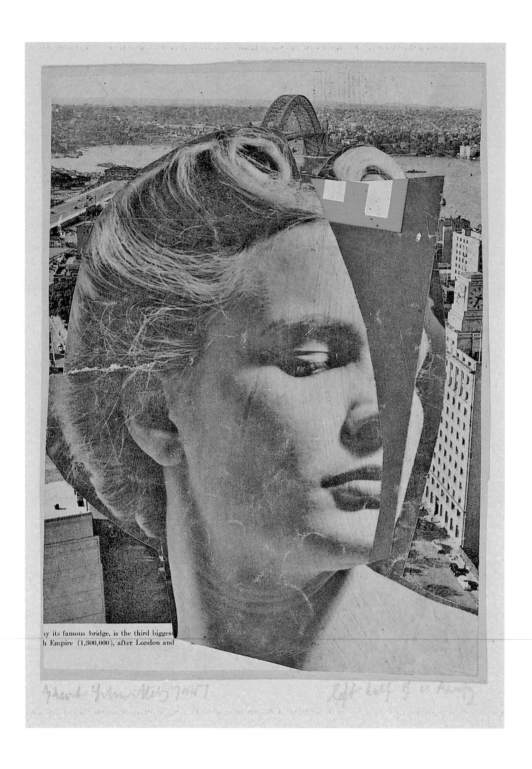

left half of a beauty
1947
Paper on cardboard
CR:3623

EN MORN
1947
Paper aad tracing paper on paper
CR:3624

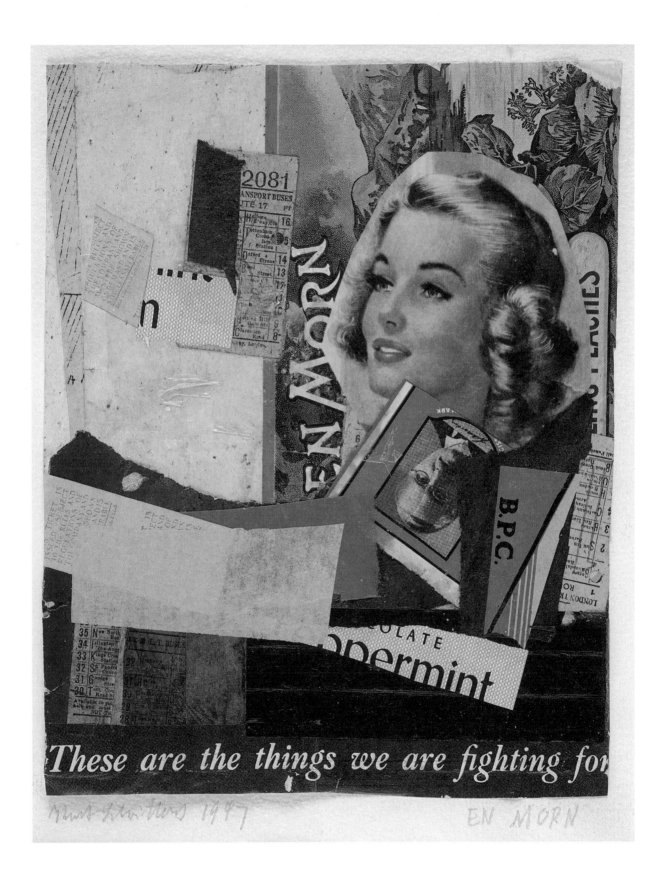

These are the things we are fighting for

Mz x 22 Wantee
1947
Graphite, paper, cardboard and photograph
on paper
CR:3452

Untitled (Portrait of Harry Pierce)
1947
Oil on cardboard
CR:3431

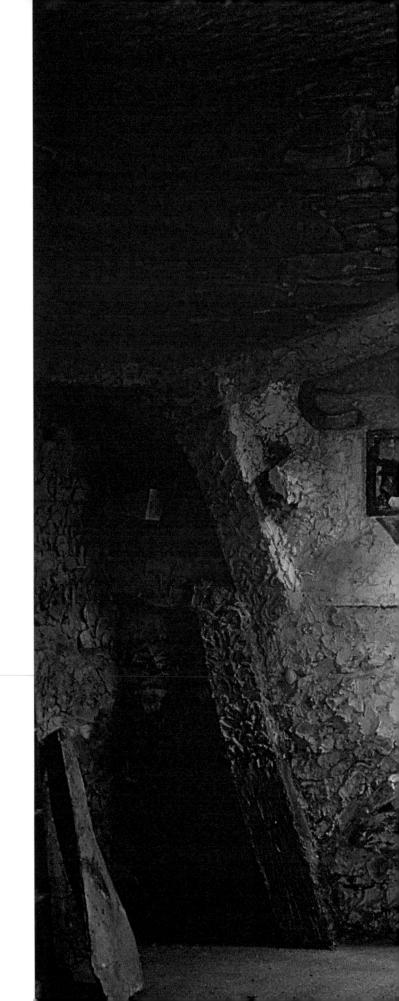

Untitled (Relief Wall from the *Merz Barn*)
1947 [when photographed]
Relief, oil, plaster, wood, branch, root, blossom,
bamboo sticks, stone, ceramics, metal (window
frame), wire, grating, cord, fragment of wheel,
fragment of mirror frame (aureated), porcelain
egg, rubber ball, part of watering can

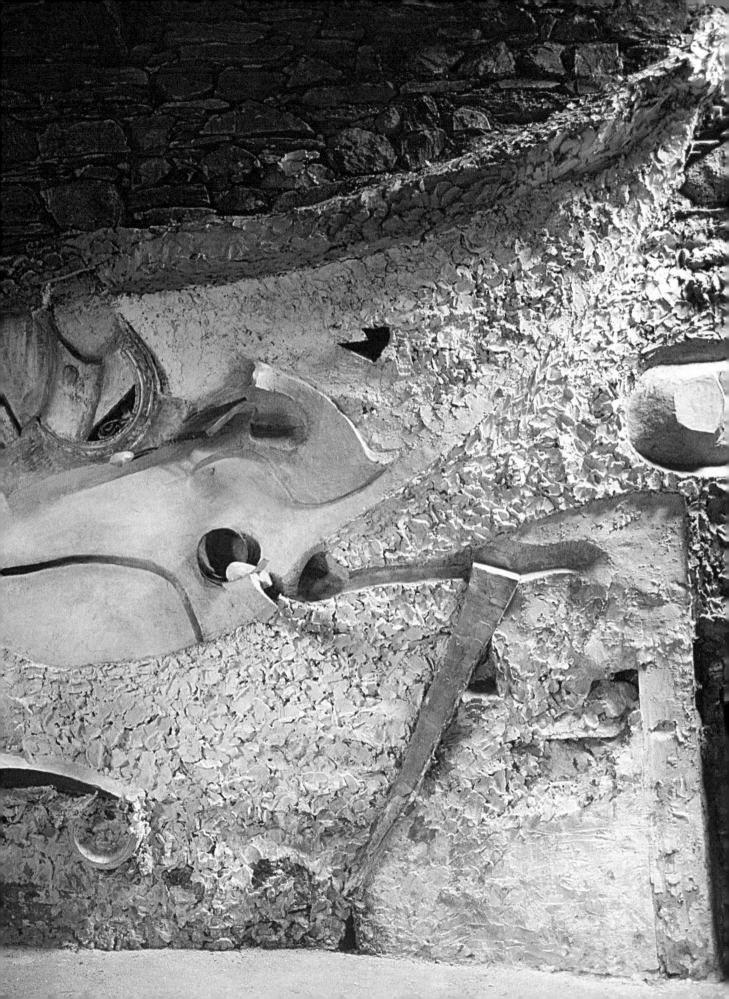

ISABEL SCHULZ

THE

MERZ BARN

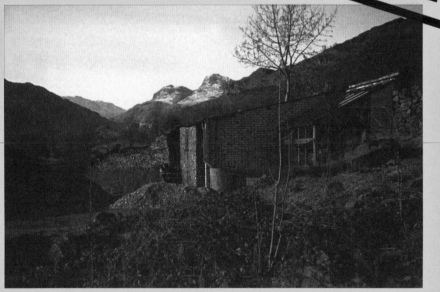

37
Merz Barn, Cylinders farm,
Elterwater, Langdale
1948

The Merz constructions were Kurt Schwitters's work-places and living spaces. He created these proliferating, walk-in sculptures, using whatever was to hand, in a constantly evolving process of forming, and in a series of locations. The private and the public, life and art came together in these complicatedly organic, cavelike spaces. As an exile in Britain during the Second World War, Schwitters learnt that his 'life's work', which he had been constructing in Hanover until the end of 1936, had been destroyed, later learning that the damage was irrevocable. There was also no way at that time of resuming work on its sequel, the *House on the Slope*, which he had started in Norway in 1937 but had had to leave unfinished when he fled from the Nazis yet again in 1940. Schwitters was well aware of the unprecedented nature and historic significance of his work, which is now regarded as a precursor to installation art. With this in mind, in April 1946 he started to search for ways of preventing what he had done in his Merz constructions from being completely lost and forgotten.

Although the American businessman Oliver M. Kaufmann soon offered him support in his efforts to rescue his Merz constructions,[1] it took months – until March 1947 – for Schwitters finally to decide to make a new beginning.[2] This was also when he met the professional landscape gardener Harry Pierce, whose portrait he had been commissioned to paint (p.127).[3] The portrait sittings took place at Cylinders, Pierce's property five miles west of Ambleside, which is not far from Elterwater. For Schwitters, as Pierce later recalled, 'wished to work where I was busy forming a garden on a hillside near my home. Whilst he painted he asked me if I had any old barn where he could start afresh on his abstract work, this being impossible in his lodgings.'[4] On 20 June 1947, on his sixtieth birthday, Schwitters received official confirmation from the Museum of Modern Art, New York, that he had been awarded a fellowship to the value of $1,000,[5] which allowed him to start making concrete plans for his barn (figs.40 and 41); he also drew up a lease agreement of sorts, which was to run for fifty years, ensuring the continued existence of his work beyond his death.[6]

Schwitters's tireless creativity was fuelled by his hope that the *Merz Barn* might make good the losses he had suffered hitherto. Even when his health failed him, he refused to slow down. With the experience he had gained from his two previous Merz projects, he was now determined to create an important work that would outdo what he

had done in the past.[7] On 19 July, not long after he had survived a haemorrhage, he wrote to his son's family describing his plans: 'In this Park he [Pierce] will build for me on a prominent place a small house of 2 rooms, 4 x 4 and 4 x 2 meter. I can build in these rooms a new Merzbau, No 3, with the American Money… And the house would be in a park, what is great for showing it. It would be a Lakeland monument.'[8] He described in glowing terms the barn's wonderful situation in the landscape and made special mention of its closeness to nature.[9] Schwitters had always been close to nature. Now in England, true to form, he had left the city streets of London for the Lake District, yielding to an old, Arcadian longing for a more authentic, holistic life that he hoped would fill him with new energy. In its very simplicity, the barn already communicated a sense of being close to nature. A traditional dry-stone construction in slate (fig.37), it had been built as a hay-barn in 1943 – with an earthen floor and no window panes – on the remains of a magazine for storing gunpowder that had burnt down in 1930. There was neither electricity, lighting nor heating, and sometimes water flowed through the barn.[10] Initially Pierce just added a door and makeshift windows; he planned to put in a cement floor and to plant a grass roof later. Schwitters also asked for a skylight in the roof as an additional light source for the main wall, which he started work on first (fig.38).

At that time Cylinders was certainly not a rural idyll; bearing the scars of its past use, it had run wild and was now the scene of much hard work to turn it into a viable agricultural business and estate. Schwitters felt at ease in these surroundings and appreciated Pierce's skill, which he compared to his own Merz art: 'He lets the weeds grow, but makes it into a composition merely by adding some *small touches*. Exactly like I make art from *rubbish*.'[11] After years of coping with confined spaces at last he now had a place of his own where he could operate on his own terms and store his works and that even promised a degree of publicity for what he was doing.

Despite energetic help from his companion Edith Thomas, from the Pierce family and from their employee Jack Cook, by October Schwitters had to admit that, no longer as strong as he once had been, it would take another three years to fully realise his *Merz Barn*. He reckoned at that point that just a tenth had been completed, and he hoped only to live long enough to finish it.[12] When he died just six months after beginning work on the barn, it was no more than a fragment.

The construction that had been started at the window in the left wall, which is visible in photographs taken by Ernst Schwitters in January 1948 (fig.39), was removed.[13] And the relocation of the relief wall to the Hatton Gallery in Newcastle in 1965 meant that few original traces of Schwitters's work in the barn were left, aside from some plastering on the wall in the entrance area and some nails to which guidelines had been fixed.[14] Today the empty, modest barn is a quiet place of haunting remembrance of the Merz artist and his moving fate as an exile.

How Schwitters's last Merz construction might have grown inwards from the external walls can only partially be imagined because there are so few sources of information on this.[15] Tiny sketches of ground plans by Schwitters himself (figs.40 and 41) show that, bearing in mind the lighting situation in the barn, he planned to partition the space with a clearly drawn diagonal division running from the door at the front left to the skylight at the far right, with a branch leading to the window in the left side wall. In addition to this, there were to be low walls and lowered ceilings with curved shapes and bulges designed to draw the light into the interior. No doubt individual works by Schwitters would have been accommodated on or in these walls. The unfinished construction at the left window gives an impression of how Schwitters, in his customary manner,[16] was already creating acute-angled, spiralling, convoluted forms from intersecting guide lines (wooden laths and planks) connected together by patches of plaster. However, this geometric substructure was destined to largely disappear under the relief-like finish of the walls. In many parts of the barn, the roughly worked, coarse surface of pale-grey decorator's plaster, so reminiscent of the artificial tufa grottos made in the sixteenth century, would have contributed to the 'faerylike' effect of the Merz Barn, as Schwitters put it with a sideways glance to Hans Arp.[17]

In terms of style, the approach and the organic language of forms used in the relief that Schwitters had already started on recall other recent abstract works, such as Untitled (Heavy Relief) 1945 (CR:3148) and the sculpture Untitled (Togetherness) 1945–7 (p.55), which also have a plaster finish and nuanced colouring. There is a characteristic symbiosis here of geometric planes and natural-looking, organic sections, that draws on what Schwitters and other abstract artists had developed in the 1930s as a reaction to the constructivists' purism.[18] Aside from the stylistic difference, Schwitters's approach

to the Merz Barn was fundamentally the same as it had been in his two previous Merz constructions. As before, he still remained true to his Merz principles by which he had lived since 1919 – that is, to create a work 'by selecting, distributing and disforming materials' and by 'constructing new artistic forms from the detritus of past cultures'.[19] As in the hard times he had suffered after the First World War, Schwitters now had only the humblest of means at his disposal, which he worked with basic tools and his own bare hands. Whereas the first Merz construction was above all his way of dealing with the (cultural-) historical impact of urban life in the Weimar Republic and was influenced by both dada and constructivism (albeit not to the exclusion of natural elements), at Cylinders he found inspiration in the landscape of the Great Langdale Valleys and in the circumstances of the barn itself. The rough stonework led Schwitters to develop a new mode of construction: in the spaces between the stones, he lodged elements that now boldly reached out, up to seventy centimetres, into the space; he painted hollows so that they now became striking colour accents and framed niches so that they could be filled with small assemblages. Found objects from his rural surroundings, such as a piece of a cartwheel or a section of water pipe, were integrated, now as artistic forms, into a rhythmically vibrant, three-dimensional composition whose angular braces and 'modellised' arcs reached up towards the light. Schwitters even added some highly perishable gentians to his relief.[20] Besides being an allusion to the 'blue flower' of German romanticism, that symbol of longing for the unattainable, these also continued the old 'Merzblümchen' tradition[21] and reinforced the Merz Barn's many connections to the preceding Merz constructions, which were always present in Schwitters's thinking and doing.

To this day the 'spirit of Merz' still creates an imaginary bond between the many parts of Schwitters's Merz constructions – in different places, partially destroyed, never finished or separated from each other. And although Schwitters never managed to realise his plans for a 'Lakeland monument', in the context of our present awareness of his lifelong Merz project, the Merz Barn arouses more than merely 'the same kind of wonder as a natural curiosity does',[22] for it allows us at least to imagine what might have become one of the greatest and most exceptional examples of biomorphic abstract sculpture in European modernism after the Second World War.

Translated by Fiona Elliott

1

See letter from Oliver Kaufmann, Pittsburgh, to Kurt Schwitters, on 25 June 1946, Kurt und Ernst Schwitters Stiftung at the Kurt Schwitters Archive, Sprengel Museum Hannover (hereafter KESS). Kaufmann had previously already supported Schwitters's attempt, in March 1941, to take up residence in the United States. He delegated the relevant financial transactions to his nephew Edgar, a curator at the Museum of Modern Art, New York.

2

See letter to Ernst Schwitters, 7 March 1947, KESS.

3

Fred Brookes describes Pierce as 'an educated and cultured man, and, though he had no previous knowledge of modern art, he was very impressed by Schwitters's painting and was one of the few people who, during this period, took Schwitters's abstract work seriously.' V.J. Brookes, 'Schwitters in Exile: The Rural Art of Kurt Schwitters 1937–1948', unpublished PhD thesis, Newcastle University 1967, p.23.

4

Harry Pierce, 'Kurt Schwitters', in *Prospects*, October, Lancaster 1965, p.15.

5

See letters from Margaret Miller to Kurt Schwitters on 16 June 1947 and 25 June 1947, both KESS.

6

See 'Suggestions for the agreement Pierce', reproduced in *Kurt Schwitters in Exile: The Late Work 1937–1948*, exh. cat., Marlborough Fine Art, London 1981, p.57, and 'An agreement between Harry Pierce …', Tate Archive TGA 9510.3-1 No. 2–3. Neither of these documents is signed. It is not clear whether there was ever a valid agreement. In a letter to Marguerite Hagenbach, of 23 Ocotebr 1947, Schwitters writes that Pierce put the barn at his disposal 'without recompense', in *Kurt Schwitters: Wir spielen, bis uns der Tod abholt. Briefe aus fünf Jahrzehnten*, ed. Ernst Nündel, Frankfurt (Main)/ Berlin/Vienna 1974, p.286.

7

See letter to Ernst and Eve Schwitters, 28 September 1947, KESS, and letter to Katherine S. Dreier, 6 October 1947, in Nündel 1974 (see note 6), pp.291–2.

8

Letter to Ernst, Eve and Bengt Schwitters, 19 July 1947, KESS. The exact dimensions of the barn are main space: c.4.7 x 4.7m; roof height: 2.5 to 3.5m.

9

See letter to Carola Giedion-Welcker, 19 August 1947, in Carola Giedion-Welcker, *Schriften 1926–1971: Stationen zu einem Zeitbild*, ed. Reinhold Hohl, Cologne 1973, p.506; letter to Marguerite Hagenbach, 23 October 1947, in Nündel 1974 (see note 6), p.286; letter to Ernst and Eve Schwitters, 28 September 1947, KESS.

10

'Vor einer Woche entsprang ein grosser Fluss aus dem Fussboden. Ein neues Hindernis.' ['A week ago a large river burst out of the floor. A new obstacle.'], letter to Ernst Schwitters, 29 November 1947, in Nündel 1974 (see note 6), p.296.

11

Letter from Kurt Schwitters to Carola Giedion-Welcker, 19 August 1947, in Carola Giedion-Welcker, *Schriften 1926–1971* (see note 9), p.506 [translator's note: the words set in italics here are Schwitters's own, i.e. his original German letter included some words in English]. For more on Pierce's concept, see his notes 'Cylinders Farm, Elterwater, Ambleside, Cumbria. An Experiment', unpublished typescript, c.1952, reordered and with additions by Celia Larner, Littoral Trust, Ramsbottom, c.2008, above all p.12.

12

See letter to Eve Schwitters, 15 October 1947, KESS; letter to Katherine S. Dreier, 6 October 1947, in Nündel 1974 (see note 6), p.291; letter to Marguerite Hagenbach, 23 October 1947, ibid., p.286.

13

As many photographs show, two parts of this broken-off form were placed on the floor to the left of the relief wall. These later became 'independent sculptures'; see *Kurt Schwitters Catalogue Raisonée*, CR:3660 and CR:3661.

14

There is still a horseshoe above the entrance. The fragment of relief on the right-hand wall, where it adjoins the wall opposite the door, was not made by Schwitters; see Harry Pierce, *The Abstract Art of Kurt Schwitters: The Story of the Merzbarn*, private press, Elterwater 1948, unpaginated. There was another relief (now lost), which must have been to the right of the side window. A reproduction of this was only recently discovered in the Hatton Gallery by Robert Airey.

15

The reconstruction drawings in Brookes 1967 (see note 3) in John Elderfield, 'Kurt Schwitters' Last Merzbau', in *Artforum*, October 1969, p.56, and in Elderfield, *Kurt Schwitters*, New York/ London 1985, fig.317, convey an impression of this, although certain details are clearly no longer correct.

16

See Schwitters's description of the Merz construction in Hanover in 'Ich und meine Ziele', in *Kurt Schwitters: Das literarische Werk*, ed. Friedhelm Lach, vol.5, Cologne 1973, p.344.

17

See letter to Marguerite Hagenbach, 23 October 1947, in Nündel 1974 (see note 6), p.286. [Translator's note: Arp used the word *'feeenhaft'*, with three 'e's instead of two, to make it particularly fanciful, perhaps.]

18

See, for instance, the images of works by various artists that were published between 1932 and 1936 in the Parisian journal *Abstraction, Création, Art non-figuratif*, and particularly the vocabularies of forms developed by the sculptors Hans Arp and Henry Moore.

19

Lach, vol.5 (see note 16), pp.37 and 241. [Translator's note: 'disforming' is used here to translate Schwitters's non-conventional use of *Entformung*, meaning to change but not to 'deform' the shapes of things.]

20

'I remember him coming into the barn one day and there fixing two or three gentians he had picked on his rambles.' Pierce 1965 (see note 4), p.17.

21

See Schwitters, 'Veilchen', in Lach, vol.5 (see note 16), p.349. In a letter to Eve Schwitters in Lysaker, 5 May 1947, Schwitters asks her to send 'one blue flower from my studio … because these Merzblümchen [little Merz flowers] dont exist in England.' KESS.

22

Elderfield 1985 (see note 15), p.223.

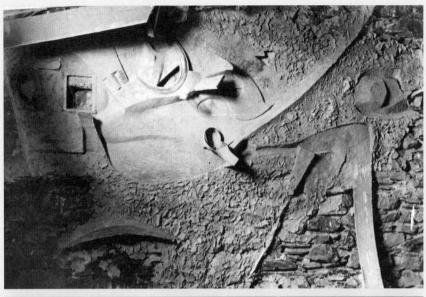

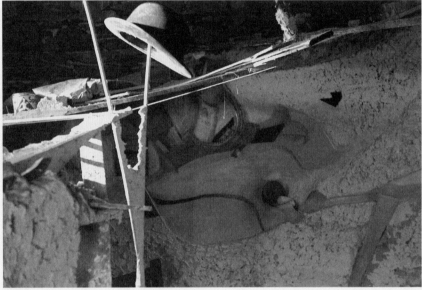

38

Earliest photograph of the relief in the
Merz Barn, September – December 1947
Photograph, Nick Wadley collection

39

Interior of the *Merz Barn*, January 1948;
photograph by Ernst Schwitters

Schwitters's sketch of a floor plan for
the *Merz Barn*, 1947

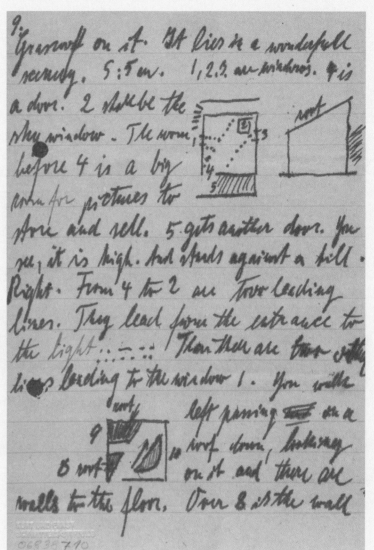

Schwitters's sketches and descriptions of
the *Merz Barn* (Letter in English to Ernst and
Lola Schwitters, Ambleside, 28 September
1947): '1, 2. 3. are windows. 4 is a door. 2
shall be the sky window. The room before 4
is a big room for pictures to store and sell.
5 gets another door. You see, it is high. And
stands against a hill – Right. From 4 to 2 are
two leading lines. They lead from the entrance
to the light - - - Then there are two other lines
leading to the window 1 . You walk left passing
on a roof down, looking on it and there are
walls to the floor. Over 8 is the wall [next
page] to be decorated. 10 is also a roof, and
there are walls to the ceiling. You can walk
under this roof.'

SCHWITTERS'S

LEGACY IN THE LAKE DISTRICT

42
**Schwitters with Edith
Thomas and Bill Pierce at
Cylinders farm, Ambleside**
c.1947

INTRODUCTION

In late 2011, Grizedale Arts, a residency-based curatorial organisation situated at Lawson Park in rural Cumbria, and Tate Britain invited artists Adam Chodzko and Laure Prouvost to develop new work in response to the history and legacy of Kurt Schwitters's time in the Lake District. They conceived projects that have evolved over time, through close collaboration with these two institutions with very distinct remits and contexts. On one level the commissions can be described as specific responses to the locality and history of Schwitters's incomplete *Merz Barn* near Ambleside, but they also reflect upon wider concerns, such as the role and perception of an artist within society. The artists share an interest in how memories and factual narratives about a historical figure can shift and be revised across time and through circumstance. Prouvost conceived the idea of creating the 'muddy living room' of her fictional grandfather, who is a conceptual artist and turns out to be one of Schwitters's close friends. Once constructed at Lawson Park, it will become the setting for both a tearoom and a new video work that will be presented at Tate Britain. Chodzko is interested in the international context within which Schwitters was operating during this period, in particular the individuals and institutions he was in contact with while living in the Lake District. This set of connections led Chodzko to an office designed by the American architect Frank Lloyd Wright in 1937 for Kaufmann's department store in Pittsburgh, which had been commissioned and then donated to the V&A by the same businessman, Edgar J. Kaufmann, who had arranged the grant of $1000 that MoMA wired to Schwitters while he was living in poverty in Ambleside. The office will be reconfigured at Tate Britain, and will house a new video work by Chodzko.

The following interview reflects some of the questions and discussions that have taken place during the realisation of the project. It has been edited from email correspondence between Adam Chodzko (**AC**); Laure Prouvost (**LP**); Alistair Hudson, deputy director of Grizedale Arts (**AH**); Katharine Stout, curator of contemporary art at Tate Britain (**KS**).

KS These two projects share common ground in that they both consider the fragmented accounts that relate to Kurt Schwitters and the time he spent in the Lake District, but they approach the subject from very different directions. Laure's work presents a more inward-looking personal narrative and how this can be distorted and reinterpreted by different people at different times. Adam's is attempting to capture the sense of a psychological vortex spinning outwards, from the *Merz Barn*, out of the Lake District and across the Atlantic to MoMA in New York (taking in Tate along the way).

LP You mention the more personal angle I have taken. I have wanted to draw upon the side of Kurt that up to now has been thought to be less interesting. I am intrigued by the way he painted quite conventional portraits throughout his career, and how this side of his practice has been ignored by the art world. What were the circumstances that made him do them? For sure they were financial, but he must have also enjoyed making these works. Or was he responding to a certain audience's demand, especially since he was in the Lake District and struggling financially. What different needs was he fulfilling when doing these paintings for people and for money?

His portraits and landscapes were ignored for many years or erased altogether. What interests me is how the artist can control so little the way his work will be perceived, how the work will change with time and place. I have also been thinking about the idea of displacement and how the past gets reinvented constantly – for example, the fact that the *Merz Barn* was 'saved' has reinvented Schwitters's work because it is now exhibited completely out of context. Related to this is the idea of what is considered art, and how that changes with time. I wanted to work on the notion of not belonging, of not fitting in a group ... of not being accepted – of the work not being 'right'. I am also interested to draw here on the romantic idea of the artist, struggling, being an outsider.

I have also been looking into his personal life. He called his girlfriend of the time 'Wantee', a nickname he gave her as she kept asking if he wanted some tea. I have explored his relationship with her, and confused the history linking Wantee to my conceptual grandfather – who would possibly have been friends with both of them, as perhaps was also my grandma – in an exchange between fiction and reality.

AC I see the 'vortex' you describe as something that emerges and expands from a certain kind of looking, from my researching details, exploring a subject's traces and identifying patterns of repetition, echoes and synchronicities, then falling asleep, overwhelmed, while trying to visualise its totality. This vortex has an eye, a starting point: 'Let's think about Schwitters's *Merz Barn*!' But hilariously, astonishingly, the barn is empty! The original Schwitters's Merz work has been displaced somewhere else. So, what does the presence (of an international network around Schwitters) and the absence (a vacuum from a remote barn) start provoking?

On the one hand it catalyses a hyperbole for me. I imagine this displacement massively magnified and all-encompassing, rippling outwards, drawing in everything in its wake. From Schwitters's international network in the 1940s through to our present, this show at Tate Britain, Grizedale's involvement, and on into the future, with museums exhibiting other museums and expanded, or even 'exploded' museums that hold entire countries within their galleries. Then, on the other hand, I'm trying to make all of this movement very immediate and intimate. Paralleling it all to myself in the present. Being an artist. Sitting in a room in Whitstable.

I get giddy from following the movements of this vortex. It appears calmer right out on the edges. And there I am curious to find Edgar J. Kaufmann, who in the 1940s sits in his Frank Lloyd Wright-designed office (of course, itself another kind of immersive, organic, all-encompassing Merz) and is taking time off from running his department store to contemplate sending some money to Ambleside for the elderly, ill but very excited Schwitters, in order to help him build something intriguing in a barn in the middle of nowhere.

KS Among Schwitters's copious writings on his newly invented concept of Merz, a statements stands out: 'Merz is consistent. Merz cultivates nonsense. Merz builds the new from fragments. Merz develops the studies for a communal creation of the world. Merz detoxifies. Merz is Kurt Schwitters.' Schwitters saw himself as synonymous with Merz. How much do you place yourself at the centre of your work?

LP Well, I was invited to do the project because it was known that my grandfather had work by Schwitters!

AC Everything I make always starts and ends with the personal. But, as with all of us, that self is constantly changing. Just as some dreary art comes from a practice that is kept at arm's length from the self, I think some very boring art comes out of the narcissistic complacency that arises from the total merging of art and life. I think the truth is always closer to a dynamic movement between intimacy and distance. This is why painters have to step back and forth from the easel. Frequent moments of coming out of our artist's gaze in order to empathise with a viewer or subject is important because they destabilise and unsettle our position as creators. It's uncomfortable. But from this uncertainty new questions arise, and I think that is what art should be doing, catalysing amazing contradictions.

I think particularly when making the *Merz Barn*, in ailing health, Schwitters was able to become very lost within his process – becoming temporarily 'at one' with matter. Yet throughout his life he was also constantly pragmatic about making work in any situation, in any environment and his style always changed to suit the times. You can see in Schwitters an acute sensitivity to what was 'outside' himself, rather than a navel-gazing dogmatic belief that 'Everything I do is Art!!'

KS How important is knowledge of artistic precedents for creating new work, and how does an artist's approach to researching them differ from that of art historians?

LP I like the idea of being inside someone's brain. Not always making sense, adding confusion to the perception of a work ... with words being mistranslated. More than anything I am interested in how everything becomes an influence. In this instance, I wanted to know how looking at and thinking about Schwitters might affect my own practice – and how in the process my work would lose control of itself. I am also interested in the different sides of his practice – in particular his non-institutional way of creating, maybe going against the idea of the 'Master'.

AC I would get very claustrophobic if I became too fascinated by another artist's work. It seems incestuous. So, I'm very wary about making a work that focuses on another visual artist. But I got over these misgivings by imagining that I am making something at a time when art does not exist. It is over. Lost. Degenerated. I imagine that Art as a category of human activity has currently become useless. That gives me some space. I can forget

Schwitters is 'an artist' and see him as someone who was trying out a new language. Because he needed to use it. And I am doing the same thing.

AH I'm glad you mentioned the idea of art becoming useless, because Grizedale's position is that art, whoever made it, should be useful in some way. This is a distinct but vital position that has been somewhat neglected by art history of late. I always saw the triangular relationship in this project – between Tate, the artists and ourselves – as way to discuss this idea within the context of a formal exhibition. How are we all using this exhibition, this opportunity? How is someone who has bought a ticket to the show, or reading the catalogue, using the work here? In each case you would have a very wide range of reasons not all to do with the timeline of formal developments in art – maybe to feel cultural or to meet a friend or to connect with a romanticised idea of modernity long withered away.

Schwitters is a good case study in this respect. Looking at the way he's pushed and pulled in different directions by art historians, artists, audiences, students, tourist boards, art organisations and so on is perhaps more of a central issue for me than his way with torn-up bus tickets. But how is it that this material has such import and why should we dig it over? Here in the Lake District, Schwitters is virtually invisible. In the rankings of local creative mavericks he's way down there with Ken Russell, Millican Dalton and Joss Ackland, not up there with Beatrix Potter, Alfred Wainwright, William Wordsworth and John Ruskin. Yet there is a nostalgia for a moment of modernism in full nonsensical swing, when there was an urgency for a global consensus on the way things should go, even if you found yourself in a hovel in a wet corner of Britain. This is where Adam's vortex or Laure's introspection come in as useful ways of getting away from the structures imposed by art historians and the expectations of reason that in one way or another seek to clarify and strip away fiction from fact. My understanding of history is that it is not objective but continually remembered and forgotten, broken and rebuilt as a malleable (but slippery) matter.

In this light, I wouldn't like to put too much faith in the facts, even if they are from first-hand accounts, and to use this material in a way that allows us to be more open to how art might function in the wider world. Cumbria Tourist Board will no doubt use the exhibition to enhance the 'tourist offer', and this will hopefully result in greater awareness of the work the Littoral Trust are doing to develop the *Merz Barn* site. The artists will develop their work, and Tate and Grizedale will capitalise intellectually and economically – we may even get a new farm building that has practical, productive uses, and so on. When people go to museums, I'd like them to think about why they are doing so in a more complex way. This approach makes for a more interesting, dynamic social ecology, whether we are talking about experiencing art in a museum or making a life in the country.

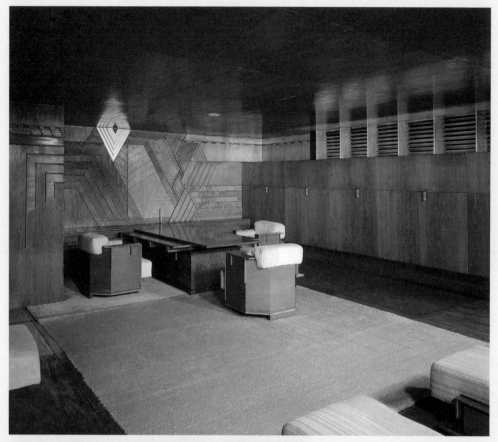

43

Frank Lloyd Wright
Office designed by Frank Lloyd Wright in
1937 for Kaufmann's department store in
Pittsburgh, now in the collection of
Victoria and Albert Museum, London

44

Adam Chodzko
KomMERZvortex
2012
Sketch for installation

45

Laure Prouvost
Sketch for grandfather's dining room, 2012

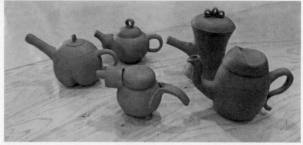

46

Laure Prouvost
Detail from 'Wantee's teapots', 2012

P.152

P.142

1887 — **1914** — **1915** — **1919**

1887
–
20 June: Curt Hermann Eduard Carl Julius Schwitters is born in Rumannstrasse, Hanover. His mother, Henriette, and father, Eduard (née Beckemeyer), are shop owners.

1894
–
Schwitters begins school at Modernes Realgymnasium I, Hanover.

1901–1905
–
Moves house with his family to 5 Waldstrasse, Hanover. Suffers his first epileptic seizure. Begins to produce his first pictures at the age of eight.

1908–1909
–
Enrols at Kunstgewerbeschule (School of Applied Art), Hanover, where he is taught by Richard Schlösser.

1909
–
Schlösser recommends that Schwitters studies in Dresden at the prestigious Königlich Sächsische Akademie der Künste (Royal Saxon Academy of Art) where he is accepted as a pupil. He studies painting under Carl Bantzer during summer semesters between 1909 and 1911. From winter 1912 onwards, he studies landscape painting under Gotthardt Kuehl. Schwitters continues his studies at the Academy until 1915.
–
Begins to write his first poems.

1910
–
Spring: Begins to write notes for a publication on abstract painting.

1911
–
August: Takes part in his first exhibition in Hanover organised by the Kunstverein (art society). Shows four still-life paintings and a portrait of his mother that he produced as a student.
–
Applies to study at Akademie der Künste, Berlin, but is not accepted as a student.
–
Christmas: Exhibits work at Kunst und Gewerbehalle, Hanover.

1913
–
February – May: Exhibits again at Kunstverein, Hanover, in *Grosse Kunstausstellung* and later in their autumn exhibition. He regularly contributes to these shows until 1934.

1915
–
13 June: Is engaged to Helma Fischer, his second cousin whom he had been courting since 1908.
–
9 August: Leaves Königlich Sächsische Akademie der Künste.
–
5 October: Marries Helma and the couple move to an apartment on the second floor of Schwitters's parent's three-story house at 5 Waldhausenstrasse (formerly named Waldstrasse).

1916
–
9 September: Schwitters's first son Gerd is born, but tragically dies shortly afterwards on 17 September.

1917
–
Begins work on the series of paintings entitled *Abstraktionen*.
–
12 March – 19 June: Serves as a soldier in German Reich Infantry Regiment 73. Is declared unfit for service and assigned clerical duties.
–
May – June: Exhibits at Kestner-Gesellschaft, Hanover.
–
25 June: Is drafted for auxiliary military service as a mechanical draughtsman in Wülfel Ironworks, Hanover. Withdraws from service on 28 November 1918 to pursue his painting career.
–
Winter: Studies in the architecture department at the Königliche Technische Hochschule.

1918
–
February – March: Is included in the first show of the Hannoversche Sezession at Kestner-Gesellschaft (he shows there again in 1919–21 and 1932).
–
June: Exhibits at Herwarth Walden's Galerie Der Sturm, Berlin, and regularly performs and exhibits there until 1928.
–
Autumn: Meets artists Hans Arp, Raoul Hausmann and Hannah Höch in Berlin, with whom he later develops close friendships.
–
16 November: Schwitters's son Ernst is born.
–
Produces his first collages and assemblages. First invents the concept of *Merz* to describe his art work.

1919
–
Produces his first rubber stamp drawings (*Stempelzeichnungen*) and graphic prints. Begins a series of dadaist watercolours.
–
Joins the International Association of Expressionists, Cubists and Futurists (IVEKF).
–
May: Meets Richard Huelsenbeck, founder member of Berlin dada. Schwitters is supported by Huelsenbeck, but is not accepted as an official member of the group. He nevertheless contributes essays, poems and texts to various dada publications.

–
May – June: Exhibits at Jena Kunstverein in a joint show with Otto Gleichmann and Max Burchartz. Writes to Tristan Tzara, a leading protagonist of Zurich dada, enclosing poems and reproductions of his works.
–
June – July: Exhibits at Galerie Emil Richter and Neue Vereinigung für Kunst, Dresden.
–
July: First displays his *Merz* pictures at the seventy-sixth exhibition of Galerie Der Sturm, Berlin. He defines his concept of Merz in the essay 'Die Merzmalerei', for the periodical *Der Sturm*.
–
July – September: Exhibits work in another show organised by Galerie Der Sturm at Kunstsalon Rembrandt, Zurich, which includes cubist, expressionist and futurist works.

Publishes the poem 'An Anna Blume' in *Der Sturm*, no.4. The book *Anna Blume: Dichtungen* is published later this year as part of the series *Die Silbergäule*, nos.39–40. Its publisher Paul Steegemann promotes Schwitters as a dadaist poet and writer and the book becomes a bestseller.

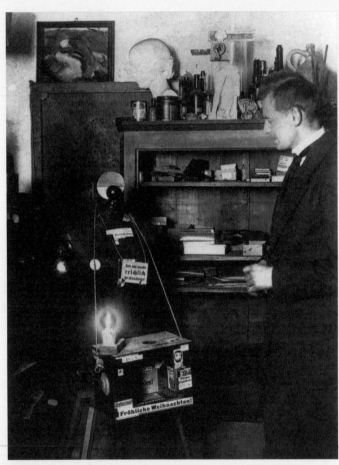

47
Schwitters with *Die Heilige Bekümmernis (The Holy Affliction)*
c.1920

1920
–
Dresden Stadtmuseum purchases *L Merzbild L3* 1919.
–
April: Visits Max Ernst in Cologne.
–
5 – 11 May: Performs his first public poetry recitals at Galerie Der Sturm, Berlin.
–
May – July: Visits the dada art fair in Berlin.
–
July: Exhibits in Darmstadt, and the following month travels to Dresden and exhibits work in a joint exhibition with Oskar Schlemmer and Willi Baumeister at Galerie Arnold.
–
October: Exhibits in Rome. The following month his work is included in a show by Société Anonyme, New York. He shows there regularly until 1940 and contributes works to an exhibition of the collection of Société Anonyme in New Haven in 1942.

Christof Spengemann publishes the first book on Schwitters: *Die Wahreit über Anna Blume*, Der Zweeman Verlag, Hanover.

Begins working on dada-inspired *Merz Columns* in his studio, which later inspire the columns that are the foundations of his *Merzbau*.

1921
–
Publishes his essay 'Merz' in the periodical *Der Ararat* (no.1).
–
April: Galerie Der Sturm stages his first solo show, entitled *96th Exhibition. Kurt Schwitters. Merz Pictures. Merz Drawings. Survey.*
–
July: Publishes poems and text in the periodical *De Stijl*.
–
September: "Anti-Dada-Merz-Trip" to Prague with Raoul Hausmann, Hannah Höch and Helma Schwitters.
–
Inspired by Hausmann, begins work on his first sound poem, the *Ursonate*.

1922

–

March – April: Solo exhibition at Roemer-Museum, Hildesheim.

–

September: Participates in the Internationaler Kongress für Konstruktivisten und Dadaisten, Weimar. Takes part in a number of dada soirées, including one with Hans Arp, Nelly and Theo van Doesburg, and Tristan Tzara at Galerie von Garvens, Hanover.

–

October: Travels to Berlin on invitation of El Lissitzky. Visits "First Russian Exhibition" at the Galerie van Diemen, Berlin.

–

New edition of *Anna Blume* and numerous poems are published.

–

Winter: Shares a studio with the Hungarian-born artist László Moholy-Nagy in Spichernstrasse, Berlin, until 1923.

1923

–

Publishes six issues of his periodical *Merz* .

–

January – April: Takes part in the dada tour with Theo and Nelly van Doesburg and Vilmos Huszár. They travel to The Hague, Haarlem, Amsterdam, Delft, Bois-le-Duc, Utrecht, Rotterdam, Leiden, and Drachten.

–

March: Has work included in a Constructivist show at Galerie Emil Richter, Dresden with Oskar Schlemmer, Moholy-Nagy, El Lissitzky, and Max Burchartz.

1924

–

Continues to publish his *Merz* magazines including *Merz 8/9 Nasci* with El Lissitzky in April/July.

–

September – October: Exhibits in Vienna, and then in a joint show with Arp and Alexej Jawlensky at Kesterner-Gesellschaft, Hanover.

–

Sets up a publishing house called Apossverlag. Also founds his *Merz-Werbezentrale*, a graphic design agency through which he pursues his interest in typography.

1925

–

Collaborates on Merz publications with van Doesburg and Käte Steinitz.

–

Pictures of Schwitters's studio are reproduced in the book *Die Kunstismen* by El Lissitzky, Hans Arp and others.

–

14 February: Schwitters and Nelly van Doesburg (on the piano) give a recital at Irmgard Kiepenheuer's house in Potsdam. Schwitters performs his *Ursonate* for the first time.

–

April: Meets Katherine S. Dreier on the occasion of her visit to Hanover to prepare the *International Exhibition of Modern Art*, for the Brooklyn Museum, New York, organised by Société Anonyme.

–

Travels to the Netherlands and exhibits in Berlin and Prague.

1927

–

Works on new *Merz Columns* that would become the foundation of the *Merzbau* in a studio in his parents' apartment at Waldhausenstrasse 5.

–

Publishes four poems, and a number of his artworks are reproduced in the British avant-garde periodical *Ray*.

–

Becomes a co-founder of the international association of graphic designers called *ring neue werbegestalter*.

–

A major retrospective exhibition entitled *Grosse Merzausstellung 1927* tours to several German cities.

–

12 March: Co-founds the group *die abstrakten hannover* with Carl Buchheister, Rudolf Jahns, Hans Nitzschke, and Friedrich Vordemberge-Gildewart. They exhibit together in numerous group shows in the following years. The group is the official subgroup of the Berlin artists' group *Die Abstrakten. Internationale Vereinigung der Expressionisten, Kubisten, Futuristen, und Konstruktivisten e. V.*

–

April: Travels to France with Hans Arp. Visits Theo and Nelly van Doesburg in Paris. Meets Tristan Tzara, André Breton, and E.L.T. Mesens, and subsequently travels to Brussels with Mesens.

–

Travels to Prague and the Netherlands and is represented in an exhibition of new typography in Gewerbemuseum Basel.

1928

–

Travels for five weeks to Italy as a guest student of the Technische Hochschule, Hanover.

–

May – July: Exhibits in the show *Grosse Berliner Kunstausstellung*.

1929

Signs a contract with Hanover town Council to work as the official typographer until 1934.

Becomes a member of the artists' association *Cercle et Carré*, France.

Visits Norway with his family for the first time. He makes annual summer trips until 1936, and also travels to Paris annually until 1932.

Autumn: Designs the exhibition publications for Walter Gropius's Dammerstock-Siedlung project, Karlsruhe.

October – November: Is represented in the exhibition *Abstrakte und Surrealistische Malerei und Plastik*, Kunsthaus, Zurich.

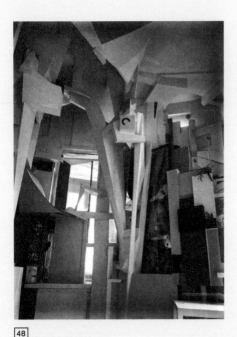

48

**The Hanover Merzbau,
detail of the 'Blue Window'**
1933

1930
–
Joins the PEN literary club, founded in London in 1921. He also co-founds the *Ring Hannoverscher Schriftsteller* with Christof Spengemann.
–
Exhibits with *Cercle et Carré* in Paris at Galerie 23.

1931
–
Is elected Honorary President of the Société Anonyme, and becomes a member of the artists' association Abstraction-Creation, Paris.
–
Travels to the Netherlands and to Norway, and exhibits work in Amsterdam.
–
Autumn: A photogram by Schwitters is included in the *Studio* special edition 'Modern Photography'.
–
Schwitters's work on his *Merz Columns* expands to incorporate the whole room – the *Merzbau*. Over the next six years he gradually expands this into other areas of the house.

1932
–
Merz 24 Ursonate is published (typography by Jan Tschichold). The Scherzo from the *Ursonate* and the poem *An Anna Blume* are recorded for the broadcaster Süddeutscher Rundfunk Stuttgart.
–
Visits the island of Hjertøya and finds a dilapidated hut that he begins to convert into a Merz construction. Continues to visit the site until 1939.

Two works and an artist's statement by Schwitters are published in the journal *Abstraction-Creation*.
–
Schwitters's work features in George Hugnet's article 'L'Esprit Dada dans la peinture III' in *Cahiers d'Art*.

1933
–
Is defamed in the exhibition *November Spirit: Art in the Service of Moral Corruption* in Stuttgart and Bielefeld, organised by the Nazi party.
–
Is included in the first *Entartete Kunst* (Degenerate art) touring exhibition organised by the Nazi party. He is represented by his *Das Merzbild*, *Merzbild mit Ring*, and his poem *An Anna Blume*. His work is accompanied by the quotation 'Everything an artist spits out is art'.
–
Declares his *Merzbau* finished and photographs of the structure are published in the journal *Abstraction-Création*. However, he continues to expand the *Merzbau* until 1937.
–
Schwitters's work is reproduced in Herbert Read's book *Art Now*.

1934
–
Travels to, and exhibits in shows in Oslo and Berlin. Stays on Hjertøya again with Helma. Takes a camping trip in Norway with Ernst and meets Hans and Suzanne Freudenthal with whom he becomes close friends.
–
October – November: Schwitters's work is presented at the Kunstverein, Hanover, for the last time.

1935
–
Travels to Norway, Denmark and Switzerland.

1936
–
Meets Piet Mondrian on a trip to Paris. Also travels to Switzerland, the Netherlands, Basel and Amsterdam.
–
March – April: Takes part in the exhibition *Cubism and Abstract Art*, Museum of Modern Art, New York.
–
May – September: Travels to Norway, staying on the island of Hjertøya, then in Molde and Djupvasshytta, where he is visited by the Freudenthals. He subsequently travels also to Stockholm and the Netherlands.
–
Schwitters's *Merzbau* now occupies at least six rooms in his apartment.
–
Schwitters's friends are arrested in Hanover in August and he seeks support from the United States to save his *Merzbau*, which is not forthcoming. The former Bauhaus teacher Josef Albers offers to negotiate a visiting professorship in the United States for Schwitters, but he declines the offer.
–
December – January 1937: Exhibits work in the exhibition *Fantastic Art, Dada, Surrealism*, Museum of Modern Art, New York (MoMA).
–

1937

NORWAY

1937
–
2 January: Chooses to emigrate from Germany to Norway. His son Ernst is already living there having fled on 26 December 1936, probably to avoid interrogation for his resistance activities. Schwitters's wife Helma stays in Hanover with her parents and mother-in-law, to look after the family's various properties. She travels to Norway annually until 1939.
–
February – September: Lives with Ernst in Lysaker near Oslo and in Molde in the summer, producing a large body of work capturing the new landscape that surrounds him. Stays on Hjertøya and then travels around western Norway, returning to Lysaker in late September.
–
December: Begins work on his second Merz construction (*Haus am Bakken* [House on the Slope]), a self-built studio structure on his landlord's property in Lysaker (this is destroyed by fire in 1951). The basic structure is completed between May and October 1938. Schwitters continues to work on it, but the interior is unfinished in April 1940 when Germany invades Norway.

EXHIBITIONS

January – February
Exhibits in the *Konstruktiv-isten* exhibition, Kunsthalle, Basel.

July – August
A number of works by Schwitters are confiscated from German museums in Mannheim, Hanover, Berlin and Dresden. Four of his works are included in the second *Entartete Kunst* exhibition in Munich in July after being labelled 'degenerate' by the Nazi party.

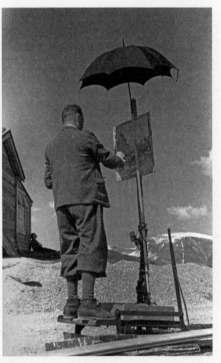

49

Kurt Schwitters with his easel in Norway
1936–7
Photograph by
Ernst Schwitters

1938
–
January – February: Helma Schwitters moves a number of Schwitters's key works from Hanover to Lysaker.
–
Easter: Paints landscapes and portraits in western Norway.

EXHIBITIONS

4–26 November
Exhibits five works in *Collages, Papier-Collés, and Photomontages*, Guggenheim Jeune, London. Peggy Guggenheim purchases five collages.

7–31 July
Exhibits two works in *Exhibition of Twentieth Century German Art*, New Burlington Galleries, London, staged in protest against the *Entartete Kunst* exhibition the previous year.

1939
–
Schwitters travels in Norway. He sees his wife Helma for the last time.

EXHIBITIONS

11–27 May
Exhibits two works in *Abstract and Concrete Art*, Guggenheim Jeune, London.

1940

BRITAIN

1940
–

February: Schwitters's passport expires and he begins to receive official demands to leave Norway; he fails to renew his passport or to obtain a visa for the United States.

–

9 April: Is forced to flee when Germany invades Norway. Travels for several weeks with his son and his son's wife Esther to Molde, the Lofoten islands and then to Tromsø in north-western Norway. They are briefly detained at various points on their journey.

–

8 June: Flees Norway with his son and daughter-in-law by boarding the icebreaker Fridtjof Nanssen. They cross to Scotland.

1940
–

Schwitters in Britain
19 June: Arrives in Edinburgh. Is interned in various camps including: Midlothian, Edinburgh; Edinburgh; York; Warth Mills at Bury, Lancashire.

17 July: Joins his son in Hutchinson Camp ('P' Camp), Douglas, one of eleven camps on the Isle of Man. Is joined there by a large number of artists, writers and intellectuals with whom he becomes friends. Paints more portraits than at any other time in his career (charging for some of these commissions), and produces landscape views of his surroundings. Continues to work on his abstract pieces. Recites his dada poems and stories in the camp.

–

24 August: With sixteen fellow internee artists writes a letter to *New Statesman and Nation* declaring that 'Art cannot live behind barbed wire'. The artists had previously written to Kenneth Clark, Director of the National Gallery, to ask for his help in securing their release from the camp (10 August).

–

December: Contributes drawings and short stories to the camp's newspaper *The Camp Almanac*.

EXHIBITIONS

**19 November 1940 – ?
(November)**
Exhibits at least two portraits in oil at the *2nd Art Exhibition*, Hutchinson Camp, Isle of Man.

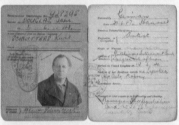

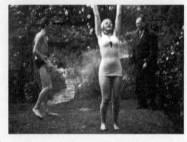

[50]

**Hutchinson camp, Douglas,
Isle of Man**
November 1940
Peter Daniel Collection

[51]

**Certificate of registration
for Hutchinson camp**
1941

[52]

**Schwitters, Gert Strindberg
and Edith Thomas in the
garden of the house in
Barnes**
c.1941–3

1941
–

22 November: Is released from Hutchinson Camp.

–

December: Moves into a two-room attic flat at 3 St Stephens Cresent, London, where he meets his future companion Edith Thomas (Wantee), who is living on the second floor. Ernst and Esther also live in the house.

1942

Joins the Artists International Association (founded in 1933).

–

March: Re-establishes contact by letter with Naum Gabo and László Moholy-Nagy and in May he meets Ben Nicholson for the first time. Sends Nicholson one of his collages the following February.

–

August: Moves with Ernst to 39 Westmoreland Road, Barnes, London, along with Gert Strindberg.

–

September: Visits the Lake District for the first time on a holiday with Edith Thomas.

–

Begins to write poetry in English including his 'London Symphony' which he continues to work on until 1946.

EXHIBITIONS

January
Exhibits five works in *Exhibition of Paintings, Sculpture and Drawings*, The Modern Art Gallery, London. This gallery was set up by fellow German émigré artist Jack Bilbo in 1941.

7–27 February
Exhibits three works at *Artists' International Association Members Exhibition*, R.B.A. Galleries, London.

18 March – 9 May
Exhibits one work in *New Movements in Art: Contemporary Work in England*, London Museum, Lancaster House, London. Also exhibits three works in the touring version of this exhibition *New Movements in Art*, which travels to Leicester Museum and Art Gallery, Leicester, 21 May – 21 July; Manchester City Art Gallery, Manchester, 19 September – 18 October; and also to Birkenhead, Bolton, Hull, Doncaster and Liverpool.

4–18 June
Exhibits four works in *Aid to Russia*, Willow Road, Hampstead, London (the home of émigré architect Erno Goldfinger).

1 July – 4 August
Exhibits one work in *Artists Aid Russia*, Wallace Collection, London. The exhibition raised funds for soldiers in the Soviet Union.

1943
–
Begins a more intense period of work on his small-scale sculptures.
–
8–9 October: Learns that his *Merzbau* in Hanover has been destroyed by bombing.

EXHIBITIONS

31 March – 25 May
Exhibits one work in *Artists Aid China*, Wallace Collection, London.

1944
–
April: Suffers a stroke leading to temporary paralysis on one side of his body.
–
22–25 August: Takes part in the PEN literary club's conference, meeting Stefan and Franciszka Themerson and Lucia Moholy-Nagy (ex-wife of artist László Moholy-Nagy).
–
29 October: Schwitters's wife Helma dies of cancer.

EXHIBITIONS

19 January – 29 February
Exhibits four works in *The World of Imagination*, The Modern Art Gallery, London. His sculptures are featured in a *Pathé* news piece on the show.

4 December
Holds a solo show at The Modern Art Gallery. Herbert Read writes the introduction to the catalogue. The exhibition includes thirty-nine works: eleven collages, eighteen paintings and ten sculptures. Schwitters also recites four poems, and performs his *Ursonate* at the opening.

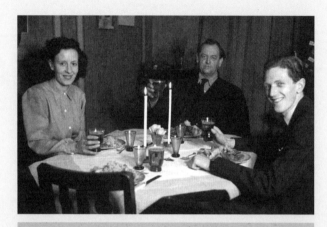

DECEMBER EXHIBITION, 1944

MASTERPIECES by GREAT MASTERS
Vincent Van Gogh's "Le Mont Gaussier" (1889)
PICASSO, RENOIR, VUILLARD, ROUAULT, VLAMINCK, COURBET, KLEE, MODIGLIANI, UTRILLO, SOUTINE, PIC, BILBO, SCHAMES, ADLER, GAUDIER-BRZESKA, BORÈS, DERAIN, BOMBOIS, VIVIN

ALSO
PAINTINGS AND SCULPTURE
by
KURT SCHWITTERS
(The founder of Dadaism and "Merz")
Private View and Press Day, Monday, 4th December, 1944
at 2 p.m.

KURT SCHWITTERS will recite some of his poems on December 4th at 7 p.m.
EVE (Eve blossom has wheels)
FISHBONE (Small-poem for big stutterers)
FMMSBWTZU (Part of a sound poem called "Sonata")
THE FLYING FISH (A fantastic story)

the modern art gallery ltd.
24 Charles II Street, Haymarket, London, S.W.I
Weekdays 10—5.30 Saturdays 10—1
ADMIT TWO

53
Schwitters, Edith Thomas and Gert Strindberg, Christmas
London, 1944

54
Painting and Sculpture by Kurt Schwitters
The Modern Art Gallery, London, 1944

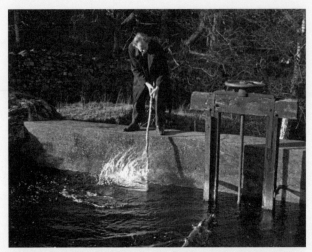

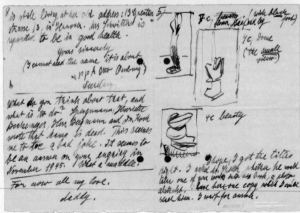

[55]

**Schwitters by the lock
at Tarn Hows, Coniston,
Cumbria**
1945

[56]

**Letter with drawings of
sculptures from Kurt
Schwitters to Ernst and Lola
Schwitters, Ambleside**
5 May 1946

1945
–
An acquaintance from
Hanover, the London-based
émigré industrialist Walter
Dux, provides Schwitters with
financial assistance, for which
he receives artworks.
–
26 June: Moves to 2 Gale
Cresent, Ambleside, Lake
District, with Edith Thomas.
–
In Ambleside, meets the
teacher Harry Bickerstaff
(whose portrait he paints in
March 1946) and the artist
Hilde Goldschmidt. Sustains
himself by undertaking por-
traits, landscapes and still-life
paintings for friends.
–
Ernst Schwitters returns to
Norway and gains Norwegian
citizenship. He re-marries, and
Schwitters and Edith Thomas
visit him in London in Novem-
ber to attend his wedding.
–
Writes to Alfred Barr, Jr,
Director of Painting and
Sculpture at MoMA describ-
ing his small-scale sculptures
to him.
–
Travels around Britain to
London, Manchester, Liver-
pool, Southport, Blackpool,
Preston and Penrith to
undertake a number of portrait
commissions from 1945–7.

EXHIBITIONS

19 February – 2 April
Exhibits nineteen works in
a solo exhibition as part of
*Der Sturm: Sammlung Nell
Walden aus den Jahren
1912–1920*, Kunstmuseum,
Bern.

1946
–
February: Collapses due to
a stroke and further illness.
Moves with Edith to a more
easily accessible house on
lower ground at 4 Millans
Park, Ambleside.
–
April: Begins to look for
ways to prevent his Merz
constructions in Hanover and
Norway from being lost and to
salvage parts of the *Merzbau*
in Hanover. The businessman
Oliver Kaufmann offers his
early support.
–
Discusses the possibility of a
solo exhibition of his work and
his inclusion in an international
exhibition of collages with
Margaret Miller at MoMA (this
is not realised in his lifetime).
–
Summer: Renews contact by
letter with Raoul Hausmann
and works with him on the
periodical *PIN* until the follow-
ing spring.
–
October: Breaks his femur
and is confined to bed for a
number of weeks.

EXHIBITIONS

19 July – 18 August
Exhibits one work in the
*1er Salon des Réalitiés
nouvelles: Art abstrait,
concret, constructivisme,
non figuratif*, Palais des
Beaux-Arts, Paris.

12 September – 3 October
Exhibits two works in *Lake
Artists' Society Annual Exhi-
bition*, Grasmere. Is elected
to the society following the
display of his portraits of Dr
George Ainslie and Harry
Bickerstaff in the exhibition.

1947

–

February – March: Travels to London with Edith Thomas. Suffers an asthma attack and is confined to bed again for two weeks.

–

5 and 7 March: Performs in two Merz evenings at The London Gallery on the occasion of his exhibition there. BBC representatives attend, but decline the invitation to record his *Ursonate*.

–

From March onwards, decides to work on a new Merz construction. Meets Harry Pierce whose portrait he had been commissioned to paint. Pierce owns Cylinders Farm, Elterwater, Cumbria, which Schwitters uses as the site for his new *Merz Barn*.

–

Schwitters travels the five miles from Ambleside to Elterwater each day to work on the *Merz Barn*. He describes the project in a letter to his son (19 July) as a small house of two rooms at Cylinders in which he can produce 'a new Merzbau, No 3, with the American Money'. The dry-stone-walled barn that he transforms was originally built in 1943.

–

9 June: Schwitters's grandson, Bengt Schwitters, is born in Norway.

–

20 June: On the day of Schwitters's sixtieth birthday he receives notification from The Museum of Modern Art, New York, that he has been awarded a fellowship of $1000. This was intended to fund the rebuilding or continuation of Schwitters's Merz constructions in Hanover or Lysaker, but he uses the award to work on his *Merz Barn* in Cumbria.

17 July: Work on the *Merz Barn* is interrupted when Schwitters suffers a haemorrhage. He is admitted to Kendal hospital in December.

EXHIBITIONS

10 June–12 July
Exhibits six works in *Lake Artists' Society Annual Exhibition*, Grasmere.

3 March–12 April
Exhibits one work in *The White Plane*, The Pinacotheca, New York.

June – July
Exhibits in group show at The London Gallery.

57
Schwitters drawing in the Lake District,
c.1946–7

58
Schwitters with Bill Pierce, Edith Thomas and Gwenyth Alban Davis at Cylinders farm, Elterwater, Langdale
1947

1948

1949

1950

1948

–

7 January: Receives noti-
fication that he has been
granted British citizenship.
The following day, however,
Schwitters dies from acute
pulmonary edema and myo-
carditis in Kendal Hospital,
still a German citizen.

–

10 January: Schwitters is
buried in the churchyard
of St Mary, Ambleside.
His remains are removed
to Hanover in 1970.

–

The *Merz Barn* is left
unfinished. The relief wall
construction on which he
had focused his energies
is removed from the barn
in 1965 and re-sited in the
Hatton Gallery, Newcastle,
where it remains to date.

EXHIBITIONS

Three works are exhibited
posthumously in the *Lake
Artists' Society Annual
Exhibition*, Grasmere.

19 January – February
Twenty-six collages and
constructions selected by
Schwitters are exhibited post-
humously in *Kurt Schwitters*,
Pinacotheca, New York.

21 September – 5 December
Nineteen collages are
exhibited posthumously in
Collage, MoMA.

1950

–

19 April – 13 May: Thirty-three
works are exhibited post-
humously in *An Homage to
Kurt Schwitters*, The London
Gallery, London.

FURTHER READING

Mary Burkett, *Kurt Schwitters: Creator of Merz*, exh. cat.,
Abbot Hall Art Gallery, Kendal 1979 (reprinted 2006).

Kurt Schwitters in Exile: The Late Work 1937–1948, exh. cat.,
Marlborough Fine Art, London 1981.

John Elderfield, *Kurt Schwitters*, London and New York 1985.

Gwendolen Webster, *Kurt Merz Schwitters: A Biographical Study*,
Cardiff 1997.

No Socks: Kurt Schwitters and the Merzbarn, exh. cat.,
Hatton Gallery, Newcastle 1999.

Karin Orchard and Susanne Meyer-Büser (eds.), *In the Beginning was
Merz: From Kurt Schwitters to the Present Day*, exh. cat., Sprengel
Museum Hannover 2000.

Karin Orchard and Isabel Schulz (eds.), *Kurt Schwitters: Catalogue
Raisonné*, 3 vols., Ostefildern-Ruit 2000–6.

'I Build My Time': Kurt Schwitters in Ambleside, exh. cat., Armitt Museum
and Library, The Armitt Trust, Ambleside 2003.

Shulamith Behr and Marian Malet (eds.), *Arts in Exile in Britain 1933–1945:
Politics and Cultural Identity*, Yearbook of the Research Centre for German
and Austrian Exile Studies, vol.6, London 2004.

Jutta Vinzent, *Identity and Image: Refugee Artists from Nazi Germany in
Britain 1933–1945*, Kromsdorf/Weimar 2006.

Karin Orchard and Henie Onstad Art Centre (eds.), *Schwitters in Norway*,
exh. cat., Henie Onstad Art Centre, Høvikodden 2009.

Sarah MacDougall and Rachel Dickson (eds.), *Forced Journeys: Artists in
Exile in Britain c.1933–1945*, exh. cat., Ben Uri Art Gallery, London 2009.

Isabel Schulz (ed.), *Kurt Schwitters: Colour and Collage*, exh. cat.,
The Menil Collection, Houston 2010.

Kurt Schwitters, *Three Stories*, introd. Jasia Reichardt, text E.L.T Mesens,
London 2010.

Roger Cardinal and Gwendolen Webster, *Kurt Schwitters*, Ostfildern 2011.

A comprehensive bibliography on Kurt Schwitters can be found at the website
of the Sprengel Museum Hannover: http://www.sprengel-museum.de/kurt_
schwitters_archiv/bibliografie_/index.htm

EXHIBITED WORKS

Schwitters works are ordered by catalogue raisonné number. Original titles are given with translations in English where necessary. Works with no original title are given in English. The works listed here are for the Tate exhibition only.

Abstraktion No 16 (Schlafender Kristall)
Abstraction No 16 (Sleeping Crystal)
1918
Oil on canvas
73.5 x 51.5
Kurt und Ernst Schwitters Stiftung on loan to Sprengel Museum Hannover
CR:0246
(p.78)

Ja-was? Bild
Yes-what? Picture
1920
Oil, paper, cardboard, and wood on cardboard
98 x 69
Collection Victor and Marianne Langen
CR:0604
(p.80)

Bild mit Raumgewächsen/
Bild mit 2 kleinen Hunden
Picture with Spatial Growths/Picture with 2 Little Dogs
1920, 39
Oil, paper, cardboard, fabric, wood, hair, ceramic and metal on cardboard
97 x 69
Tate. Purchased 1984
CR:0614
(p.81)

Merzz. 80. Zeichnung 130
Merzz. 80. Drawing 130
1920
Gouache, fabric and paper on paper
13 x 9.5
Private collection
CR:0652

Mz 120 leer
Mz 120 Empty
1920
Paper and fabric on paper
13.3 x 10.5
Private collection
CR:0672a

Merzbild 46 A. Das Kegelbild
Merz Picture 46 A. The Skittle Picture
1921
Oil, wood, metal, and cardboard on cardboard
47 x 35.8
Sprengel Museum Hannover
CR:0781
(p.82)

Mz 245. Mal Kah
1921
Chalk, paper and cardboard on paper
12.5 x 9.8
Private collection
CR:0838

Mz 300 mit Feder.
Mz 300 with Feather.
1921
Feather, fabric, net, paper and canvas on paper
16 x 13
Private collection on loan to Sprengel Museum Hannover
CR:0867
(fig.28, p.57)

Mz. 307. Erster Platz./Mz 307 Jettchen
Mz.307. First Place./Mz 307 Jettchen
1921
Paper on paper
17.5 x 14.5
Private collection
CR:0872

Mz 268 Hannover
Mz 268 Hanover
1921
Collage on paper
19.9 x 14.3
Private collection
CR:0852b

Untitled (Wool)
1924–6
Paper on paper
15.2 x 11.4
Private collection
CR:1249

Bild 1926,14 mit grünem Ring/Merzbild mit grünem Ring
Picture 1926,14 with Green Ring/Merz Picture with Green Ring
1926, 37
Oil, cork and wood on wood
62.3 x 51.2
LWL – Landesmuseum für Kunst und Kulturgeschichte, Westfälisches Landesmuseum, Münster
CR:1354

Mz 26,42. alt
Mz 26,42. Old
1926
Paper on paper
13.5 x 10
Private collection
CR:1413

Untitled (DER STURM, Cubists/Futurists)
1926
Paper on paper
19.5 x 15
Private Collection
CR:1449

Untitled (Trunk with Collages)
c.1926
Paper on wood
77 x 73 x 65
Kurt und Ernst Schwitters Stiftung on loan to Sprengel Museum Hannover
CR:1467

Untitled (With Gentleman in Overcoat and Bowler Hat)
1926
Gouache and paper on cardboard
15.6 x 11.4
Private collection
CR:1461

Untitled (Merz, Diagonal)
1927
Paper on paper
15.5 x 15.4
Private collection
CR:1518
(fig.31, p.61)

Untitled (With Two Large Transport Tickets)
1928
Paper on paper
13.4 x 9.2
The Mayor Gallery, London
CR:1534

für Frau Fränkel
1927
Paper on paper
7.6 x 5
Mrs Margaret Dane
CR:1515a

Hochgebirge (Gegend Öye)
High Mountains (Øye Region)
1930
Oil, cardboard, wax paper, wooden peg, wood and sheet metal on cardboard
53.8 x 46
Kurt und Ernst Schwitters Stiftung on loan to Sprengel Museum Hannover
CR:1651

Halbmond/Ugelvik
Half Moon/Ugelvik
1930–3
Oil, paper, wood on cardboard
65.7 x 53.7
Private collection
CR:1652

Mz 30,9
1930
Paper on paper
17.1 x 13.3
British Museum
CR:1678

doremifasolasido
c.1930
Paper on paper
29.4 x 23.3
Private collection
CR:1737
(p.84)

KÖRTINGBILD
THE KÖRTING PICTURE
1932
Oil, wood, tree bark, sheet metal and algae on canvas
73.6 x 60.5
Private collection
CR:1826
(p.83)

Untitled (Briarwood Sculpture)
1936–9
Wood, metal and cardboard (covered with imitation leather), painted
17.5 x 11.5 x 6.3
Kurt und Ernst Schwitters Stiftung on loan to Sprengel Museum Hannover
CR:2106

Das Gewitterbild.
The Thunder Storm Picture.
1937–9
Oil and wood on plywood
76.5/77.2 x 65
Kurt und Ernst Schwitters Stiftung on loan to Sprengel Museum Hannover
CR:2120
(p.87)

Mz. Oslofjord
Mz. Oslo Fjord
1937
Oil on plywood
32.2 x 23.6
Kurt und Ernst Schwitters Stiftung on loan to Sprengel Museum Hannover
CR:2124
(p.86)

Isbræ under sne
Isbreen under Snow
1937
Oil on wood
67 x 56
Kurt und Ernst Schwitters
Stiftung on loan to Sprengel
Museum Hannover
CR:2164

Untitled (With an Early
Portrait of Kurt Schwitters)
1937–8
Paper, tissue paper and
cardboard on cardboard
22.7 x 18.1
Sprengel Museum Hannover
CR:2262
(p.88)

Untitled (MIER-BITTE)
1937–8
Paper, photograph and
fragment of phonograph
record on paper
32.5 x 25
Abbot Hall Art Gallery,
Lakeland Arts Trust, Kendal,
Cumbria
CR:2266

Untitled
(Opened by Customs)
1937–8
Paper, greaseproof paper and
cardboard on paper
32.5 x 25
Tate. Purchased 1958
CR:2267
(p.88)

Untitled (For the Hand)
1937–40
Plaster, painted
6.6 x 21 .6 x 13.3
Sammlung NORD/LB in
der Niedersächsischen
Sparkassenstiftung on loan to
Sprengel Museum Hannover
CR:2323

Phantasie über Dächern
Fantasy on Roofs
1939
Oil, wood, cardboard
and metal on wood
34.8 x 27
Kurt und Ernst Schwitters
Stiftung on loan to Sprengel
Museum Hannover
CR:2486
(p.89)

Untitled (Oil Wiping on
Newspaper 3)
1939
Oil on paper
16.3 x 14
Victoria and Albert Museum,
London
CR:2580

Bild abstrakt Kabelvaag
Abstract Picture Kabelvaag
1940
Oil and wood on wood
58.1 x 48.6
Annetta and Gustav Grisard
CR:2619

Untitled (Glass Flower)
1940
Oil, wood, glass and
plaster on wood
77.5 x 67.5 x 25.5
Museum Ludwig, Cologne/
Permanent Loan Ludwig
Collection
CR:2624

Untitled
(The Basket Picture)
1940
Paint, wood, plaster, tree bark,
lobster shell, metal chain,
rubber, wicker basket and
mixed materials on wood
67.1 x 75.5 x 18
Collection Victor and
Marianne Langen
CR:2625
(p.94)

Untitled (Abstract Oval
Picture)
[Part of a presentation
book containing 38 pages
with original art work by
various artists]
1940, 41
Oil on canvas
31 x 23
Peter Daniel Collection
CR:2630
(p.41)

Untitled (With
Madonna-like Form 1)
1940–1
Oil on burlap on wood
66.3 x 55.1
Kurt und Ernst Schwitters
Stiftung on loan to Sprengel
Museum Hannover
CR:2631

Bild abstrakt Skøyen II
Abstract Picture Skøyen II
1940, 42, 46
Oil, paper and cardboard
on wood
51 .5 x 63.5
Collection of Ellen and
Michael Ringier, Switzerland
CR:2642

Parti fra Skodje ved
Ålesund
Partial View from Skodje
near Ålesund
1940
Oil on wood
63.8 x 49.5
Kurt und Ernst Schwitters
Stiftung on loan to Sprengel
Museum Hannover
CR:2643

Untitled
(Portrait of Fred Uhlman)
1940
Oil on wood
100 x 73
Hatton Gallery:
Great North Museum,
Newcastle upon Tyne
CR:2651
(p.37)

Portrait of the
Sculptor Charoux
1940
Oil on cardboard
34.2 x 27.6
Kurt und Ernst Schwitters
Stiftung on loan to Sprengel
Museum Hannover
CR:2661
(p.38*)*

Pink, green, white
1940
Paper on paper
21.6 x 16.5
Tom Melly
CR:2690
(p.90)

Untitled (LAST)
1940–5
Net, paper, ribbon and
oil on paper
26 x 21
Private collection
CR:2701

Untitled (JAM UIT
STANDARD)
1940–5
Oil, calico tape, net, fabric
and paper on paper
34.8 x 24.6
Kurt und Ernst Schwitters
Stiftung on loan to Sprengel
Museum Hannover
CR:2703

British made
1940–5
Paper, fabric, cellophane,
cardboard and oil on paper
23.2 x 18
Galerie Rosengart, Lucerne
CR:2708
(p.91)

Untitled
(In the Piano Room)
1940
Graphite on cardboard
37.5 x 27.5
Kurt und Ernst Schwitters
Stiftung on loan to Sprengel
Museum Hannover
CR:2728

Untitled
(Birchwood sculpture)
1940
Wood
19.1 x 8.5 x 7.5
Kurt und Ernst Schwitters
Stiftung on loan to Sprengel
Museum Hannover
CR:2759

Untitled (Picture with Ring
and Frame)
1941
Oil, wood frame and rubber
ring on plywood
78.9 x 68.4
Kurt und Ernst Schwitters
Stiftung on loan to Sprengel
Museum Hannover
CR:2760
(p.98)

AERATED V
1941
Oil, wood and ping-pong
ball on plywood
32 x 27.9
Kurt und Ernst Schwitters
Stiftung on loan to Sprengel
Museum Hannover
CR:2764
(p.95)

Anything with a stone
1941–4
Oil, paper, cardboard,
wood, stone and plastic
on plywood
59.5/61 .3 x 47.8/44.8
Sprengel Museum Hannover
CR:2766
(p.105)

Untitled
(Picture with Wooden Ring)
1941
Oil and wood on plywood
35 x 45.2
Private collection
CR:2767

Blue Paragraph
1941–4
Oil and wood on wood
27.2 x 20
Kurt und Ernst Schwitters
Stiftung on loan to Sprengel
Museum Hannover
CR:2770
(p.96)

Untitled (Curving Forms)
1941
Oil on plywood
61.2 x 48.4
Geoff and Judy Thomas
CR:2774

Scenery from Douglas [1]
1941
Oil and wax tempera
on plywood
32.7 x 24.9
Kurt und Ernst Schwitters
Stiftung on loan to Sprengel
Museum Hannover
CR:2787

Untitled (Roofs of Houses
in Douglas, Isle of Man)
1941
Wax tempera on linoleum
38.7 x 43.7
Kurt und Ernst Schwitters
Stiftung on loan to Sprengel
Museum Hannover
CR:2790
(p.36)

Untitled (Portrait of
Klaus Hinrichsen)
1941
Oil on wood
55 x 45
Private collection
CR:2795
(p.39)

Untitled (MAGIC SED!)
1941–2
Paper on paper
13.1 x 10.5
Tate. Accepted by HM Gov-
ernment in lieu of inheritance
tax and allocated to Tate 2007
CR:2819
(fig.29, p.59)

Untitled (Curving Forms
or Isle of Man)
1941
Oil, cardboard and plastic?
on linoleum on paper
112 x 97
Collection Van Abbemuseum,
Eindhoven
CR:2775
(p.40)

Untitled
(Courting the Bride)
1941–2
Paper on cardboard
18.5 x 24.5
Tate. Accepted by HM Gov-
ernment in lieu of inheritance
tax and allocated to Tate 2007
CR: 2820

Untitled
(The Wounded Hunter)
1941–2
Paper on cardboard
20.3 x 26.1
Kurt und Ernst Schwitters
Stiftung on loan to Sprengel
Museum Hannover
CR:2826
(p.92)

Untitled (The Doll)
1941–2
Paper and photograph
on cardboard
24.5 x 18.9
Private collection
CR:2827
(p.68)

HALDANE
1941–5
Ink on paper
13.8 x 10.2
Kurt und Ernst Schwitters
Stiftung on loan to Sprengel
Museum Hannover
CR:2865

Red wire and half spoon
1942
Oil, wire, metal (spoon frag-
ment) and plastic on paper
on canvas
19.6 x 12.1
Private collection
CR:2893
(p.100)

AERATED VI
1942
Oil, plywood and cardboard
on plywood
23.5 x 17.7
Private collection
CR:2897

Untitled
(The Double Picture)
1942
Relief, oil and gilded wood
frame fragment on canvas on
gilded wood
67 x 55.6
Courtesy Galerie Gmurzynska
CR:2900

Untitled (White
Construction)
1942
Oil and wood on wood
56.5 x 44.9
Geoff and Judy Thomas
CR:2901
(p.97)

Untitled (Relief within
Relief)
1942–5
Oil and wood on wood
41.2 x 32.4
Tate. Purchased 1970
CR:2908
(p.101)

Untitled (Lovely Portrait)
1942
Oil on canvas on wood
126 x 101
Museum Ludwig, Cologne/
Permanent Loan Ludwig
Collection
CR:2910

Untitled (Rainbow
Column or Picture with
Birchwood Sculpture)
1942–5
Oil on cardboard
38.2 x 48.2
Kurt und Ernst Schwitters
Stiftung on loan to Sprengel
Museum Hannover
CR:2923

Untitled (Garden in
Barnes)
1942–5
Oil on plywood
35 x 29.8
Kurt und Ernst Schwitters
Stiftung on loan to Sprengel
Museum Hannover
CR:2938

like an old master
1942
Paper and fabric on canvas
26.9 x 21.5
Sprengel Museum Hannover
CR:2941
(fig.33, p.63)

Untitled (Bassett)
1942
Paper on paper
23 x 17
Walter Feilchenfeldt, Zurich
CR:2946

Untitled
(This is to Certify that)
1942
Paper on paper
24 x 19.3
Kunsthalle Mannheim
CR:2947
(p.93)

Untitled (THE OX)
?1942
Oil, cardboard and paper
on cardboard
30 x 25.2
Private collection
CR:2954

Untitled (TERNATIONA)
1942
Paper on paper
51.1 x 40.5
Private collection
CR:2956

Untitled (Little Whale)
1942–5
Plaster, painted
10.5 x 21.4 x 13.2
Sammlung NORD/LB in
der Niedersächsischen
Sparkassenstiftung on loan to
Sprengel Museum Hannover
CR:2980

Untitled (Solid Sculpture)
1942–5
Plaster, painted
46.2 x 23.1 x 15.3
Kurt und Ernst Schwitters
Stiftung on loan to Sprengel
Museum Hannover
CR:2981
(p.108)

Untitled
(Opening Blossom)
1942–5
Plaster, painted
12.2 x 8.5 x 5.1
Sammlung NORD/LB in der
Niedersächsischen
Sparkassenstiftung Hannover
on loan to Sprengel Museum
Hannover
CR:2982
(p.106)

Untitled (The All-
Embracing Sculpture)
1942–5
Wood, iron and
plaster, painted
43.6 x 18.5 x 15.2 (incl. base)
Kurt und Ernst Schwitters
Stiftung on loan to Sprengel
Museum Hannover
CR:2984
(p.106)

Untitled (Mask)
1943
Oil, paper, plaster and corru-
gated cardboard on wood
32/30 x 25.3
Courtesy Galerie
Thomas Knoell
CR:2990

Take
1943
Oil, paper, wood, linoleum,
fabric, leather and scrubbing
brush on paper
77 x 54
Private collection
CR:2993
(p.103)

As you like it
1943–4
Oil, wood, frame moulding,
cardboard, twig, porcelain,
metal toy and mixed media
on wood
54 x 41
Private collection
CR:2995

Untitled
(Picture with White Slat)
1943
Oil and wood on canvas
91 x 71
Private collection
CR:3000
(p.99)

Coloured wood construction
1943
Oil and wood on wood
35 x 28.8
Kurt und Ernst Schwitters
Stiftung on loan to Sprengel
Museum Hannover
CR:3003
(p.104)

Surrealistic.
1943
Oil, tree bark, wood on
metal on wood
31.2 x 24.5
Courtesy Galerie Gmurzynska
CR:3004
(p.102)

Untitled (Relief
Construction)
1943–5
Oil on wood on plywood
18.9 x 16
Geoff and Judy Thomas
CR:3009

Untitled (Composition with
Strip of Cardboard)
1943–5
Paint, cardboard and paper
on cardboard box
26.2 x 20.8
Courtesy Galerie Gmurzynska
CR:3012

Untitled (Asbestos Mat)
1943–5
Oil, wood, leather and
asbestos on wood
49.8 x 39.4
Art Collection HypoVereins-
bank – Member of Uni Credit
CR:3013

Untitled (With Black
Cross on Red Circle)
1943
Oil, glass and linoleum
on canvas
63 x 75.5
Private collection
CR:3015

Untitled (Picture with
Wooden "Knife")
1941–3
Oil, wood and paper
on canvas
111.7 x 86.2
Kurt und Ernst Schwitters
Stiftung on loan to Sprengel
Museum Hannover
CR:3017

Untitled (Quality Street)
1943
Paper on paper
25 x 20.8
Sammlung NORD/LB in
der Niedersächsischen
Sparkassenstiftung on loan to
Sprengel Museum Hannover
CR:3036
(p.25)

Speed
1943
Wood and plaster, painted
28.9 x 15.3 x 12.2
Sammlung NORD/LB in
der Niedersächsischen
Sparkassenstiftung on loan to
Sprengel Museum Hannover
CR:3049
(p.109)

Dancer
1943
Bone? and plaster, painted
78 x 20 x 15
Courtesy Galerie Gmurzynska
CR:3050
(p.23)

Beautiful Stillife
1944
Oil, wood and plaster on wood
18.1 x 23.2
Private collection
CR:3061
(fig.12, p.14)

Untitled (Moved White
on Blue and Yellow)
c.1944
Oil, wood and plastic on wood
32.2 x 28.4
Galerie Haas AG Zürich
CR:3065

Red Line [2]
1944
Oil, gouache, paper, canvas
and cardboard on wood
12.7 x 9.6
Kurt und Ernst Schwitters
Stiftung on loan to Sprengel
Museum Hannover
CR:3079
(fig.9, p.12)

For Herbert Read.
1944
Fabric, paper and cardboard
on cardboard
21 x 16.5
Private collection
CR:3081
(p.24)

Untitled (The Hitler Gang)
1944
Oil, canvas, cardboard
and paper on paper
34.8 x 24.6
Kurt und Ernst Schwitters
Stiftung on loan to Sprengel
Museum Hannover
CR:3086
(p.69)

**Untitled (Flowers in
a Garden 2)**
1944
Crayon on paper
23 x 18.2
Kurt und Ernst Schwitters
Stiftung on loan to Sprengel
Museum Hannover
CR:3102

Untitled (Standing One)
1944
Plaster, painted
15.3 x 11.5 x 6
Sammlung NORD/LB in
der Niedersächsischen
Sparkassenstiftung on loan to
Sprengel Museum Hannover
CR:3129

Fant/Good-for-Nothing
1944
Wood and plaster, painted
29 x 11.5 x 11.5
Sammlung NORD/LB in
der Niedersächsischen
Sparkassenstiftung on loan to
Sprengel Museum Hannover
CR:3130
(p.52)

**Untitled
(Red Wire Sculpture)**
1944
Wood, wire, clay, ceramic,
stone, dried fruit and
plaster, painted
25 x 13 x 13
Tate. Purchased 1990
CR:3132
(p.110)

Untitled (Everybody's)
?1945
Oil, fabric, buttons, netting,
paper, leather, plaster, card-
board and metal on cardboard
33.2 x 27.4
Private collection
CR:3134
(p.116)

Untitled (Flight)
1945
Oil, wood, plastic and rubber
on wood on cardboard
22.7 x 15.6
Abbot Hall Art Gallery,
Lakeland Arts Trust, Kendal,
Cumbria
CR:3137

Untitled (BLACK POWDER)
1945–7
Oil, wood and cotton wool
on wood
37.5 x 31 .5
Private collection
CR:3141

Untitled (Heavy Relief)
1945
Oil, plaster, wood, leather
and asbestos on wood
54.2 x 45.5
Courtesy Galerie Gmurzynska
CR:3148

**Untitled (Bridge House,
Ambleside, Front View)**
1945
Oil on cardboard
25.5 x 19.15
Courtesy of The Armitt Trust,
Ambleside
CR:3163
(p.29)

Untitled (Rothay Valley 2)
?1945
Oil on plywood
29.5 x 44.2
Private collection
CR:3168

**Untitled (Portrait of
Frank Routledge)**
1945
Oil on wood
68.8 x 55.3
Abbot Hall Art Gallery,
Lakeland Arts Trust, Kendal,
Cumbria
CR:3171

**Untitled
(Portrait of Conrad Slater)**
1945
Oil on cardboard
39.5 x 32.7
Private collection courtesy of
The Armitt Trust, Ambleside
CR:3181

Untitled (Rydal Water)
1945–7
Oil on canvas
55 x 44.5
Geoff and Judy Thomas
CR:3187

**Untitled
(ROSS, with Penny)**
1945–7
Feather, plastic foil, coin and
paper on cardboard
47.5 x 38
Private collection, Germany
CR:3218
(p.117)

**Untitled
(Landscape with Trees)**
1945
Graphite on paper
20.4 x 28
Kurt und Ernst Schwitters
Stiftung on loan to Sprengel
Museum Hannover
CR:3227

Untitled (Lofty)
c.1945
Plaster, painted
25.2 x 16 x 13
Tate. Purchased 1990
CR:3242
(p.111)

Untitled (The Clown)
1945–7
Plaster and stone, painted
19.5 x 15.2 x 6
Tate. Lent by Geoff Thomas
1991
CR:3243
(p.112)

Untitled (Togetherness)
1945–7
Stone, cardboard and
plaster, painted
21 .9 x 7.5 x 7
Tate. Lent by Geoff Thomas
1991
CR:3244
(p.55)

**Untitled (Painted Plaster
and Wood Form)**
1945–7
Wood, bone and
plaster, painted
22.3 x 16 x 16
Tate. Lent by Geoff Thomas
1991
CR:3246
(fig.27, p.49)

**Untitled (Construction
on a Sheep Bone)**
1945–7
Wood, bone, nails and
plaster, painted
22.9 x 19.5 x 15.6
Abbot Hall Art Gallery,
Lakeland Arts Trust,
Kendal, Cumbria
CR:3247
(p.54)

Untitled (Ochre)
1945–7
Plaster and stone, painted
9.5 x 22.6 x 15
Tate. Purchased 1990
CR:3249
(fig.17, p.44)

Untitled (Mother and Egg)
1945–7
Plaster, painted
11 .2 x 19.3 x 10.5
Tate. Lent by Geoff Thomas
1991
CR:3251
(p.22)

Untitled (Peg Sculpture)
1945–7
Wood, ?plaster and wooden
peg, painted
8.2 x 28 x 13.7
Tate. Lent by Geoff Thomas
1991
CR:3253

Untitled (White Miniature)
1945–7
Bone and plaster, painted
12.6 x 10.9 x 10.9
Tate. Lent by Geoff Thomas
1991
CR:3255

Untitled (Painted Stone)
1945–7
Painted stone
3.5 x 31 .3 x 8
Tate. Lent by Geoff Thomas
1991
CR:3258
(fig.18, p.45)

Untitled (Stone)
1945–7
Painted stone
9.5 x 8.2 x 5
Tate. Lent by Geoff Thomas
1991
CR:3259
(p.53)

**Untitled
(The Nipple Picture)**
1946
Oil, paper, cardboard, rubber,
ribbon and glass on cardboard
24.5 x 19.5
Kurt und Ernst Schwitters
Stiftung on loan to Sprengel
Museum Hannover
CR:3263

Untitled (Wood on Wood)
c.1946
Oil and wood on wood
27.3 x 24.8 x 11
Courtesy of The Armitt Trust,
Ambleside
CR:3273
(p.27)

**Untitled (Smithy Brow,
Ambleside)**
1946
Oil on wood
28.2 x 33.5
Courtesy of The Armitt Trust,
Ambleside
CR:3280
(p.28)

**Untitled (Landscape
from Nook Lane)**
1946
Oil on cardboard
36 x 25.3
Mary E. Burkett O.B.E.,
Iselhall
CR:3281

Chrysanthemum
1946
Oil on cardboard
34.3 x 25.8
Courtesy Michael Werner
Gallery, New York, London
and Märkisch Wilmersdorf
CR:3293
(fig.13, p.15)

**Untitled (Portrait of
George Ainslie Johnston)**
1946
Oil on cardboard
66.5 x 50
Courtesy of The Armitt Trust,
Ambleside
CR:3297
(fig.14, p.15)

c 63 old picture
1946
Paper on paper
36.8 x 30.9
Kurt und Ernst Schwitters
Stiftung on loan to Sprengel
Museum Hannover
CR:3344
(p.120)

c 77 wind swept
1946
Paper doily, fabric, cardboard
and paper on cardboard
24.5 x 18.8
Staatliche Museum zu Berlin,
Kupferstichkabinett
CR:3349
(p.71)

Untitled (FOREMOST)
1946
Graphite and paper on paper
20 x 17
Private collection, London
CR:3362

**Untitled
(With Porcelain Shard)**
1946
Oil, porcelain and paper
on paper
12.3 x 10
William Alban Davis
CR:3363

**Chicken and Egg,
Egg and Chicken**
1946
?Wood and plaster, painted
44.5 x 18.5 x 24
Tate. Lent by Geoff Thomas
1991
CR:3395
(p.113)

C 21 John Bull.
1946, 47
Gouache, fabric, paper lace
and paper on paper
19.5 x 16.8
Kurt und Ernst Schwitters
Stiftung on loan to Sprengel
Museum Hannover
CR:3312
(p.119)

47. 15 pine trees c 26
1946, 47
Oil, photograph, paper
and corrugated cardboard
on cardboard
25.3 x 21
Kurt und Ernst Schwitters
Stiftung on loan to Sprengel
Museum Hannover
CR:3315
(p.30)

**Untitled
(Y. M. C. A. OFFICIAL
FLAG THANK YOU)**
1947
Oil, paper and cardboard
on wood
30.4 x 27.2
Abbot Hall Art Gallery,
Lakeland Arts Trust,
Kendal, Cumbria
CR:3396
(p.31)

Untitled (REFREE)
1947
Oil, paper, cardboard,
corrugated cardboard and
leather on cardboard
50 x 41
Alex Lachmann, London
CR:3406

**Untitled
(Portrait of Harry Pierce)**
1947
Oil on cardboard
80 x 62
On loan from The Armitt
Museum and Library, Amble-
side with kind permission from
the Pierce family
CR:3431
(p.127)

Mz x 20 Big Fight
1947
Paper on paper
13.2 x 8.4
Victoria and Albert Museum,
London
CR:3450
(p.122)

Mz x 22 Wantee
1947
Graphite, paper, cardboard
and photograph on paper
13.4 x 9.7
Liz Wantee Craigie
CR:3452
(p.126)

47 12 very complicated
1947
Oil, canvas and paper
on paper
24.4 x 21
Kurt und Ernst Schwitters
Stiftung on loan to Sprengel
Museum Hannover
CR:3461
(p.123)

For Herbert Reat.
[Schwitters's own spelling
of Read]
1947
Paper and cardboard on paper
18.7 x 15.5
Private collection
CR:3486
(p.118)

Untitled (BOOK)
1947
Paper and cardboard
on cardboard
25.3 x 22.2
Private collection
CR:3487

horizontal
1947
Paper and cardboard
on paper
20.3 x 16.5
Private collection
CR:3524

Mr. Churchill is 71
1947
Gouache, paper, fabric,
cardboard and photograph
on cardboard
19.5 x 15.8
The Sherwin Collection
CR:3544
(p.70)

Untitled (NSPORT BU)
?1947
Paper and photograph
on cardboard
17 x 17.8
Centre Pompidou, Musée
national d'art moderne, Paris/
Centre de création
industrielle. Purchased 1987
no. inv.: AM 1987-788
CR:3556

**Die heilige Nacht, von
Antonio Allegri, gen.
Correggio worked through
by Kurt Schwitters
The Holy Night by
Antonio Allegri, known as
Correggio reworked by
Kurt Schwitters**
1947
Paper, ribbon, cardboard,
photograph and corrugated
cardboard on cardboard
52.9 x 38.8
Private collection
CR:3616
(p.67)

Drawing.
1947
Ribbon and cardboard
on cardboard
19.1 x 15.3
Kurt und Ernst Schwitters
Stiftung on loan to Sprengel
Museum Hannover
CR:3618

**This was before H. R. H.
The Late DUKE OF
CLARENCE & AVONDALE.
Now it is a Merz picture.
Sorry!**
1947
Leather, paper and
cardboard on paper
39.1 x 27.3
Sammlung NORD/LB in
der Niedersächsischen
Sparkassenstiftung on loan to
Sprengel Museum Hannover
CR:3620
(p.121)

left half of a beauty
1947
Paper on cardboard
22.5 x 16.8
Galerie Kornfeld, Bern
CR:3623
(p.124)

EN MORN
1947
Tracing paper and paper
on paper
21 x 17/16.5
Centre Pompidou, Musée
national d'art moderne, Paris/
Centre de création
industrielle. Purchased 1995
no. inv.: AM 1995-204
CR:3624
(p.125)

Untitled (HIT AT CRETE)
1947
Paper and cardboard
on paper
26.2 x 20
Kurt und Ernst Schwitters
Stiftung on loan to Sprengel
Museum Hannover
CR:3627

Zebra
1947
Oil on paper
21.3 x 17.2
Private collection, Düsseldorf
CR:3650
(fig.34, p.63)

**Untitled (Street with Power
Masts in the Lake District)**
1947
Graphite on paper
11.2 x 17.3
Kurt und Ernst Schwitters
Stiftung on loan to Sprengel
Museum Hannover
CR:3654

**Untitled (Fragment from the
Merz Barn, Elterwater 1)**
1947
Stone, bamboo and
plaster, painted
82 x 27 x 19
Private collection, Hamburg
CR:3660
(p.115)

**Untitled (Fragment from the
Merz Barn, Elterwater 2)**
1947
Stone, bamboo and plaster
64 x 31 x 25
Museum Ludwig, Cologne/
Permanent Loan Ludwig
Collection
CR:3661

Kirkston Pass
1948
Graphite on paper
11.2 x 17.3
Kurt und Ernst Schwitters
Stiftung on loan to Sprengel
Museum Hannover
CR:3664

Lender note: The foundation
of Kurt und Ernst Schwitters
Stiftung was enabled by
the Schwitters family with
the support of NORD/LB
Norddeutsche Landesbank,
the Savings Bank Foundation
of Lower Saxony, Nieder-
sächsische Lottostiftung,
the Cultural Foundation
of the Federal States, the
State Minister at the Federal
Chancellery for Media and
Cultural Affairs, the Ministry
for Science and Culture of the
Land of Lower Saxony and the
City of Hanover.

WORKS BY OTHER ARTISTS

Naum Gabo
Construction on a Line
1935–7
Plastic
45.1 x 43.2 x 8.9
Tate. Purchased 1980

Naum Gabo
Spiral Theme
1941
Cellulose acetate and perspex
14 x 24.4 x 24.4
Tate. Presented by Miss
Madge Pulsford 1958

Barbara Hepworth
*Drawing for 'Sculpture
with Colour' (Forms
with Colour)*
1941
Gouache, oil and
graphite on paper
21 .7 x 39.2
Tate. Accepted by HM
Government in lieu of tax and
allocated to the Tate Gallery
1995

Erich Kahn
Lecture on the Lawn
1940
Print and watercolour
21 .4 x 34
IWM (Imperial War Museums)

Margaret Mellis
Sobranie Collage
1942
Collage on paper laid
on board
26.3 x 37
Tate. Purchased 1985

Paul Nash
Landscape from a Dream
1936–8
Oil on canvas
67.9 x 101 .6
Tate. Presented by the Con-
temporary Art Society 1946

John Cecil Stephenson
Painting
1937
Egg tempera on canvas
71.1 x 91 .4
Tate. Purchased 1963

Fred Uhlman
My Bedroom
1940
Ink and conte crayon on paper
17.9 x 23
IWM (Imperial War Museums)

Edward Wadsworth
Bronze Ballet
1940
Egg tempera on
plywood panel
63.5 x 76.2
Tate. Presented by the artist
1942

Hellmuth Weissenborn
*Almanac 1941, Hutchinson
Internment Camp, Douglas,
Isle of Man*
1940
Watercolour and lithograph
on paper
34 x 21
IWM (Imperial War Museums)

Hellmuth Weissenborn
View from Douglas Camp
1940
Linocut ink on paper
34.1 x 21.4
IWM (Imperial War Museums)

John Wells
Relief Construction
1941
Gouache, drawing and mixed
media and plastic on board
32.1 x 42.2 x 45
Tate. Purchased 1973

ACKNOWLEDGEMENTS

Schwitters in Britain has been a truly collaborative effort between colleagues in Hanover and London, and has also drawn on the expertise of a wider group of academics, curators, collectors and others who share our enthusiasm for Schwitters's work, and in different ways have supported our desire to shed greater light on his British years.

Our first and greatest debt is to the many lenders to this exhibition, who have generously released unique and fragile objects in their collections, allowing us to represent the full range of Schwitters's practice in this extraordinarily creative and prolific period of his life. Colleagues in the commercial sector have also been extremely helpful in tracing key works and we would particularly like to thank Christie's, Galerie Gmurzynska, Galerie Michael Haas, Marlborough Fine Art, Galería Leandro Navarro, Galerie Orlando GmbH and Galerie Michael Werner for their assistance in this respect.

We would like to thank the catalogue authors Megan Luke, Isabel Schulz, and Michael White, whose research into different aspects of Schwitters's practice helped to shape the direction of the show in its early stages, and whose essays have provided new insights into his British period. We are also grateful to many individuals who have generously shared their knowledge of Schwitters's life and work and its historical context during the development of the show including Rob Airey, Eva Beaumont, Joyce Blank, Fred Brookes, Yvonne Cresswell, Rachel Dickson, Peter Daniel, Bill and Marianne Davies, John Elderfield, Freddy Godshaw, Sabine de Gunzberg, Anthony, Elaine, Peter and Theresa Hallgarten, Gretel Hinrichsen, Ian Hunter, David Juda, Merry Kerr-Woodeson, Fran Lloyd, Sarah MacDougall, Leonard Marks, James Mayor, Jasia Reichardt, Ulrike Smalley, Geoff Thomas, Jutta Vinzent, Nicholas Wadley and Deborah Walsh.

The exhibition owes its existence to the vision of Penelope Curtis and Ulrich Krempel, Directors at Tate Britain and Sprengel Museum Hannover respectively, and many colleagues at the two institutions have worked with energy and commitment to ensure its success. At Tate we would like to thank Caroline Arno, Helen Beeckmans, Kirstie Beaven, Gillian Buttimer, Rachel Crome, Krzysztof Ciezkowski, Susan Doyon, Sionaigh Durrant, Matthew Gale, Bronwyn Gardner, Adrian Glew, Rebecca Hellen, Carolyn Kerr, Juleigh Gordon-Orr, Kirsteen McSwein, Fergus O'Connor, Georgina Ratcliffe, Lorna Robertson, Gates Sofer, Andy Sheil, Chris Stephens, Liam Tebbs, Amy Thompson, Roger Thorp, Piers Townshend and Jeannette Ward. At Sprengel Museum Hannover we would like to thank Pamela Bannehr, Aline Gwose, Ria Heine, Michael Herling, Dana Jonitz, Michael Kiewning, Eva Köhler, Ingrid Mecklenburg, Martina Mogge-Auerswald, Brigitte Nandingna, Peter Pürer, and Isabelle Schwarz.

The catalogue has been designed by The Studio of Williamson Curran and we are very grateful to them for bringing some of Schwitters's freshness of vision to the project. Rebecca Fortey at Tate Publishing skilfully steered the catalogue through the editorial stages, while Miriam Perez and Roanne Marner brought characteristic thoroughness to the picture research and production.

It has been a pleasure collaborating with Alistair Hudson and Adam Sutherland of Grizedale Arts and we are very grateful to artists Adam Chodzko and Laure Prouvost for their enthusiasm and commitment to this project.

Emma Chambers
Curator, Modern British Art, Tate

Karin Orchard
Curator, Department of Prints and Drawings, Sprengel Museum Hannover

Jennifer Powell
Assistant Curator, Modern British Art, Tate

Katharine Stout
Curator, Contemporary British Art, Tate

PHOTOGRAPHIC AND COPYRIGHT CREDITS

INDEX

Page numbers in **bold** refer to plates.

SUPPORTING TATE

Tate relies on a large number of supporters – individuals, foundations, companies and public sector sources – to enable it to deliver its programme of activities, both on and off its gallery sites. This support is essential in order for Tate to acquire works of art for the Collection, run education, outreach and exhibition programmes, care for the Collection in storage and enable art to be displayed, both digitally and physically, inside and outside Tate. Your donation will make a real difference and enable others to enjoy Tate and its Collection both now and in the future. There are a variety of ways in which you can help support Tate and also benefit as a UK or US taxpayer. Please contact us at:

Development Office
Tate
Millbank
London SWIP 4RG

Tel: 020 7887 4900
Fax: 020 7887 8098

American Patrons of Tate
520 West 27 Street Unit 404
New York, NY 10001
USA

Tel: 001 212 643 2818
Fax: 001 212 643 1001

Donations, of whatever size, are gratefully received, either to support particular areas of interest, or to contribute to general activity costs.

Gifts of Shares
We can accept gifts of quoted share and securities. All gifts of shares to Tate are exempt from capital gains tax, and higher rate taxpayers enjoy additional tax efficiencies. For further information please contact the Development Office.

Gift Aid
Through Gift Aid you can increase the value of your donation to Tate as we are able to reclaim the tax on your gift. Gift Aid applies to gifts of any size, whether regular or a one-off gift. Higher rate taxpayers are also able to claim additional personal tax relief. Contact us for further information and to make a Gift Aid Declaration.

Legacies
A legacy to Tate may take the form of a residual share of an estate, a specific cash sum or item of property such as a work of art. Legacies to Tate are free of inheritance tax, and help to secure a strong future for the Collection and galleries. For further information please contact the Development Office.

Offers in lieu of tax
Inheritance Tax can be satisfied by transferring to the Government a work of art of outstanding importance. In this case the amount of tax is reduced, and it can be made a condition of the offer that the work of art is allocated to Tate. Please contact us for details.

Tate Members
Tate Members enjoy unlimited free admission throughout the year to all exhibitions at Tate, as well as a number of other benefits such as exclusive use of our Members' Rooms and a free annual subscription to *Tate Etc*. Whilst enjoying the exclusive privileges of membership, you are also helping secure Tate's position at the very heart of British and modern art. Your support actively contributes to new purchases of important art, ensuring that the Tate's Collection continues to be relevant and comprehensive, as well as funding projects in London, Liverpool and St Ives that increase access and understanding for everyone.

Tate Patrons
Tate Patrons share a strong enthusiasm for art and are committed to giving significant financial support to Tate on an annual basis. The Patrons support the acquisition of works across Tate's broad collecting remit, as well as other areas of Tate activity such as conservation, education and research. The scheme provides a forum for Patrons to share their interest in art and to exchange knowledge and information in an enjoyable environment. United States taxpayers who wish to receive full tax exempt status from the IRS under Section 501 (c) (3) are able to support the Patrons through the American Patrons of Tate. For more information on the scheme please contact the Patrons office.

Corporate Membership
Corporate Membership at Tate Modern, Tate Britain and Tate Liverpool offers companies opportunities for corporate entertaining and the chance for a wide variety of employee benefits. These include special private views, special access to paying exhibitions, out-of-hours visits and tours, invitations to VIP events and talks at members' offices.

Corporate Investment
Tate has developed a range of imaginative partnerships with the corporate sector, ranging from international interpretation and exhibition programmes to local outreach and staff development programmes. We are particularly known for high-profile business to business marketing initiatives and employee benefit packages. Please contact the Corporate Fundraising team for further details.

Charity Details
The Tate Gallery is an exempt charity; the Museums & Galleries Act 1992 added the Tate Gallery to the list of exempt charities defined in the 1960 Charities Act. Tate Members is a registered charity (number 313021). Tate Foundation is a registered charity (number 1085314).

American Patrons of Tate
American Patrons of Tate is an independent charity based in New York that supports the work of Tate in the United Kingdom. It receives full tax exempt status from the IRS under section 501(c)(3) allowing United States taxpayers to receive tax deductions on gifts towards annual membership programmes, exhibitions, scholarship and capital projects. For more information contact the American Patrons of Tate office.

Simon Lee
Mr Gerald Levin
Leonard Lewis
Mrs Cynthia Lewis Beck
Mr Gilbert Lloyd
George Loudon
Mrs Elizabeth Louis
Mark and Liza Loveday
Daniella Luxembourg Art
Anthony Mackintosh
Eykyn Maclean LLC
The Mactaggart Third Fund
Mrs Jane Maitland Hudson
Mr M J Margulies
Lord and Lady Marks
Marsh Christian Trust
Mrs Anne-Sophie McGrath
Ms Fiona Mellish
Mr Martin Mellish
Mrs R W P Mellish
Professor Rob Melville
Mr Michael Meynell
Mr Alfred Mignano
Victoria Miro
Ms Milica Mitrovich
Jan Mol
Mrs Bona Montagu
Mrs Valerie Gladwin
 Montgomery
Mr Ricardo Mora
Mrs William Morrison
Richard Nagy
Daniela and Victor Gareh
Julian Opie
Pilar Ordovás
Sir Richard Osborn
Joseph and Chloe O'Sullivan
Desmond Page
Maureen Paley
Dominic Palfreyman
Michael Palin
Mrs Adelaida Palm
Stephen and Clare Pardy
Mrs Véronique Parke
Mr Sanjay Parthasarathy
Miss Nathalie Philippe
Ms Michina Ponzone-Pope
Mr Oliver Prenn
Susan Prevezer QC
Mr Adam Prideaux
James Pyner
Ivetta Rabinovich
Mrs Phyllis Rapp
Ms Victoria Reanney
Dr Laurence Reed
Mr and Mrs James Reed
Mr and Mrs Philip Renaud
The Reuben Foundation
Sir Tim Rice
Lady Ritblat
The Sylvie Fleming Collection
Ms Chao Roberts
David Rocklin
Frankie Rossi
Mr David V Rouch
Mr James Roundell
Naomi Russell
Mr Alex Sainsbury and
 Ms Elinor Jansz
Mr Richard Saltoun
Mrs Amanda Sater
Mrs Cecilia Scarpa
Cherrill and Ian Scheer

Sylvia Scheuer
Mrs Cara Schulze
Andrew and Belinda Scott
The Hon Richard Sharp
Mr Stuart Shave
Neville Shulman, CBE
The Schneer Foundation
Ms Julia Simmonds
Jennifer Smith
Mrs Cindy Sofer
Mr George Soros
Louise Spence
Mr and Mrs Nicholas Stanley
Mr Nicos Steratzias
Stacie Styles
Mrs Patricia Swannell
Mr James Swartz
The Lady Juliet Tadgell
Tot Taylor
Lady Tennant
Christopher and Sally Tennant
Mr Henry Tinsley
Karen Townshend
Melissa Ulfane
Mr Marc Vandecandelaere
Mrs Cecilia Versteegh
Mr Jorge Villon
Gisela von Sanden
Mr David von Simson
Audrey Wallrock
Stephen and
 Linda Waterhouse
Offer Waterman
Terry Watkins
Miss Cheyenne Westphal
Mr David Wood
Mr Douglas Woolf
*and those who wish to
remain anonymous*

Young Patrons
Vinita Agarwal
Stephanie Alameida
Ms Maria Allen
Miss Noor Al-Rahim
HRH Princess Alia Al-Senussi
 (Chair, Young Patron
 Ambassador Group)
Miss Sharifa Alsudairi
Sigurdur Arngrimsson
Miss Katharine Arnold
Miss Joy Asfar
Ms Mila Askarova
Miss Olivia Aubry
Flavie Audi
Josh Bell and Jsen Wintle
Miss Marisa Bellani
Ms Shruti Belliappa
Mr Erik Belz
Mr Edouard
 Benveniste-Schuler
Miss Margherita Berloni
Raimund Berthold
Ms Natalia Blaskovicova
Dr Brenda Blott
Mrs Sofia Bocca
Ms Lara Bohinc
Mr Andrew Bourne
Miss Camilla Bullus
Miss Verena Butt
Miss May Calil
Miss Sarah Calodney

Matt Carey-Williams and
 Donnie Roark
Georgina Casals
Kabir Chhatwani
Miss Katya Chitova
Dr Peter Chocian
Mrs Mona Collins
Mrs Laura Comfort
Thamara Corm
Miss Amanda C Cronin
Mr Theo Danjuma
Mr Joshua Davis
Mrs Suzy Franczak Davis
Ms Lora de Felice
Countess Charlotte de la
 Rochefoucauld
Mr Stanislas de Quenetain
Federico Debernardi
Mira Dimitrova
Ms Michelle D'Souza
Miss Roxanna Farboud
Jane and Richard Found
Mr Andreas Gegner
Mrs Benedetta Ghione-Webb
Miss Dori Gilinski
Mr Nick Hackworth
Alex Haidas
Ms Susan Harris
Sara Harrison
Kira Allegra Heller
Mrs Samantha Heyworth
Katherine Ireland
Miss Eloise Isaac
Kamel Jaber
Mr Jermaine Johnson
Mr Christopher Jones
Ms Melek Huma Kabakci
Miss Meruyert Kaliyeva
Efe and Aysun Kapanci
Ms Tanya Kazeminy Mackay
Miss Tamila Kerimova
Mr Benjamin Khalili
Ms Chloe Kinsman
Ms Marijana Kolak
Miss Constanze Kubern
Miss Marina Kurikhina
Mr Jimmy Lahoud
Ms Aliki Lampropoulos
Ms Anna Lapshina
Isabella Lauder-Frost
Mrs Julie Lawson
Ms Joanne Leigh
Miss MC Llamas
Mr Justin Lobo
Alex Logsdail
Mrs Siobhan Loughran
Charlotte Lucas
Alessandro Luongo
Mr John Madden
Ms Sonia Mak
Mr Jean-David Malat
Ms Clémence Mauchamp
Miss Charlotte Maxwell
Mr John McLaughlin
Miss Nina Moaddel
Mr Fernando Moncho Lobo
Ms Michelle Morphew
Erin Morris
Mrs Annette Nygren
Katharina Ottmann
Ilona Pacia
Phyllis Papadavid
Ms Camilla Paul

Alexander V. Petalas
Mrs Stephanie Petit
The Piper Gallery
Lauren Prakke
Mr Eugenio Re Rebaudengo
Mr Bruce Ritchie and
 Mrs Shadi Ritchie
Kimberley and
 Michael Robson-Ortiz
Mr Daniel Ross
Mr Simon Sakhai
Miss Tatiana Sapegina
Mr Simon Scheuer
Franz Schwarz
Count Indoo Sella
 Di Monteluce
Preeya Seth
Miss Kimberly Sgarlata
Henrietta Shields
Ms Heather Shimizu
Mr Paul Shin
Ms Marie-Anya Shriro
Mr Max Silver
Tammy Smulders
Miss Jelena Spasojevic
Alexandra Sterling
Mr Dominic Stolerman
Mr Edward Tang
Miss Georgiana Teodorescu
Miss Inge Theron
Soren S K Tholstrup
Hannah Tjaden
Mr Giancarlo Trinca
Mrs Padideh Trojanow
Mr Philippos Tsangrides
Dr George Tzircotis
Miss Brenda Van Camp
Mr Rupert Van Millingen
Mr Neil Wenman
Ms Hailey Widrig Ritcheson
Miss Julia Wright
Ms Seda Yalcinkaya
Michelle Yue
Mr Fabrizio Zappaterra
Miss Valeria Zingarevich
*and those who wish to
remain anonymous*

**North American
Acquisitions Committee**
Carol and David Appel
Paul Britton
Beth Rudin De Woody
Carla Emil and
 Richard Silverstein
Glenn Fuhrman
Victoria Gelfand-Magalhaes
Andrea and Marc Glimcher
Pamela Joyner
Monica Kalpakian
Elisabeth Farrell and
 Panos Karpidas
Christian K Keesee
Michael and Marjorie Levine
Massimo Marcucci
Lillian Mauer
Liza Mauer and
 Andrew Sheiner
Nancy McCain
Stuart and Della McLaughlin
Stavros Merjos
Gregory R. Miller
Shabin and Nadir Mohamed

Elisa Nuyten & David Dime
Amy and John Phelan
Liz Gerring Radke and
 Kirk Radke
Laura Rapp and Jay Smith
Robert Rennie (Chair)
 and Carey Fouks
Kimberly Richter
Donald R Sobey
Robert Sobey
Christen and Derek Wilson
*and those who wish to
remain anonymous*

**Latin American
Acquisitions Committee**
Monica and Robert Aguirre
Karen and Leon Amitai
Luis Benshimol
Billy Bickford, Jr. and
 Oscar Cuellar
Estrellita and Daniel Brodsky
Trudy and Paul Cejas
Patricia Phelps de Cisneros
David Cohen Sitton
Gerard Cohen
HSH the Prince
 Pierre d'Arenberg
Tiqui Atencio Demirdjian
 (Chair)
Lily Gabriella Elia
Angelica Fuentes de Vergara
Mauro Herlitzka
Yaz Hernandez
Rocio and Boris Hirmas Said
Anne Marie and
 Geoffrey Isaac
Nicole Junkermann
Jack Kirkland
Fatima and Eskander Maleki
Fernanda Feitosa and
 Heitor Martins
Becky and Jimmy Mayer
Solita and Steven Mishaan
Patricia Moraes and
 Pedro Barbosa
Catherine and Michel Pastor
Catherine Petitgas
Ferdinand Porák
Isabella Prata and
 Idel Arcuschin
Frances Reynolds
Erica Roberts
Judko Rosenstock and
 Oscar Hernandez
Guillermo Rozenblum
Alin Ryan von Buch
Lilly Scarpetta and
 Roberto Pumarejo
Catherine Shriro
Norma Smith
Susana and
 Ricardo Steinbruch
Juan Carlos Verme
Tania and Arnoldo Wald
Juan Yarur Torres
*and those who wish to
remain anonymous*

**Asia-Pacific
Acquisitions Committee**
Bonnie and R Derek Bandeen
Mr and Mrs John Carrafiell